D0842139

In print
C SS

Richard Lester

Photographing Fashion
British Style in the Sixties

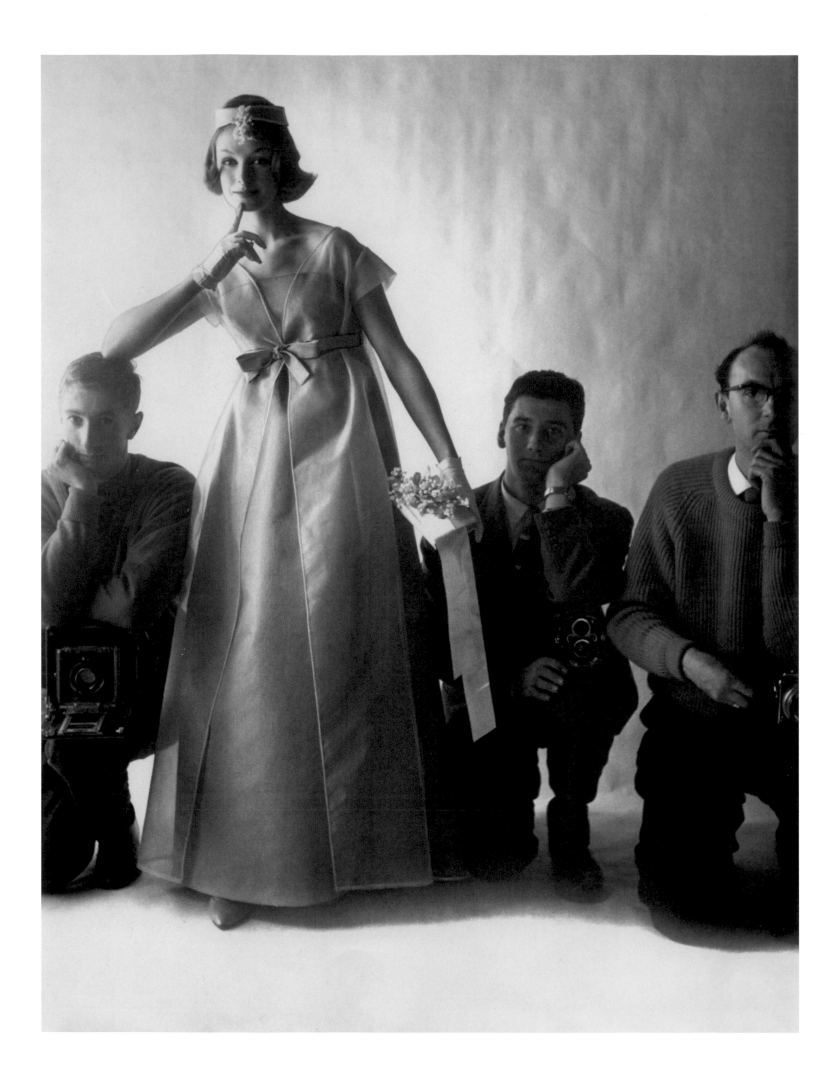

Art Center College Library
1700 Lida Street
Pasadena, CA 91103

ART CENTER COLLEGE OF DESIGN

3 3220 00274 5128

ACC Editions

Richard Lester
Foreword by John Bates

779.974692
L642p
2009

Art Center College Library
1700 Lida Street
Pasadena, CA 91103

Photographing Fashion
British Style in the Sixties

Opposite page
Studio Five photographers at work
in the early 1960s including Norman
Eales (left) and John Cole (far right).

© 2009 Richard Lester
World copyright reserved

ISBN 978 1 85149 600 6

The right of Richard Lester to be identified as author of this work has been asserted by him in accordance with the Copyright, Designs and Patents Act 1988. All rights reserved. No part of this publication may be reproduced, stored in a retrieval system, or transmitted in any form or by any means electronic, mechanical, photocopying, recording or otherwise, without the prior permission of the publishers.

Unless otherwise stated, all images are © Fashion Museum, Bath.

Every effort has been made to secure permission to reproduce the images contained within this book, and we are grateful to the individuals and institutions who have assisted in this task. Any errors are entirely unintentional, and the details should be addressed to the publisher.

British Library Cataloguing-in-Publication Data.

A catalogue record for this book is available from the British Library.

Publication designed and typeset by Northbank, Bath.
Printed in China

Mixed Sources
Product group from well-managed forests, controlled sources and recycled wood or fiber
www.fsc.org Cert no. SGS-COC-003548
© 1996 Forest Stewardship Council
FSC

ACC Editions. An imprint of
Antique Collectors' Club Ltd.,
Woodbridge, Suffolk, IP12 4SD

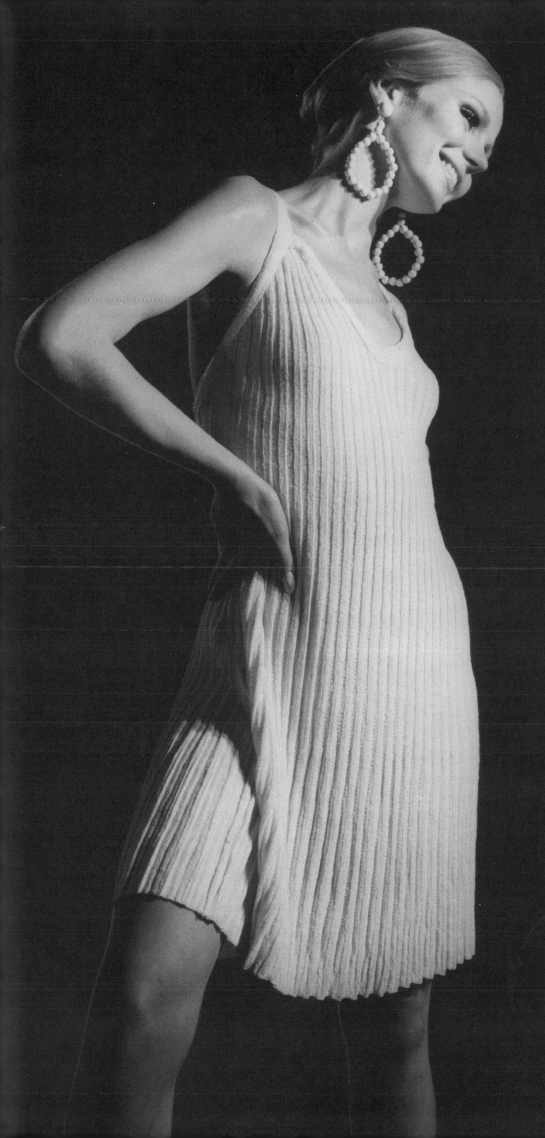

Art Center College Library
1700 Lida Street
Pasadena, CA 91103

Contents

When I started my fashion career designing for Jean Varon in the early sixties, apart from *Vogue, Queen* and *Harper's Bazaar* the one really important name was that of Ernestine Carter of the *Sunday Times* newspaper. Mrs Carter, never Ernestine in those early days, was a petite, immaculately dressed American woman with a formidable reputation.

Her weekly column encompassed reports on the important international couture and ready-to-wear collections, and was avidly read by the fashion trade. I used to think then that if Mrs Carter featured me in her pages, I would really have arrived (along, I guess, with every other designer just starting up) and people would begin to take notice, and to that end I used to write weekly letters inviting her to visit my showroom.

One day a very funny, pretty young girl called Brigid Keenan arrived to look at my small collection of minidresses and loved them. She'd just been appointed 'Young Ideas' editor to Mrs Carter, and was doing the rounds of all the new designers. Through her I got my one wedding dress from the collection into the June 1961 'Marriage Month' article by Mrs Carter. Such was her influence, the following Monday the phone started ringing from shops and stores who'd hitherto been difficult to get hold of.

It took a full year – until June 1962 – to get into the 'Suddenly it's June' article, again with a wedding dress, and it worried me slightly that people would think I only designed wedding dresses. I needn't have worried, as Brigid Keenan began to give my daywear publicity in her own column from September 1962. However, it took till May 1964, after Brigid had literally dragged her in, for Ernestine to visit and give me a comprehensive write-up. Brigid told me many moons later that Ernestine was most impressed by the Eton tie I was wearing at the time. I hasten to add that it was a tie

Foreword: *John Bates*

that I had bought because I liked the pattern; whether it was an Eton College design I have no idea. That one write-up opened so many doors that had been previously firmly shut.

Mrs Carter was fair in her coverage of most designers, featuring them and their work, with up-and-coming photographers and artists of the day to illustrate her articles. That ready-to-wear was no longer dependent on couture for ideas, and was a vibrant entity in itself, was promoted enthusiastically by Ernestine. She really did a great job of bringing to her readers' attention the fact that young British designers were here to stay, and presented our work continuously throughout her stay at the Sunday Times. Muir, Quant, Gibb, Clarke, Yuki, Fratini, Foale & Tuffin, Wainwright, Hulanicki, Rhodes and I were all beneficiaries and owe her a huge debt of gratitude.

I found her very fair and honest. She once said to me that if she didn't like a collection she simply wouldn't write about it. Not for her, the 'bitchy knocking' that lesser writers thought clever. She understood the amount of time and money needed to produce a collection and felt that it wasn't her place to be negative. Her pages were also too valuable to waste on reporting collections that were, in her opinion, below par. She was one of the few journalists to treat fashion as an industry and not some frivolous ephemeral part of show business.

When she retired in 1972, she presented the entire photographic collection from her pages, amounting to over 1,000 images, to the Museum of Costume in Bath, albeit unreferenced. This was an invaluable source when Richard Lester wrote *John Bates: Fashion Designer* in 2008, and he and Rosemary Harden are to be congratulated on researching and cataloguing such an important, extensive archive for this book, which will be an essential reference work for serious fashion historians in the future.

As Women's and later Associate Editor of the *Sunday Times* from 1955 to 1968, Ernestine Carter had a front row seat as the 1960s fashion revolution unfolded. American by birth, she came from a particular group of well connected, artistic, educated and internationally travelled Americans that took naturally to shaping perceptions of style. She worked as a curator at the Museum of Modern Art in New York during the 1930s and, after marriage to an Englishman, spent the war in London, an experience she shared with her photo-journalist friend Lee Miller. From 1946 to 1949 she witnessed Dior's 'New Look' spread across the globe as Fashion Editor of *Harper's Bazaar,* but it was her move to the *Sunday Times* that allowed her to shape the tastes of a new generation of fashion readers in her 'Mainly for Women' pages, alongside fashion writers Brigid and Moira Keenan, Sandy Boler and Meriel McCooey at the *Sunday Times* magazine.

On arrival she was far from impressed by the antiquated ways of the newspaper, describing it in her autobiography *Tongue in Chic* as 'like working in a gentleman's penal colony – the atmosphere was feudal: the journalists were vassals, Lord Kemsley the chairman our liege'. The world she entered had no conception of the drama about to unfold on the fashion scene, and the traditional fashion pages were largely unchanged from their pre-war format. The policy of the paper was to preserve continuity even though writers changed – the previous editor had the nom de plume 'Mary Dunbar'. Plans for a new style of woman's page were fraught with problems, not least as every decision had to go before art directors and ultimately Lord Kemsley for approval. Her plan was to break from the traditional 'diary page' and to expand literally to bigger and better things, using more newsprint and devising different themes each week. The pages would not be limited to fashion, but 'concerned with design in every area which could be made relevant to women'.

Traditionally a drawing, or occasionally a handout photograph, would be placed centrally in a layout, tombstone style, and only advertisers with the paper could be mentioned. Her early efforts at change were regularly frustrated as, on a number of occasions, the names of stockists were deleted by the board of the paper, which of course made it virtually impossible for readers to know where to obtain the clothes. 'My aim was to be free to establish a standard of quality not necessarily based on price, but on excellence of design, creative ability, and value'.

The early 1960s fashion landscape was still largely dominated by Paris and the couture houses, and Ernestine Carter's taste in illustration was perfectly suited to the time. She favoured photographers Richard Avedon, Norman Parkinson and Cecil Beaton for their ability to portray clothes and, as no photography was allowed at the couture shows, regularly used artists Bud Crosthwait, Joe Eula and Christian Bernais. As early as 1962, however, 'Mainly for Women' was beginning to sense change in the air, and began to feature clothes by younger designers such as John Bates at Jean Varon and Mary Quant for her Kings Road boutique, Bazaar.

Under the new regime fashion writers such as Brigid and Moira Keenan would introduce new designers whom they felt were making a mark to Ernestine Carter, and commission photographers to illustrate their clothes in a more informal and artistically innovative way. Through the revised format and expanded remit of 'Mainly for Women', Ernestine Carter had proved herself to be moving with the times, and in 1963 she was one of the first to identify and promote the talents of British designers with the *Sunday Times* International Fashion Awards. Intended to recognise those who made the greatest contribution to fashion design that year, the additional goal was to help to establish London as a fashion capital. Three international juries were set up, meeting in Paris to cast their votes at the end of the collections. The politics of keeping designers old and new happy became a headache, so each year a fashion 'Fashion Immortal' was also nominated, the first award going to Chanel.

Back in the office, Ernestine Carter could perhaps be described as a benevolent dictator, and both her personal assistant Caroline Colthurst and writer Brigid Keenan have vivid memories of the day when she suggested that all her staff should wear matching outfits with Peter Pan collars and velvet Alice bands. Brigid Keenan, on reporting that even Courrèges had shown skirts above the knee in a particular couture show, received a dismissive response from her editor: 'She simply couldn't believe it, and insisted that I must be wrong'.

From her essentially traditionalist viewpoint, the new work of photographers such as David Bailey,

Preface:
Ernestine Carter and the *Sunday Times* Archive

Terence Donovan and John Cowan could jar, a problem she referred to in her autobiography: 'Inventive, imaginative and technically skilful, they created pages which are often beautiful, always eyecatching, but the clothes they were supposed to be showing rarely had a sporting chance.'

Caroline Colthurst recalls: 'Mrs Carter was a difficult woman to work for. She never struck me as having a great sense of humour, however she was unique in having an immense knowledge of fashion, and was always immaculately turned out. She would go to the hairdressers twice a week and was very keen on wearing pillbox hats – which suited her.'

'She sacked me after eleven months – I deserved this. I had been sent to get a white synthetic toga nightdress photographed by Terence Donovan. It had been sent from America, and as I left the office I whinged to the other girls that it would need ironing. At Donovan's office there was an antique iron, and I managed to burn a huge iron-shaped hole in the nightie. When I got back to the *Sunday Times* Mrs Carter was not there, having gone off to Italy. I funked owning up until it was too late – three weeks later she was "going through" the clothes cupboard and found the dreaded toga. The next day I was sacked. However, I was the only Fashion Assistant who was re-employed by her two years later.'

'Thursdays were her copy days. She would squirrel away a flask of vodka in her desk and her secretary would be asked to make her "a Bov, dear girl". She would then sneakily lace the Bovril with a large dollop of vodka!'

She did, however, recognise that the fashion spotlight was rapidly turning to London, and that it would soon be the designers featured in her pages that dictated the latest trends, recalling of the times. 'There was a feeling of jet propulsion, as innovation followed innovation.'

Brigid Keenan was responsible for introducing a number of new names to the paper, being one of the first fashion writers to champion David Bailey. 'We introduced a new attitude to the writing – when I first started, the column was called "Young Grown-ups" which gives you an idea of how the youth market was overlooked. I introduced people like Mary Quant and Jean Muir to Ernestine Carter, and after time she accepted that they were innovative designers. Seen in isolation in London she was a unique force, but at the couture shows in Paris she rejoined a select group of great, and very grand, American fashion writers.'

By lending her authority to a growing group of young designers, Ernestine Carter enabled 'Mainly for Women' to continue into the second half of the 1960s with an avid readership. A number of writers ensured that all aspects of 'Swinging London' were covered, with commentary on fashion suited to a varied readership, often including menswear, accessories, even interior design. Like the traditional couture houses which survived the decade, such as Hardy Amies and Norman Hartnell, she realised that fashion was beginning to polarise. Couture maintained a place in a society still stratified by tradition, but Mrs Carter was quick to recognise that younger names looked set to make their mark permanent. 'I came into the world of fashion when the English ready-to-wear battened on Paris with clever adaptations or copies. When I left, the situation was reversed.'

'Mainly for Women' merged newspaper and women's magazine for the first time, and consequently had the ability to propel careers to new heights. A mention by Mrs Carter, or any of the writers, could change fortunes overnight. An uncredited reviewer of her autobiography commented in 1974: 'One of the reasons, of course, for her unique authority – whatever she praised in the *Sunday Times* was sold out by lunchtime on Monday – was that her faithful readers knew that she could spot the winners, whether in Rome, California or the King's Road'.

Her lasting legacy includes the hundreds of photographic prints and original fashion drawings commissioned by her and her writers which, on retiring from the paper in the early 1970s, she felt deserved a permanent home. 'In desperation I turned to Doris Langley Moore, founder of the Museum of Costume in Bath [now the Fashion Museum]. The archive, not only a chapter of fashion from 1959-1972 – hats, hair styles, shoes, jewellery etc, as well as clothes – but also a history of dramatic fashion photography and illustration, is now, with Lord Thomson's permission, in the Research Centre of the Museum.'

An ongoing process of cataloguing, scanning and conservation of the archive at the Fashion Museum will ensure that Ernestine Carter's contribution to fashion writing will be widely available to journalists, fashion students and members of the public in the future – just as she intended.

Art Center College Library
1700 Lida Street
Pasadena, CA 91103

The photographs

Published 21 February 1960
Photographer Michael Williams
Fashion Embroidered silk taffeta
evening gown by Victor Stiebel
Original journalist Ernestine Carter

The Incorporated Society of London Fashion Designers carried the banner of British fashion design abroad at a time when London was a poor relation of other fashion capitals. Heading for a show in New York before a thousand guests were designs by the established fashion houses: Hardy Amies, Charles Creed, Ronald Paterson, Victor Stiebel and John Cavanagh. They were sponsored by the Fashion House Group, composed of leading international fashion journalists, buyers and designers. Together they formed a formidable battery of talent, of which Ernestine Carter was the only member representing Britain.

The society had previously shown in Paris and, in contrast to later in the decade, the response to the idea of British fashion ever being a major export commodity was muted. Hardy Amies, chairman, said there were no plans for a repeat performance in France 'We don't want to wear out our welcome,' he said – but added, 'It's all been great fun.'

In the 1960s both ready-to-wear and export lines were to become increasingly important to designers who had previously relied on couture clients for their business. It was generally accepted that they could interpret and adapt designs from Paris successfully for a domestic market, but an international reputation of commercial note was some way off. For those readers who wanted to buy the clothes illustrated here, the task was equally daunting: no stockists or prices were printed in the paper, despite Ernestine Carter's early attempts to do so.

Ambassadors of Fashion

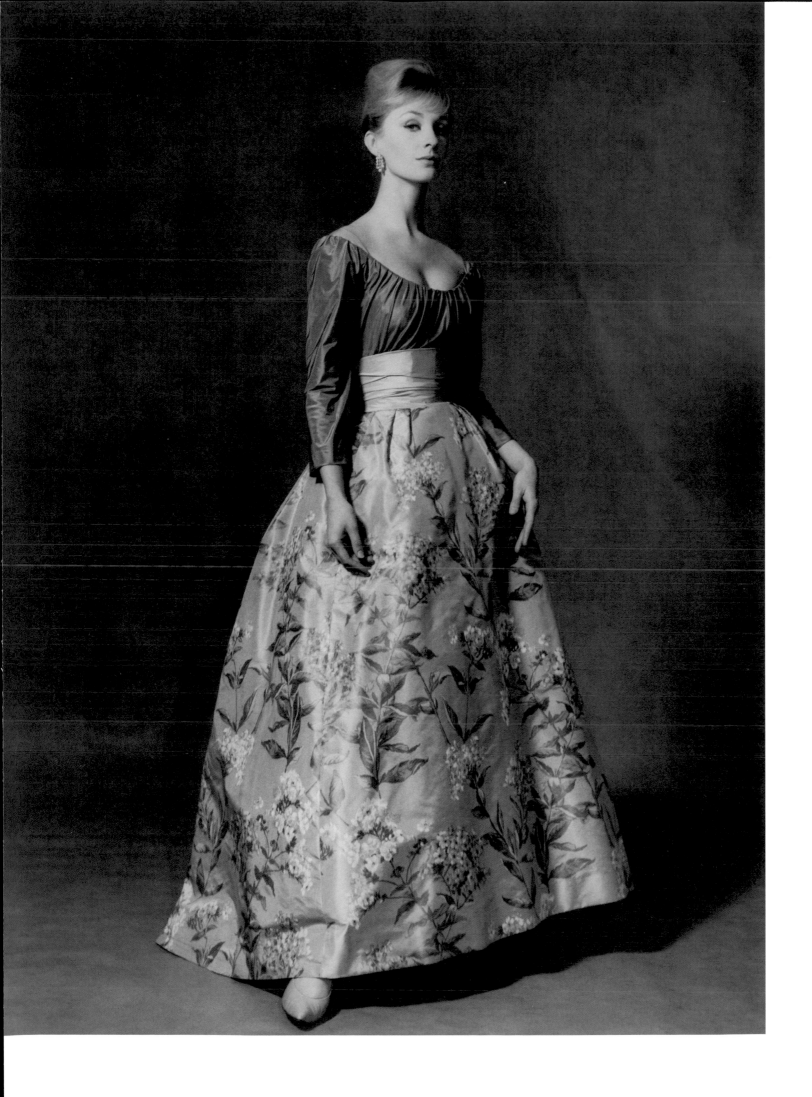

Published 2 August 1960
Photographer John French
Fashion Tiered chiffon evening dress
by Frank Usher. Drop-waisted cocktail
dress with bow details by San Clair
Original journalist Ernestine Carter

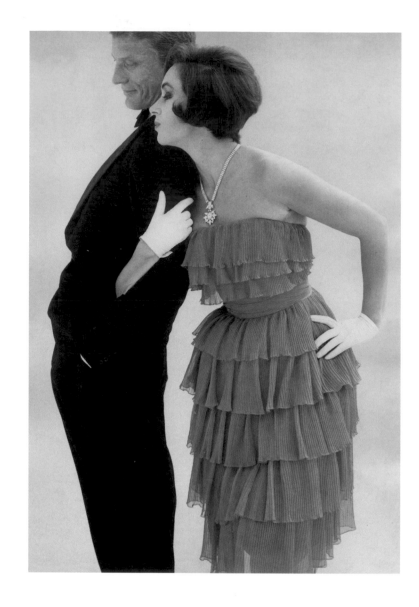

All eyes were still very much fixed on the fashionable
Princesses as leaders of society and the style stakes in
the early 1960s. Princess Margaret enjoyed the drama
of clothes and had long been a master of dressing for
evening, being helped by her good looks, film star
persona and access to one of the greatest jewellery
collections in the world. Her wedding dress by Norman
Hartnell, worn in May 1960, was hailed as a triumph
of restrained elegance, and confirmed her as a leader
of society fashion. Lesser royals such as Princess
Alexandra and Princess Paola of Belgium were also
avidly tracked in the fashion press, and Ernestine
Carter identified two dresses copied by the wholesale
firms for August, both with a 'royal provenance'.

In June Princess Alexandra had worn a tiered chiffon
evening gown designed for her by Jean Dessès, which
had generated commentary in the fashion pages of most
papers, and from Frank Usher came a version available
from Fortnum and Mason. When Princess Paola was
photographed leaving a reception in a new, shorter
length cocktail dress for evening, manufacturers San
Clair were quick to provide a version, available at
Woollands. Ernestine Carter called them 'Deb and anti-
Deb' dresses, describing Princess Alexandra's as
traditionally elegant, and Princess Paola's as 'definitely
geared to jive, not waltz'.

Fit for a
Princess

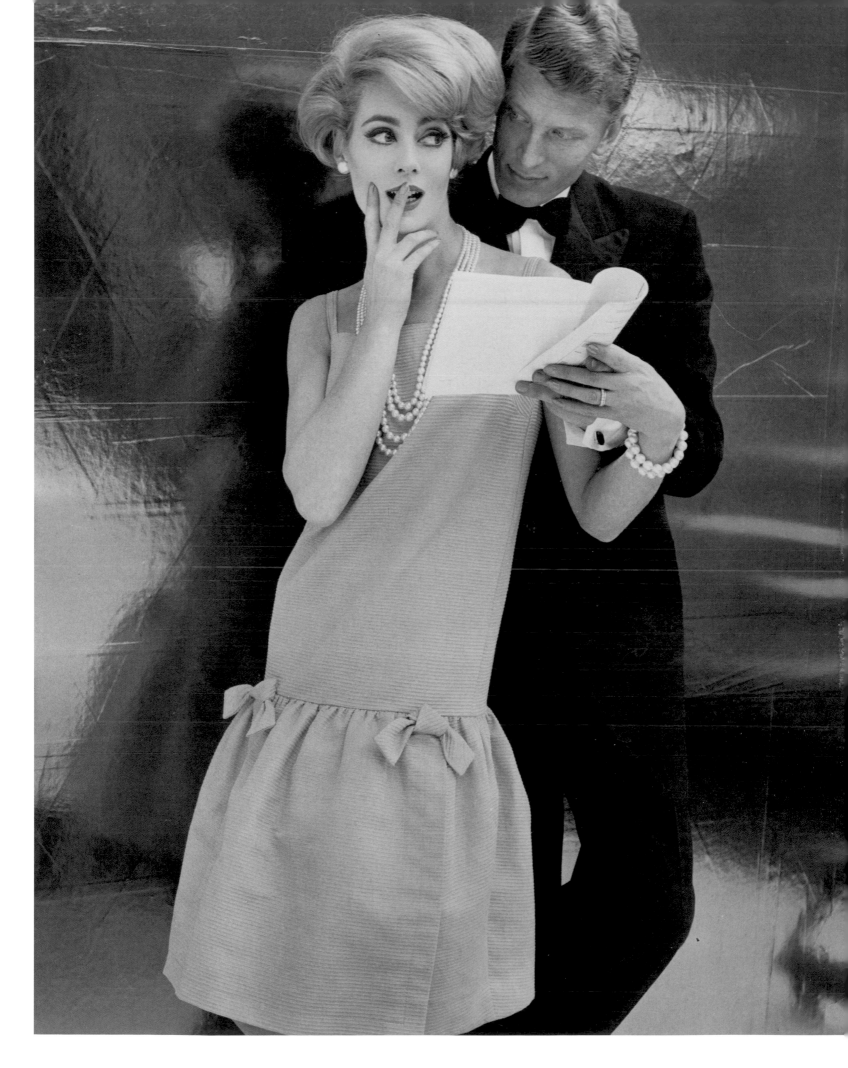

Published 30 October 1960
Photographer John French
Model Ann Gunning
Fashion Draped sheath dress for evening by Frederick Starke
Original journalist Ernestine Carter

In October 1960, as her busy social diary reported in 'Mainly for Women', Ernestine Carter visited the theatre with American playwright Lillian Hellman, who was in London to promote her work, *Toys in the Attic*. Mrs Carter was inspired, and selected evening wear suitable for attending a night of drama.

A regular to her pages was Frederick Starke, one of the first British designers to master ready-to-wear and design for television. He combined a showroom on London's fashionable Bruton Street with a number of diffusion labels including 'Frederica' for younger clients, but it was his designs for Honor Blackman as Cathy Gale in the 1963 season of *The Avengers* which were to be his most successful.

John French (1907-1966) was one of the most important fashion photographers of the twentieth century. He pioneered a standard for newsprint which had previously been reserved for the likes of *Vogue* and *Queen* magazines, and his studio was instrumental in launching the careers of photographers such as David Bailey and Terence Donovan.

His simple yet dramatic style is instantly recognisable, partly because of the quality of the light, the uncluttered composition and effortless portrayal of glamour, but also because of his army blanket, which, stretched flat behind the model, formed a perfect neutral backdrop to countless shoots.

A Touch of Drama

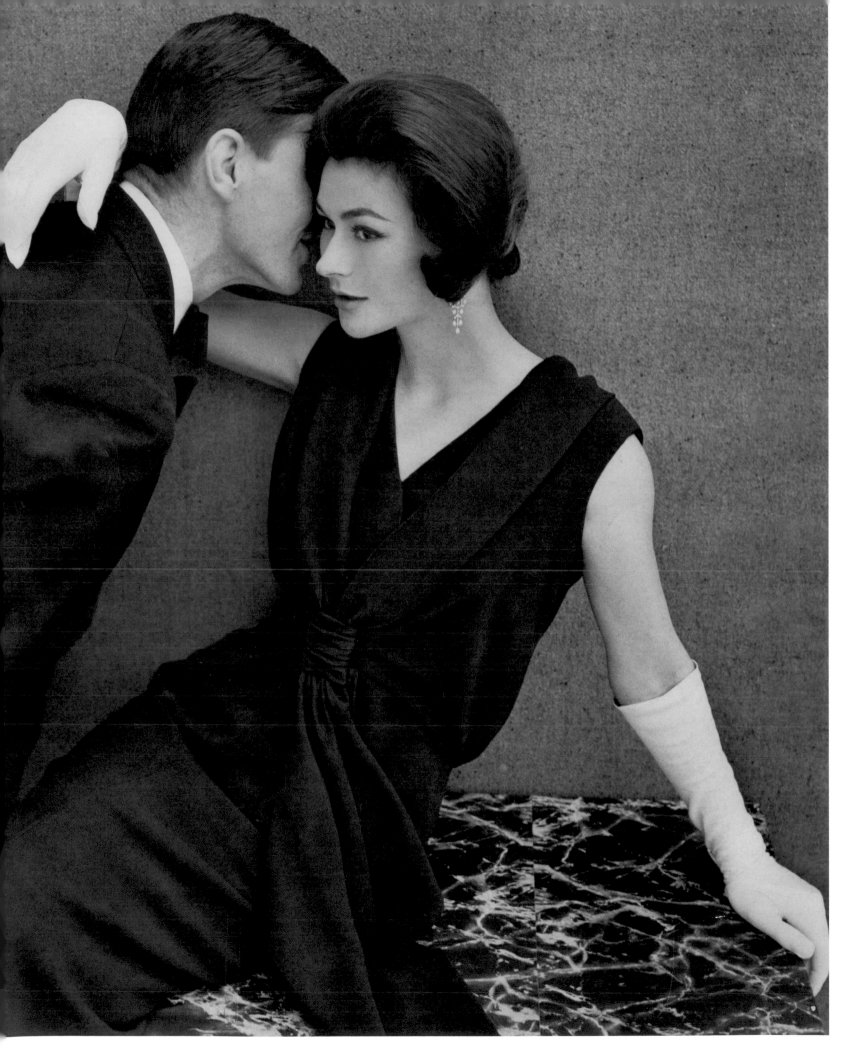

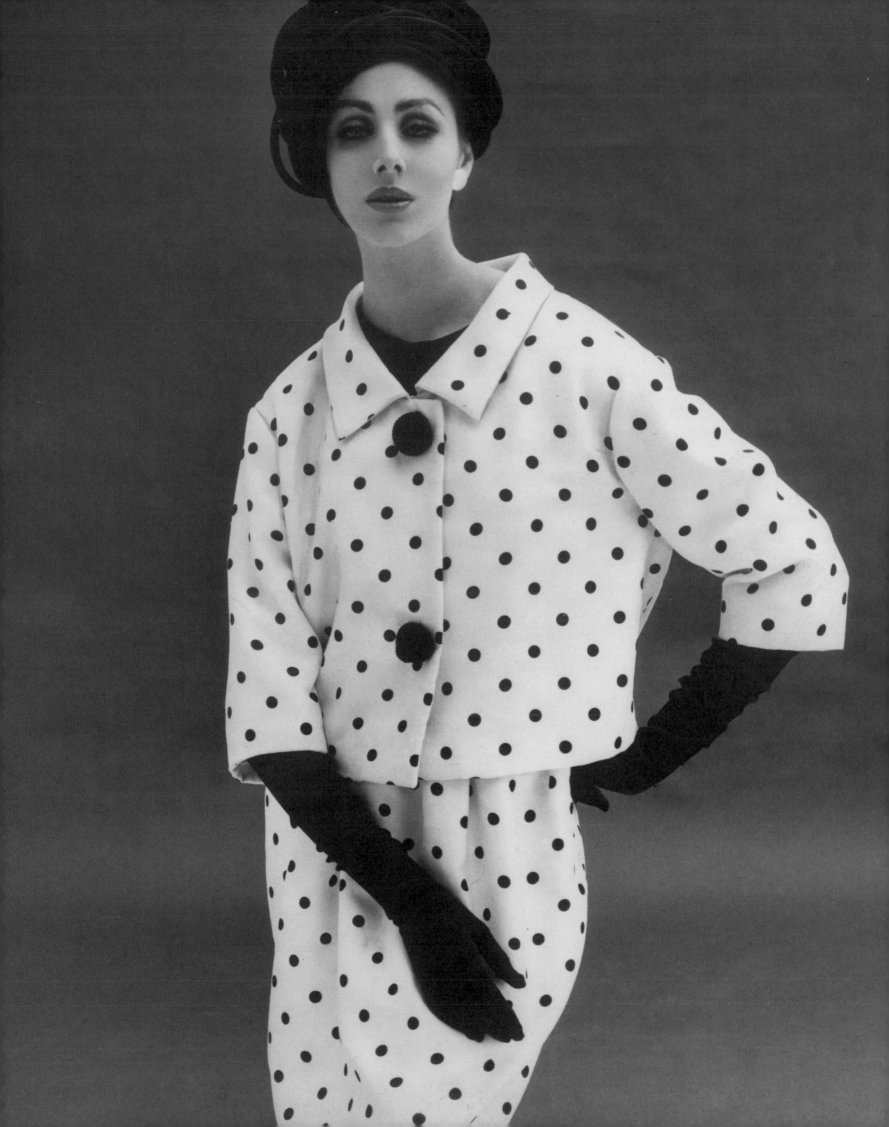

61

Published 7 May 1961
Photographer Roy Round
Fashion Navy wool coat by Dereta.
White cloche hat by Peter Robinson
Original journalist Virginia Chapman

'Do you have trouble fastening last season's coat over this season's fashions?' asked Virginia Chapman. If the answer was yes, 'that's because you need a coat with added flair'. She argued that the whole shape of coats and dresses had undergone a sea change for summer and that the latest dresses, sleeveless and inspired by the 1920s, needed the likes of Dereta's lightweight navy coat, which flared from just below the bust.

The choice of a cloche hat from the department store Peter Robinson was indicative of the wide range of pricing levels which the writers for 'Mainly for Woman' tried to include. Ernestine Carter regularly reported from the couture shows in Paris, but it was her desire to 'establish a standard of quality, not necessarily based on price, but on excellence of design, creative ability, and value' that meant that wholesale ready-to-wear firms and regional department stores were as likely to be included as Harrods, Fortnum and Mason or the Mayfair boutiques.

The policy had long term benefits: it increased her readership nationally, and from some of the then sedate institutions of Oxford Street and the provinces, great things were to evolve. Peter Robinson hosted the first Top Shop boutiques, and the now ubiquitous 'shop in shops' developed in department stores in the 1960s as an alternative to boutiques. For many readers, especially those outside London, the department store was their first and only point of contact with fashion.

Dressing with Flair

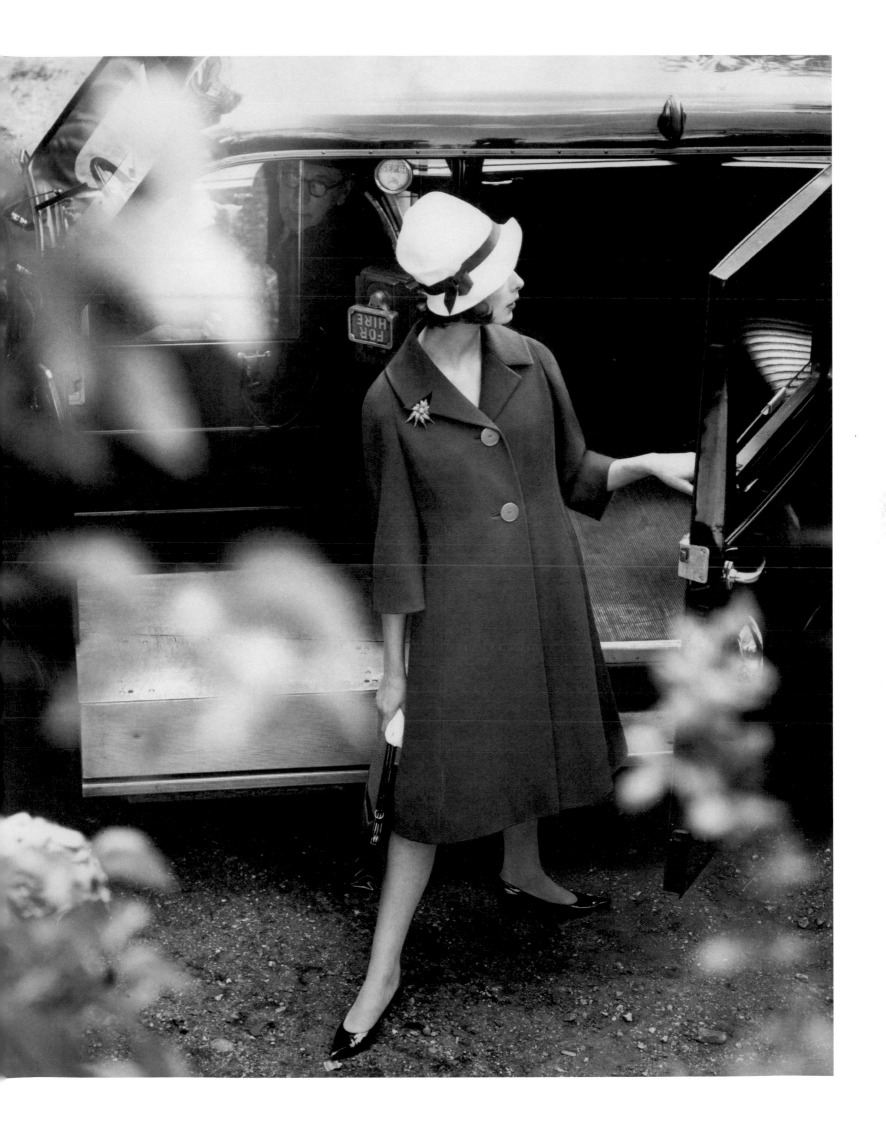

Published 18 June 1961
Photographers John French/Barry Warner
Fashion Printed silk suit by Berkertex
Polka dot evening dress by Jean Allen

'Black dots add dazzle to the crispest summer whites' – very often it was nothing more than a certain fabric design that season and a sharp play on words which made a feature in 'Mainly for Women'.

'Borrowing the spots from *A Hundred and One Dalmatians,* we photographed outfits to make any girl "A Man's Best Friend"' – and here the paper chose outfits from two successful wholesale ready-to-wear houses of the 1960s.

Both Berkertex and Jean Allen, like competitors Frank Usher and Susan Small, employed designers to copy and adapt designs from Paris for sale throughout the country in department stores and boutiques.

Essentially well-made, affordable middle market clothes, they gave the look of something more expensive at a time when what was available to consumers outside the major cities was limited. Ready-to-wear fashion houses would often pay substantial sums to buy a 'tulle', or paper pattern, authorised for sale each season from the leading French designers. This could then be adapted in infinite ways to give a season's collection, with stores competing to get the first new designs in their windows ahead of their rivals.

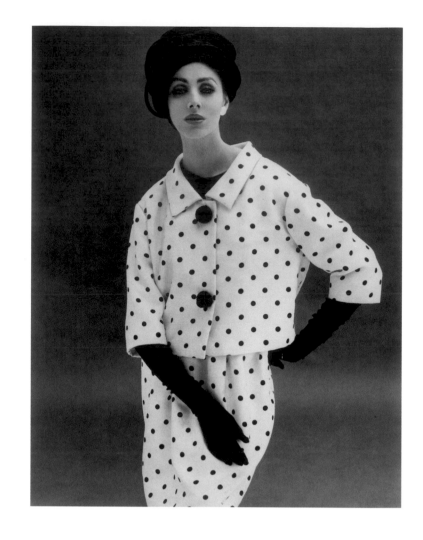

Make it a Dalmatian Summer

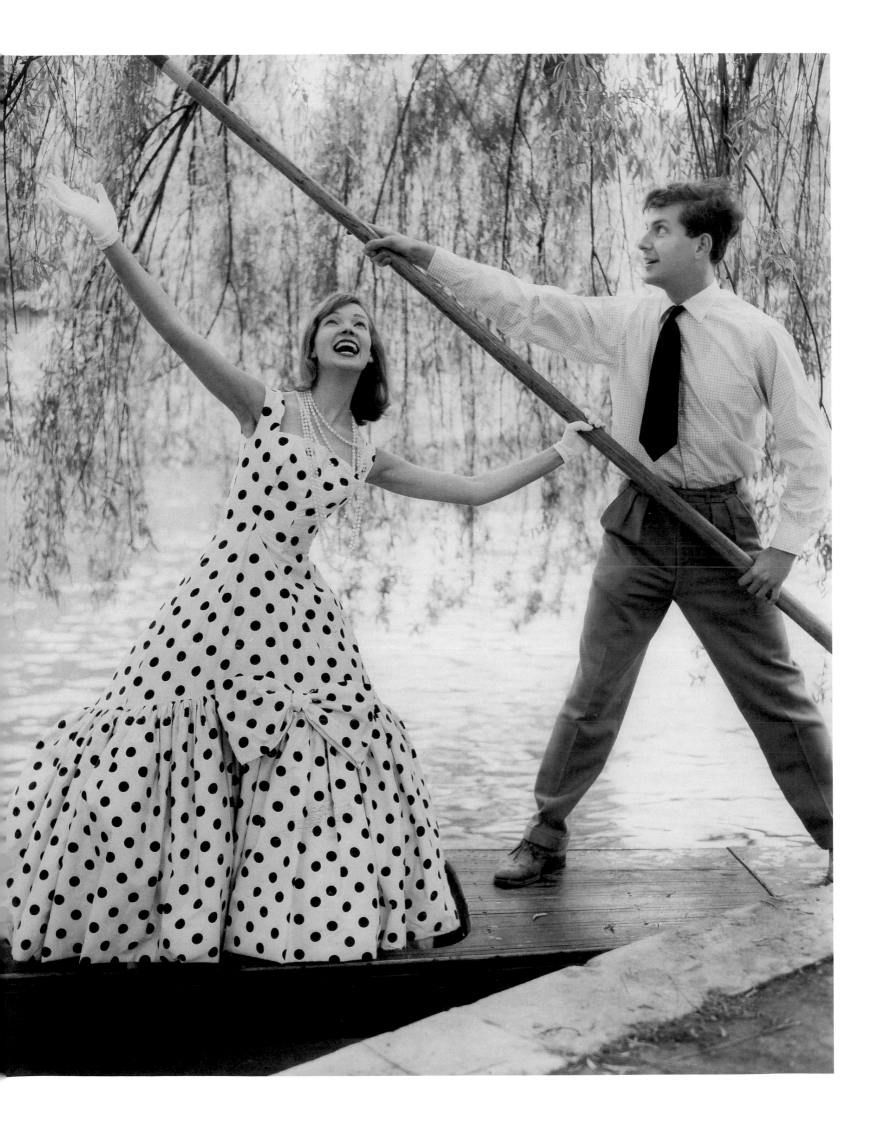

Published 13 August 1961
Photographer John Cowan
Fashion Striped cotton cowboy pants
by Jaeger
Original journalist Virginia Chapman

'Wild West fever is sweeping East,' noted Virginia Chapman in an article extolling the virtues of trousers. 'Nothing tightly clinched about the waistlines here: these pants are real low-slung, hip-bone-hugging affairs.'

To photograph them she chose John Cowan (1929-1979) whose outdoor, action-based shoots rapidly established his reputation in the fashion press. A photographer since the late 1950s, he drove an Aston Martin and was described by Terence Donovan as 'Guildford's version of Marlboro Man'.

In a break from traditional studio-based photography personified by the likes of John French, Cowan's images for the *Sunday Times* were ever more daring, featuring amongst other scenarios, a bowling alley, an airport roof, a parachute jump and even the central reservation of Park Lane. Life reflected art when his studio was used for the famous photographic session in the cult film *Blow Up*. His muse was Jill Kennington (b. 1943), one of the most popular models of the 1960s.

The New Frontier

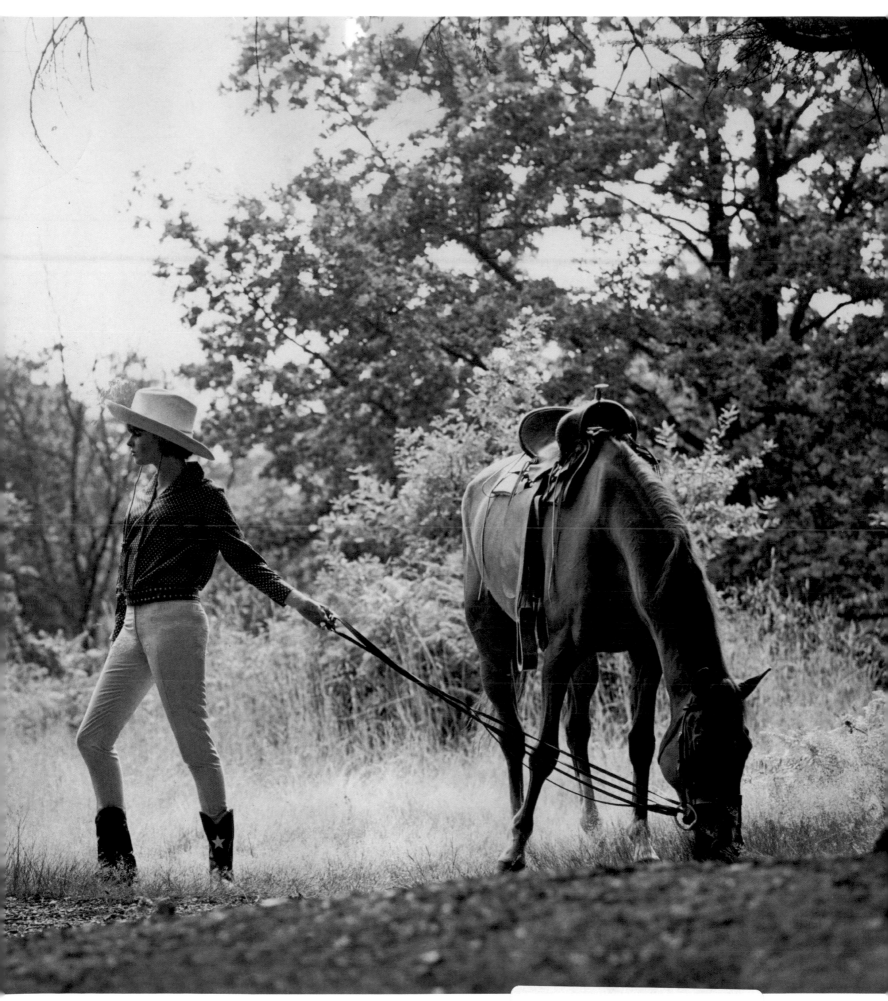

Art Center College Library
1700 Lida Street
Pasadena, CA 91103

Published 5 November 1961
Photographer Norman Eales
Fashion Collarless blue tweed coat
by Renée and Julian Robinson
Original journalist Ernestine Carter

Aware that new talent was maturing in the fashion colleges, Ernestine Carter investigated who was ahead of the field for autumn/winter 1961. Among a clutch of designers fresh to the scene was the husband and wife team of Renée and Julian Robinson. A new boutique at 61 Park Lane aimed to stock a range of their designs along with those of another notable pairing, Marion Foale and Sally Tuffin.

Mr & Mrs Robinson met while at the fashion school of the Royal College of Art, and after unsuccessfully looking for jobs they started out on their own. Working from a studio in Islington, they typified a generation of designers who were able to rent space in central London relatively cheaply, albeit often run-down and on informal leases. Foale and Tuffin began in workrooms off Carnaby Street, John Bates in a flat in Ladbrooke Grove, Barbara Hulanicki and Biba off Kensington High Street.

Adding his magic to the pictures was Norman Eales (1936-1989), widely considered to be one of the most important, and often overlooked, photographers of the 1960s. The seamless glamour he managed to convey translated particularly effectively to newspaper print, and his work is consequently amongst the most prolific in the archive.

A Team-up of Talents

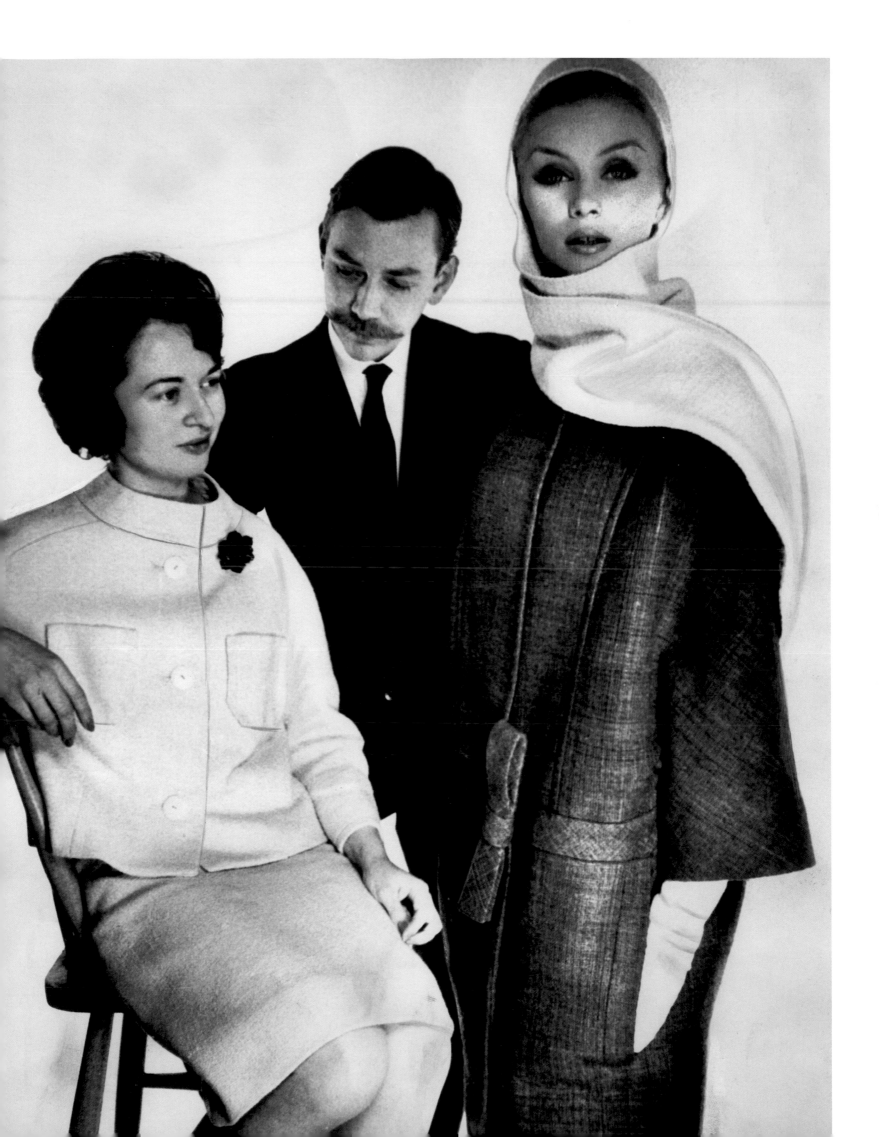

Published 12 November 1961
Photographer Michael Williams
Fashion Draped green chiffon evening
dress by Jean Allen. Grey flannel suit
by Sambo with hat by James Wedge
Original journalist Ernestine Carter

Exports were vital to the fashion trade, and the biggest trade show of the year was organised by the Fashion House Group of London. The list of members read like a snapshot of the ready-to-wear market before the sixties swung, and included names such as Hardy Amies, Polly Peck, Julian Rose, Susan Small and Frank Usher. Buyers from thirty-five countries watched the London model girls strut their stuff alongside the biggest names in American fashion writing. Eugenia Sheppard, Women's Features editor of the *New York Herald Tribune,* was one of the most respected, and was described by Ernestine Carter as 'small, blonde and non-stop – her verdicts are awaited with respect, if not awe.'

Both Jean Allen and Sambo survived the sixties as they proved adept at interpreting evening wear in particular, the latter subsequently teaming up with the youth label Dollyrockers.

James Wedge (b.1939) mastered millinery early in the decade after training at the Royal College of Art and opened his own boutiques, Countdown and Top Gear, which quickly became epicentres for London's fashionable set. Later in the decade he was to add fashion photography to his canon, regularly appearing in *Vogue, Nova* and the ground-breaking colour shoots of the *Sunday Times Magazine.*

London Exports to the Four Corners of the Earth

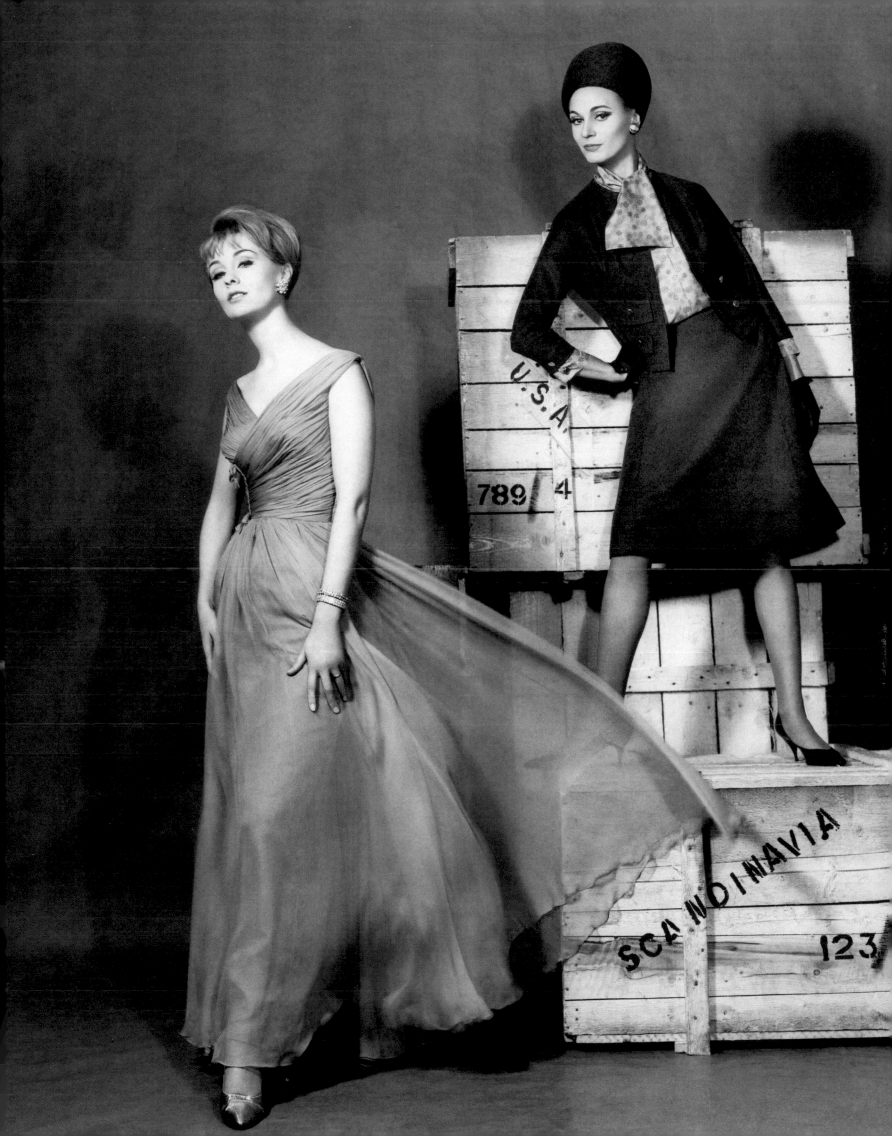

Published 17 December 1961
Photographer Norman Eales
Fashion Houndstooth check suit by
Strelitz. Sleeveless sheath dress by
Frederick Starke. Orange and yellow
coat dress by Susan Small. Black
Watch tartan dress by Dorville
Original journalist Ernestine Carter

Used to reading lists of bestselling books and records, Ernestine Carter asked why there was no league for clothes, and dared to ask four leading manufacturers for their 'Top of the Pops'. On hand to assist the model girls was David Jacobs, top picker of pop hits.

Both the designers and retailers were getting younger. Amongst the winners, and acknowledging the emerging market, was the company Susan Small, which launched a collection entitled 'Trendsetter'. Under the direction of their head designer Maureen Baker, the collection was the work of Granville Proctor, twenty-three, a graduate of the fashion school at the Royal College of Art.

One of the stockists listed was Woollands of Knightsbridge, which was to become increasingly popular after decades of gentle post-war decline mirrored by many other department stores. The turnaround was largely due to managing director Martin Moss. On being appointed he described the institution as 'a dowdy old aunties' store', but by the end of the decade Ernestine Carter acknowledged that that 'the dowager Woollands had become a debutante'.

His concept was to promote modern design, from 'homeware' to clothing, and he launched Woollands 21 on the ground floor to appeal to younger buyers, who were finding that they had money to spend on fashion. Asking students from the Royal College of Art to assist him led to a chance meeting with Terence Conran, who masterminded the project, and Vanessa Denza was recruited as fashion buyer. The reputation of the store quickly grew, and it was soon not uncommon to see queues snaking round the building, as designers promoted their clothes with catwalk shows to the music of the latest chart toppers.

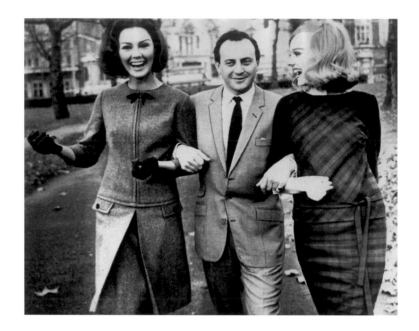

Topping the Hit Parade

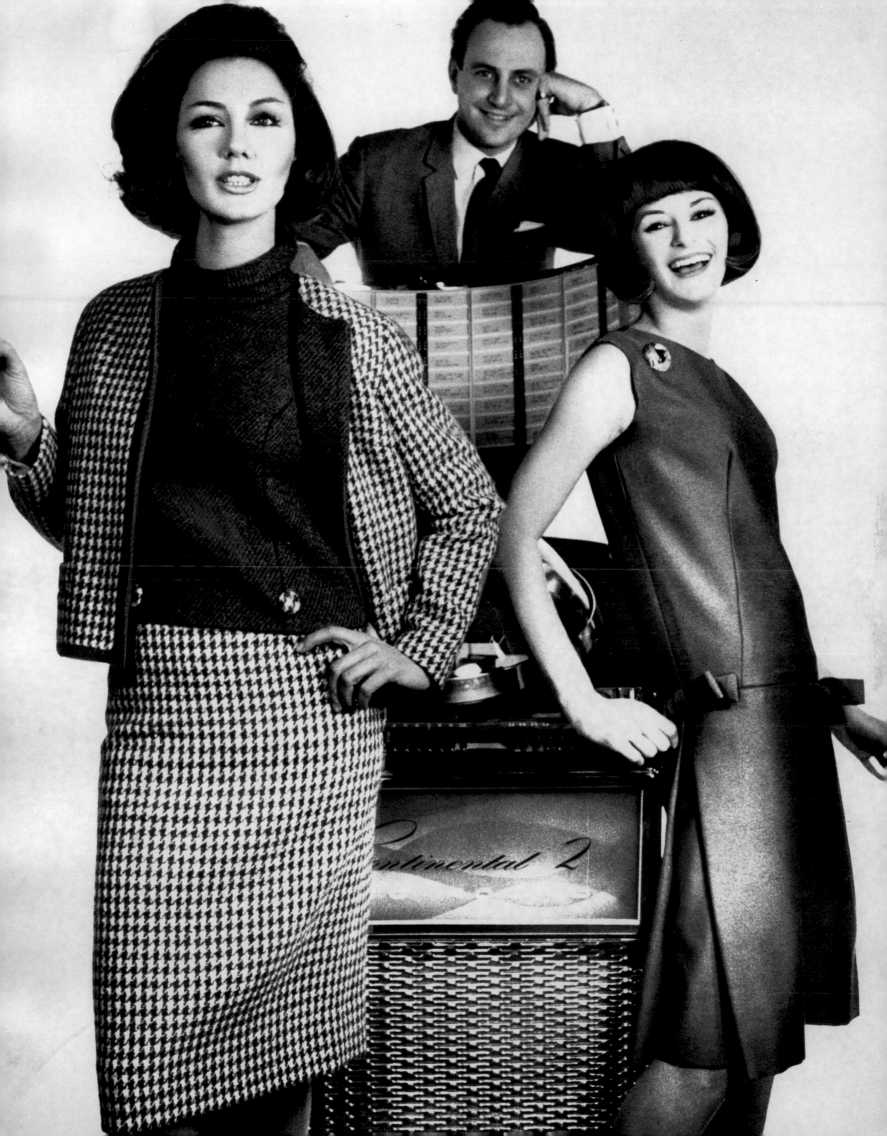

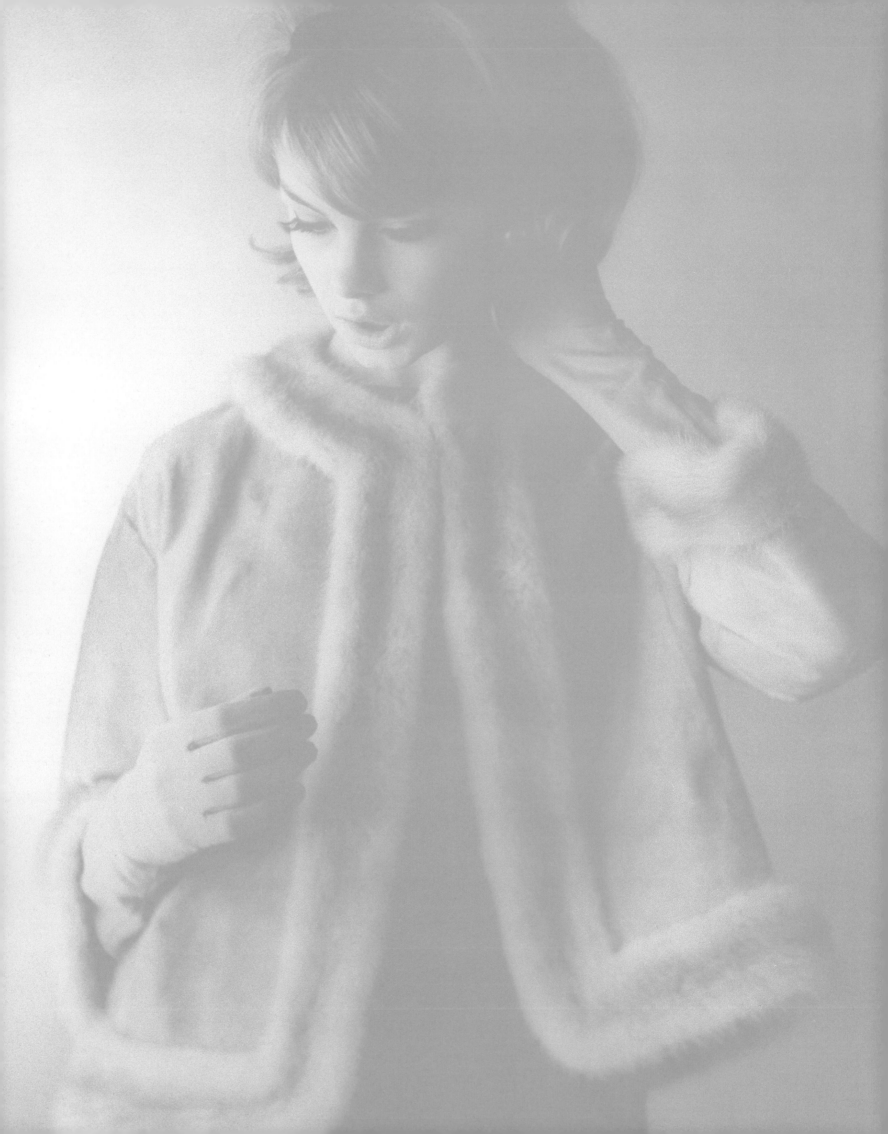

62

Published 6 May 1962
Fashion Halter dress in Terylene mix
by Polly Peck. Sheath dress with side
buckles by Sambo
Original journalist Ernestine Carter

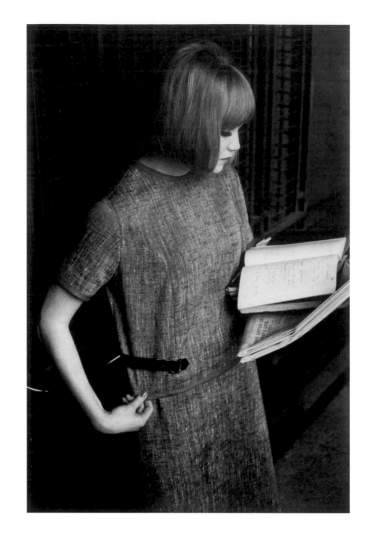

'The effective secretary is washable, uncrushable and cool,' and so should be her clothes, argued Ernestine Carter. By featuring outfits from Sambo and Polly Peck in Terylene drip-dry fabrics, 'Mainly for Women' highlighted one of the most significant developments of the 1960s: synthetic fabrics.

Rayon had been used to make synthetic silks in the interwar period and 'nylons' were the stockings of choice for the same generation, but Terylene, a polyester fibre, had not appeared until the 1940s, and only then in America. Not until it was combined with wools and cottons were the true benefits felt in Britain. When it did arrive, its low maintenance qualities meant it was applied to everything from ball gowns to beachwear, suits, blouses, nightwear, and even furnishing fabric. The advent of the drip-dry suit was the ultimate development in convenient menswear.

The trade names multiplied as ever more sophisticated blends developed, including Tricel Surah, Banlon and Orlon. The downsides, however, were substantial, as any wearer on a hot day will recall, and it was not until the craft revival of the late 1960s that natural fibres, such as Laura Ashley's printed cottons, regained favour.

Cool, Calm and Collected

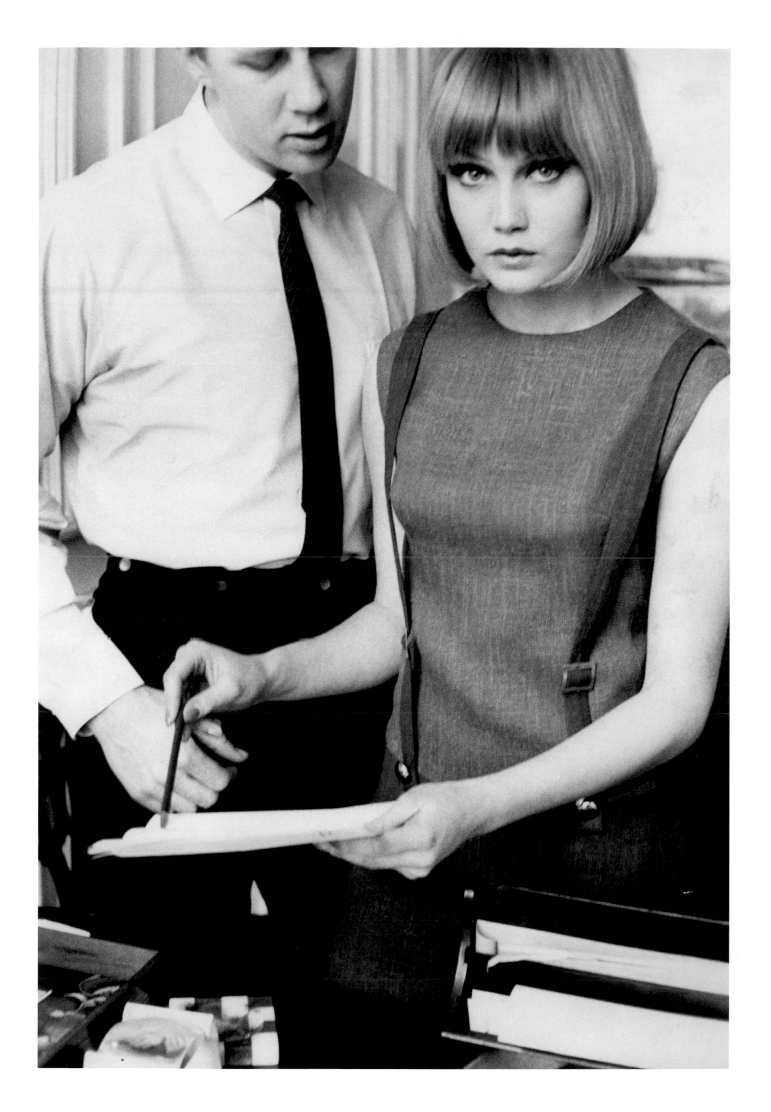

Published 27 May 1962
Photographer Barnet Saidman
Fashion White linen suit by Michael of
Carlos Place. Hat by Graham Smith
Original journalist Ernestine Carter

As the Korda Collection of Impressionist paintings was put on show at Sotheby's, the question of what might be suitable to wear to a private viewing meant that Barnet Saidman was able to create the most elegant of compositions for readers of the *Sunday Times*.

The tailored white suit by Michael of Carlos Place, with wide-brimmed hat by Graham Smith, was designed to appeal to those of Mrs Carter's readers who still relied on key pieces from London's couture houses each season, and its elongated elegance owes much to Dior's 'New Look' of the late 1940s. In the rarefied galleries and boutiques of Bond Street and the West End, this traditional chic was standard, and could be adapted for almost any age group.

Michael of Carlos Place was Michael Donnellan, a Dubliner who trained for the medical profession before moving to London to design. His couture business specialised in smart suits and cocktail wear, but it was arguably in his role as consultant to Marks & Spencer later in the decade, where he worked to improve standards in mass manufacture, that he made his most influential contribution to British design.

Graham Smith (b.1938) trained as a milliner at the Royal College of Art before leaving to work for Lanvin in Paris. After returning to London to design for Michael Donnellan he opened his own business off Bond Street. His clientele included the great and the good of fashionable London, and his hats were a regular feature on the catwalks of Jean Muir, Zandra Rhodes and Kangol.

A Bond Street Point of View

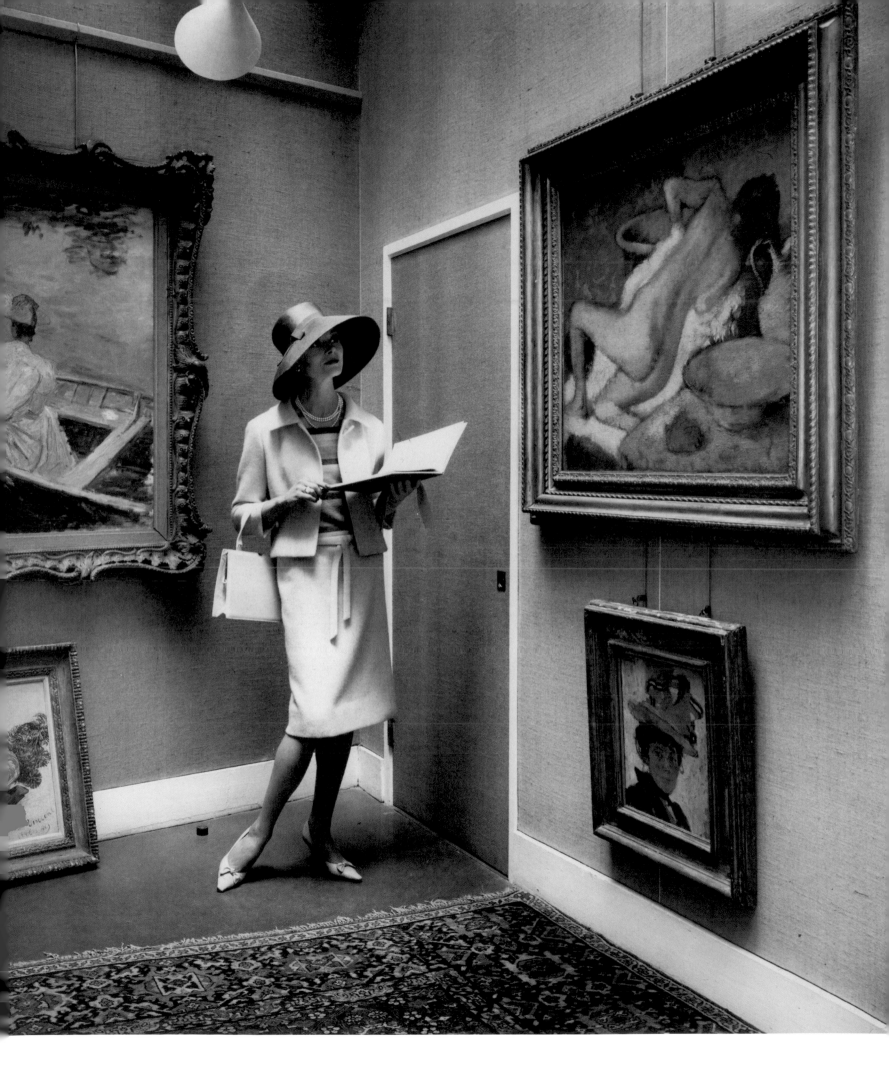

Published 3 June 1962
Photographer Sandra Lousada
Fashion Wedding dress by John Bates
for Jean Varon
Original journalist Ernestine Carter

John Bates's influence on the 1960s fashion scene is perhaps the most significant of any designer in the *Sunday Times* archive. His pioneering use of new materials such as plastics, mesh and metallic fabrics caused almost as much of a sensation as his minidresses, easily the shortest of the decade. His fashion house was Jean Varon, which, via boutiques and department stores nationwide, was to grow into one of the most successful ready-to-wear firms of the time. With over 300 appearances in the pages of *Vogue* alone, he was the star who had his first real break in the press thanks to Brigid Keenan and Ernestine Carter.

Initially working from a flat in Ladbroke Grove, the firm was based in a converted Georgian house off Oxford Street by the time a John Bates-designed wedding dress was featured in 'Suddenly it's June' in 1962, modelled by Jean Shrimpton. In order to pay the rent, and to have the funds to experiment with more groundbreaking designs, he sold wedding dresses and evening wear to Fenwick's of Bond Street. His talent was also recognised early by Wallis Shops, but it was his appearance in Ernestine Carter's columns that brought success almost overnight.

The Empire line was a favourite, and beautifully tailored and reasonably priced Jean Varon party dresses were soon everywhere. Later in the decade his coordinating wardrobe for Diana Rigg in *The Avengers* brought international stardom for both actress and designer and, credited by many as the inventor of the miniskirt, his hemlines hit both the headlines and the ceiling.

Suddenly it's June

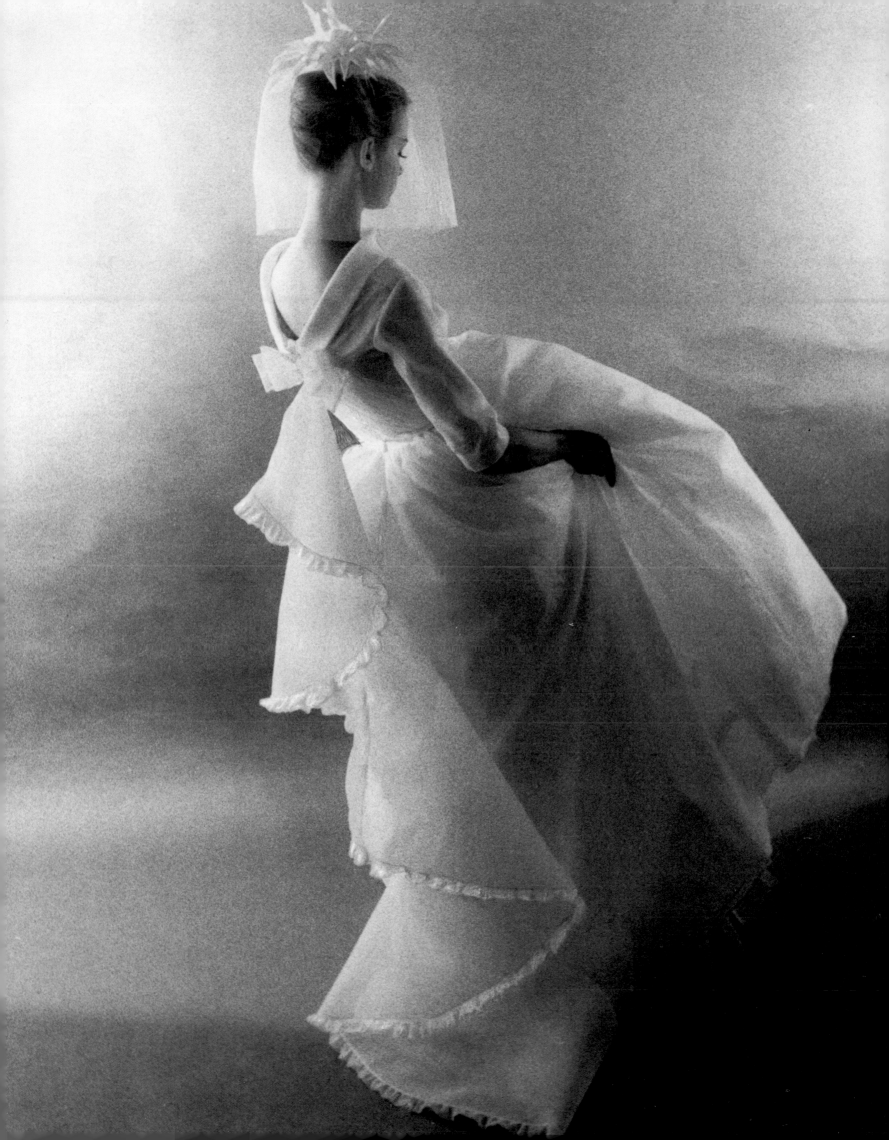

Published 17 June 1962
Photographer Sandra Lousada
Model Jean Shrimpton
Fashion 'Giraffette' short jacket with
pastel mink trim by Calman Links
Original journalist Ernestine Carter

Fur was still the ultimate status symbol for the fashion conscious and manufacturers such as Calman Links were constantly attempting to find new and exotic combinations. Intended to replicate the look of a 'spotless' giraffe, their short jacket for June 1962 was in actual fact sheared calf, edged with pastel mink.

Calman Links was founded in the late nineteenth century and carried the royal warrant as furriers to the Queen, specializing in 'Models of all Types in Exclusive and Lower-priced Furs'. Maintaining her collection was a concern for any woman of means: coats had to be stored in conditions as cold and dark as possible to avoid the 'bloom' or decay of the pelts. Calman Links offered to store and monitor collections for its clients and to remodel outdated styles – with their address for cables noted as 'Stylish-London'.

By 1960 Jean Shrimpton (b.1942) had already graced the covers of *Vogue, Harper's Bazaar* and *Vanity Fair* after graduating from Lucie Clayton's modelling school the year before. She was to become perhaps the most succesful of all the 1960s models, for her career spanned the whole decade and beyond. She possessed the unique ability to convey elegance, sophistication and sex appeal and appeared consistently in the major magazines for some of the greatest names in fashion. Her high profile partnerships with David Bailey and Terence Stamp only increased the brightness of her stardom, and it was not until the arrival of Twiggy in the mid-1960s that anyone came close to matching her influence.

Fashionable Fancy from Calman Links

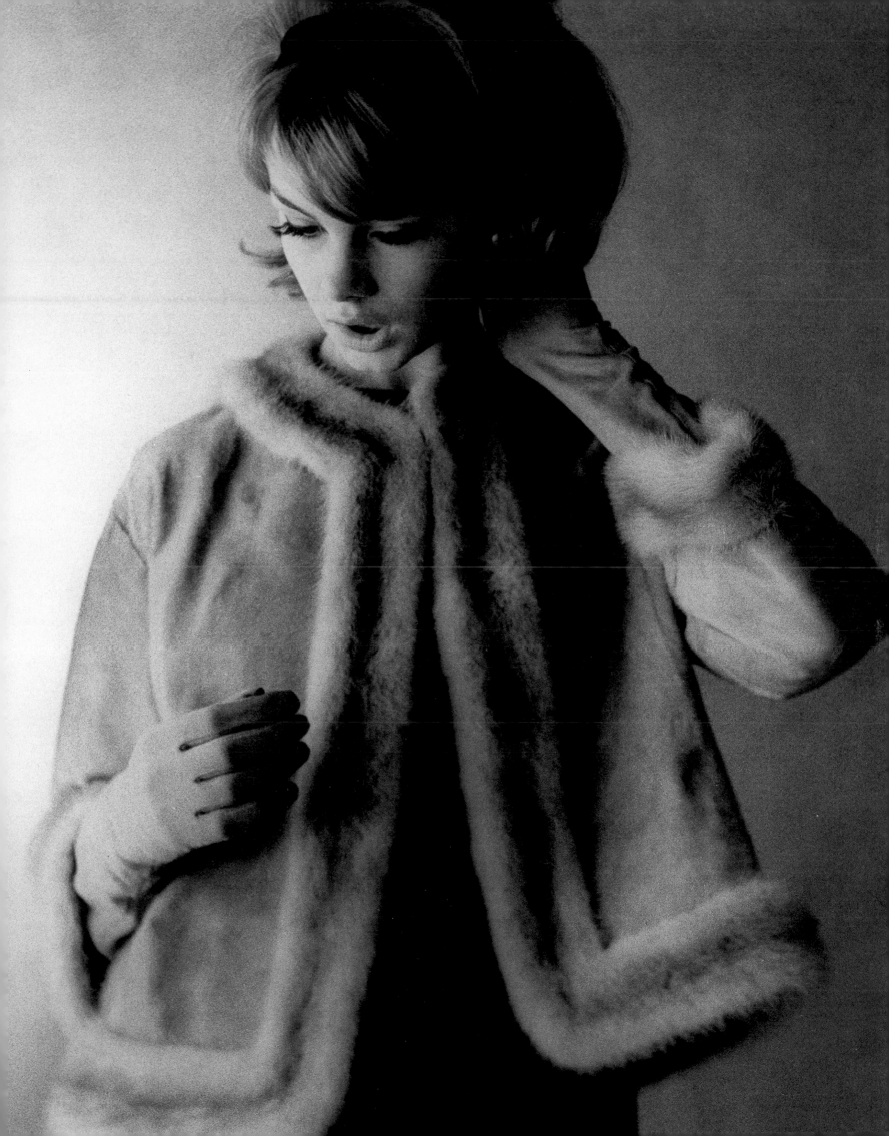

Published 26 August 1962
Photographer Alec Murray
Fashion Suit with box pleated skirt
by Charles Creed
Original journalist Ernestine Carter

Ready-to-wear was the way forward for British couture houses, as the number of their made to measure clients declined. Traditionally, couture collections would be shown each season in front of small groups of clients and fashion writers in the designer's salon, usually in Mayfair. Individual customers would then choose designs to be fitted and made to their size.

Ready-to-wear had two great advantages by comparison: it allowed clothes to be sold in a far greater number of boutiques and suitable department stores across Britain; and, most importantly, it enabled export to America, where names such as Norman Hartnell and Hardy Amies held added sway because of their royal connections. In Ernestine Carter's opinion, 'Each dress sold bears their hallmark and brings cachet to mass production'. With export came the added bonus of licensing of perfumes, accessories and even paper patterns.

Charles Creed (1906-1966) opened his couture house in London in 1949, as fashion rode high on the luxury of the 'New Look'. His training as a tailor enabled him to exploit the new, sharply defined shapes and the luxurious fabrics newly available after the war to best effect, but he is primarily remembered for his neat and practical suits, a generic part of most women's wardrobes at the time.

Couture Meets the Crowd

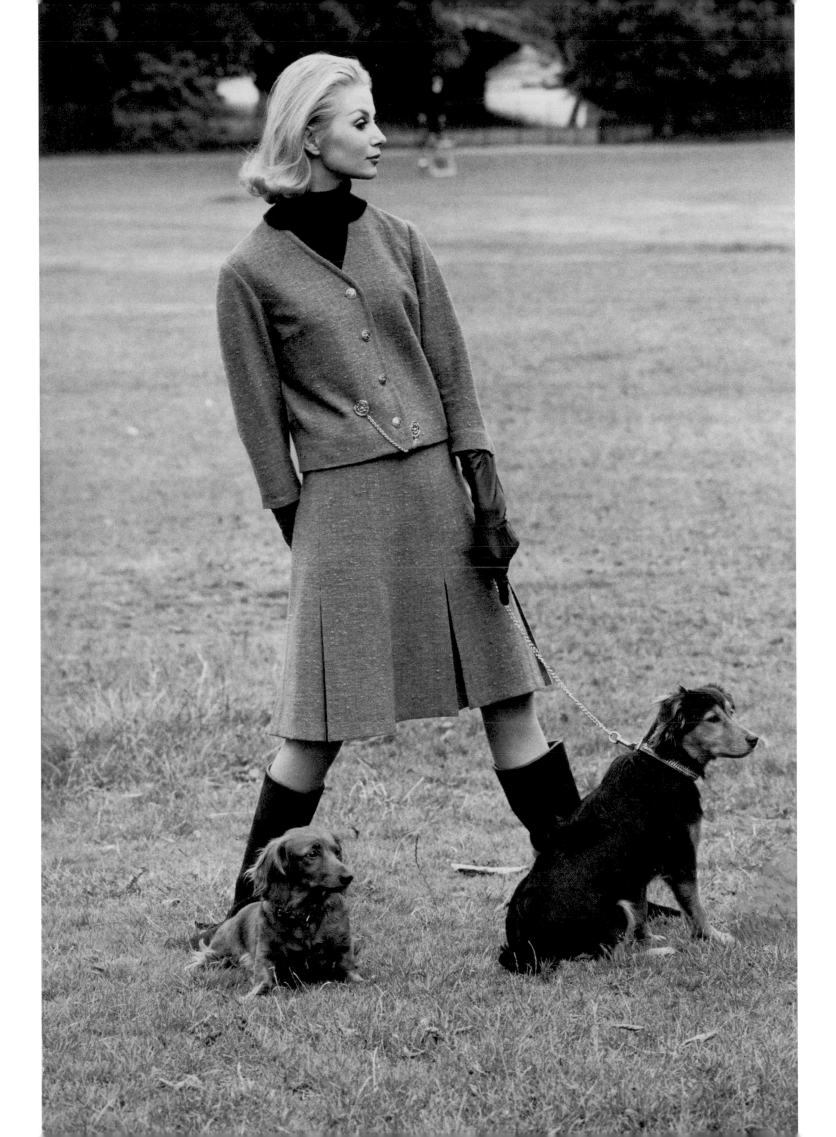

63

Published 17 February 1963
Photographer John French
Model Jean Shrimpton
Fashion Mary Quant for Bazaar
Original journalist Ernestine Carter

Bazaar was the front-runner in fashionable London boutiques by a mile, and in charge was the husband and wife team of Mary Quant and Alexander Plunkett-Green. Opened on the Kings Road in 1955, it caused a sensation, with crowds regularly stopping to stare at the daring and imaginative window displays. It helped the Chelsea street, previously unremarkable and the haunt of students and artists, to become a magnet for fashionable Londoners and tourists alike.

This was the era well before the miniskirt but the clothes at Bazaar had a new and refreshing look, almost schoolgirl-like in their simplicity. Ernestine Carter was a fan, perhaps because her younger writers were so convinced that Mary Quant's look was the way forward for younger fashion. Over the following decade 'Mainly for Women' devoted many column inches to Bazaar, and later to the designer's wholesale ready-to-wear firm, Ginger Group.

By the early 1960s Mary Quant designs were beginning to be accepted in the provinces after years of being a strictly London-based phenomenon. Her wholesale collection that year was an unqualified success and rumours of a deal with traditional manufacturer Alexon had attracted the attention of 'Mainly for Women'.

Mary Quant's masterstroke was the creation of her own retail outlet at a time when young designers still found it difficult to translate ideas into orders. It was effectively a showcase for her own talent, as Habitat on the Fulham Road was to become for Terence Conran, and Biba's first boutique in Abingdon Road was to be for Barbara Hulanicki.

Tuning into London

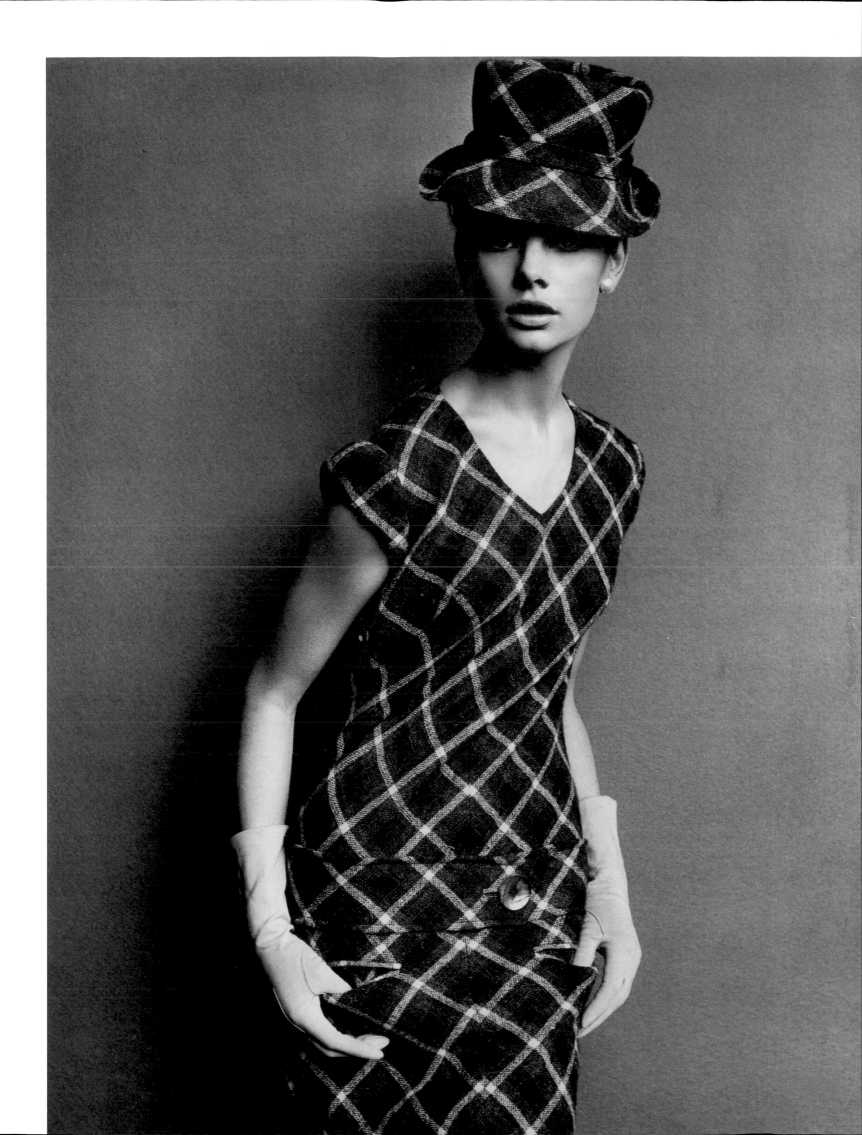

Published 17 March 1963
Photographer Norman Eales at
Vogue Studios
Fashion Emerald green coat dress
by Polly Peck
Original journalist Ernestine Carter

Great things were happening in London, but for the majority of clothes sold across Britain the seasonal Paris shows were still the most important influence on design. Ready-to-wear manufacturers 'translate the signposts of Paris,' argued Mrs Carter.

The Fashion House Group of London show was an alternative, but for the first time it was mooted that younger designers should show in what was eventually to become London Fashion Week – and a challenge to Paris, New York and Milan.

Opened in 1940 by Raymond and Sybil Zelker, Polly Peck was typical of a middle market wholesale firm which, through acute understanding of the marketplace and lightning fast copies of Paris fashion, was able to attract a large following.

Along with companies such as Horrockses Fashions and Berkertex, they clothed a generation of women with neatly tailored suits, pretty cotton summer florals and reasonably priced cocktail and evening dresses.

Paris Translation

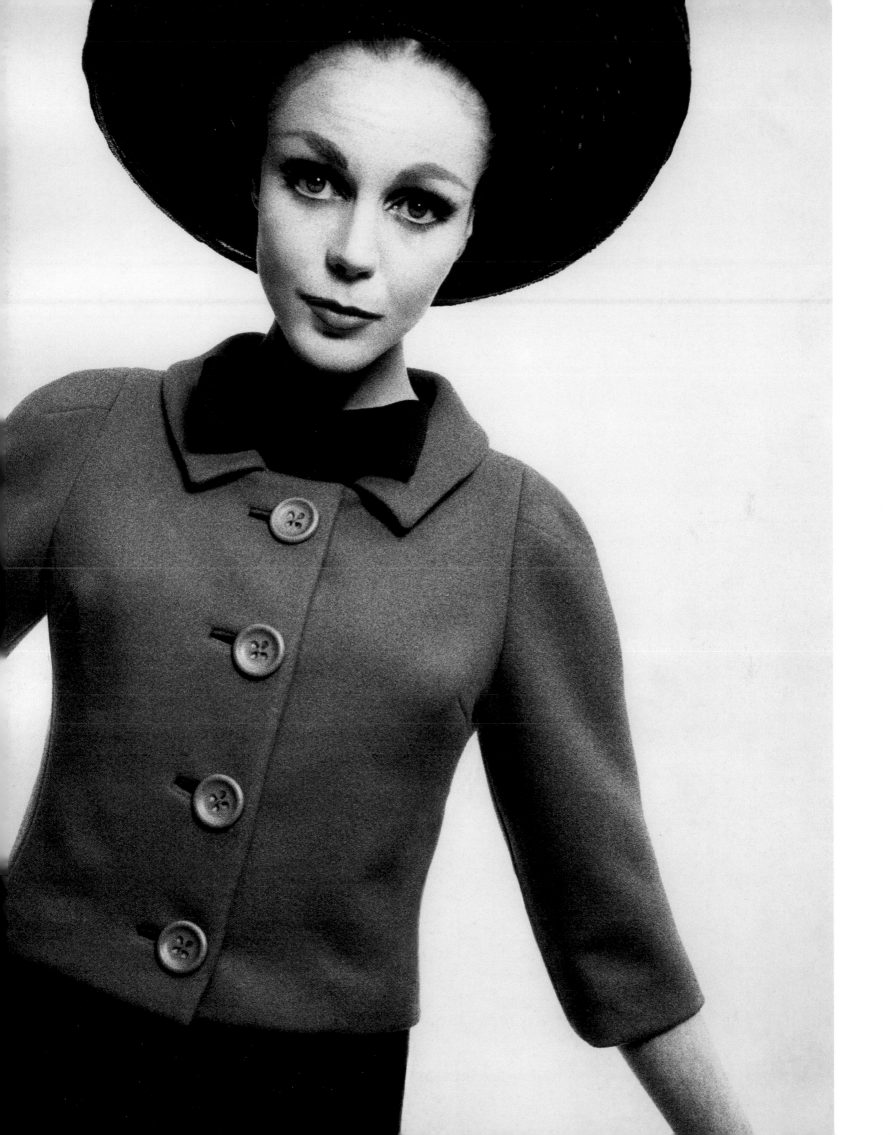

Published 14 April 1963
Photographer John French
Model Jean Shrimpton
Fashion Silk suit with white organza
bib by Polly Peck
Original journalist Ernestine Carter

Both Yves Saint Laurent and Marc Bohan at Christian Dior showed suits with flashes of white at the collar and cuffs for spring/summer 1963. 'Flattering, feminine and fragile,' judged Mrs Carter; and true to form, Polly Peck had a version inspired by them both available for sale in London within weeks.

Recommended stockist Derry and Toms on Kensington High Street had, in pre-war years, been one of the most stylish and up to date department stores in London. The huge art deco building opened in 1932, designed by Bernard George. From the Rainbow Room restaurant visitors had access to a spectacular roof garden. Covering one and a half acres, it contained mature shrubs and trees, a running stream, Spanish and Dutch gardens and even a flock of pink flamingos.

Its decline and eventual closure in 1972 mirrored the fate of many London department stores routinely referred to in 'Mainly for Women', including Peter Robinson, Swan and Edgar, and Bourne and Hollingsworth. However, a number of regional equivalents did survive, in many cases supported by stocking the only viable and comprehensive choice of fashion in their respective towns and cities.

Flashes of White

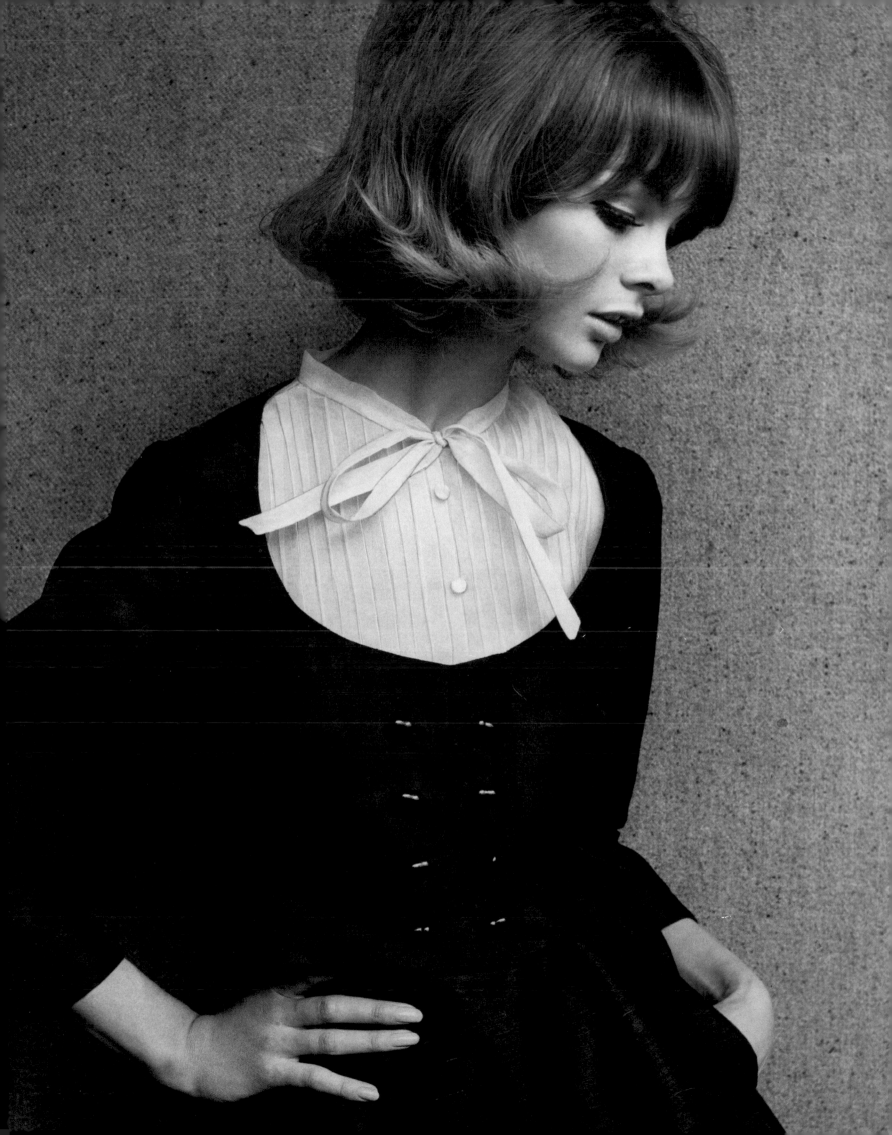

Published 23 June 1963
Photographer John Cowan
Model Jill Kennington
Fashion Hooded jersey worn with shorts by Macinnes Tartans. Chukka boots by Dolcis
Original journalist Brigid Keenan

The space race inspired John Cowan to make his models take to the skies, wearing a range of tartan casuals in June 1963. Describing the clothes of the day as having 'the same airborne freedom' as the floating models, Brigid Keenan swapped hats from fashion writer to sports correspondent as she reported where readers could go paragliding, or even take part in a parachute jump.

John Cowan's action shots could not have been in greater contrast to the restrained, studio-based elegance of John French or Norman Eales. Ernestine Carter was essentially a traditionalist and believed that the primary function of the photographs was to mirror the talents of the artist she employed at the Paris shows and portray the clothes.

Very often, the space allocated to them in the paper would be a great deal smaller than a postcard, so the 'model in landscape' shoots often rendered the clothes practically invisible. However, as the clothes changed, so did the photographs. Gradually more space was available, as column widths expanded and the quality of newsprint replication improved.

Fashion from the Skies

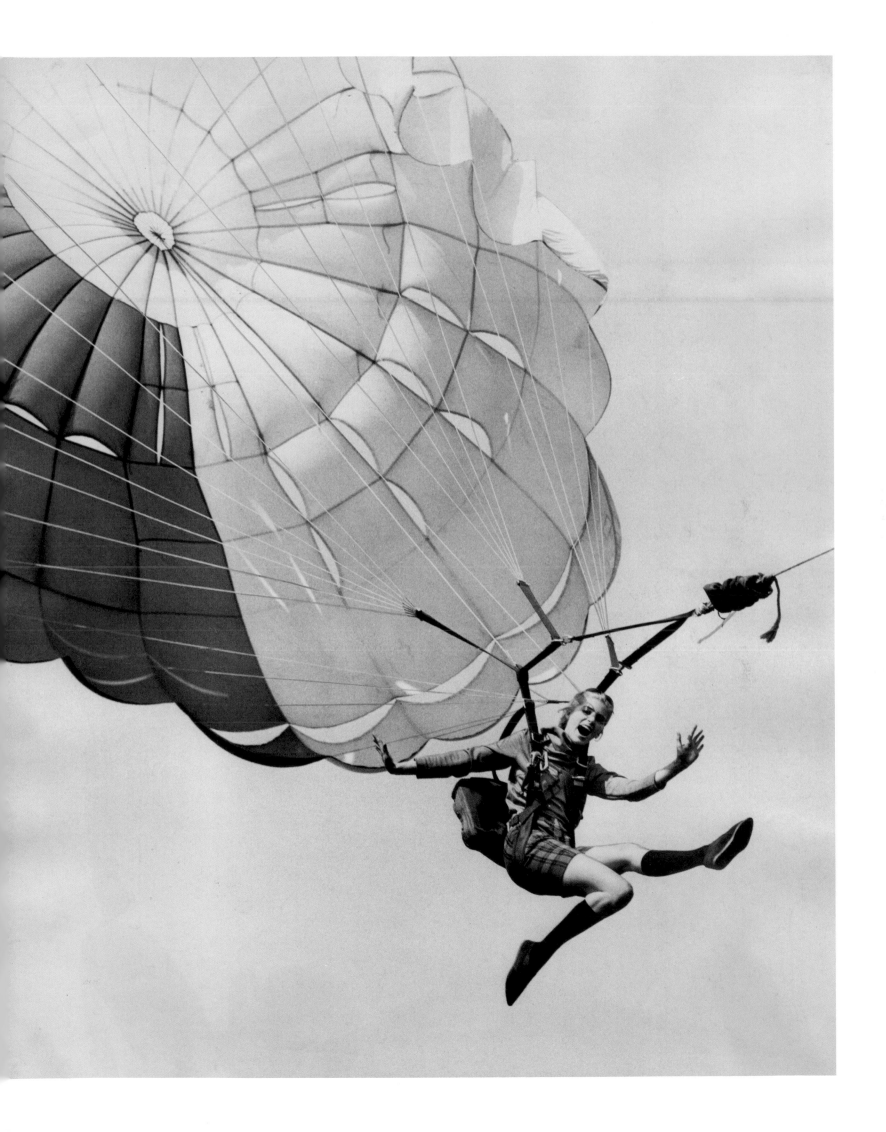

Published 7 November 1963
Photographer John French
Fashion Black and white check coat
and dress by Polly Peck
Original journalist Ernestine Carter

As the tenth London Fashion Week kicked off, the change in attitude to London amongst international fashion buyers was beginning to be become apparent, spurred on by the likes of Polly Peck's smart matching black and white checked coat and sleeveless dress.

First held in 1959 by the London Fashion House Group, its exhibitor numbers had increased from nineteen to twenty-eight, and over 400 buyers were expected to attend, representing at least twenty-five countries, together with the regional British stores.

In 1959 total fashion exports had been a meagre £50,000; by November 1963 the annual figure was calculated at just under £1,600,000. Showing clothes for spring 1964, what was seen in London in November would be ready to hit British stores sometime in mid-December.

International buyers 'expressed surprise at the use of colour (when they expected sobriety) and the youthful vernacular of the fashion (when they expected conservatism)'.

A Pattern
for Spring

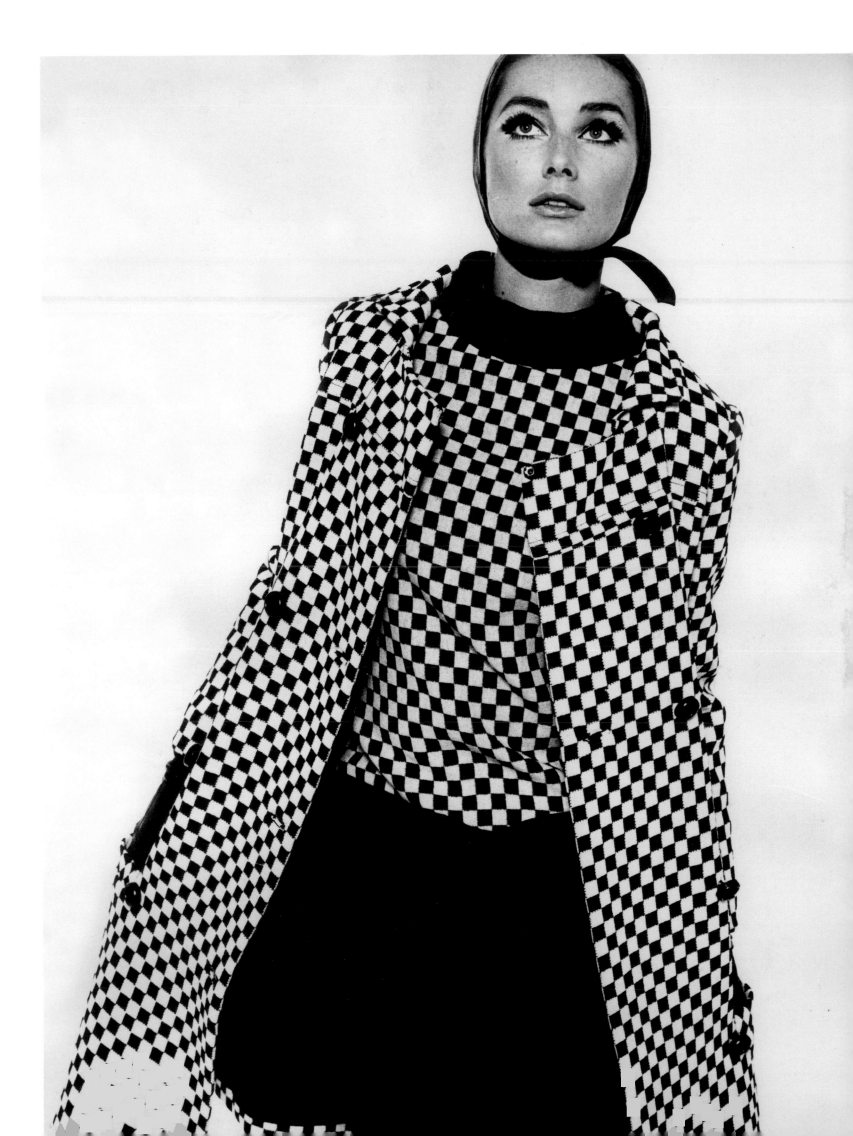

Published 1 December 1963
Photographer John French
Fashion Empire line evening dress
by Sambo for Dollyrockers
Original journalist Ernestine Carter

The hottest news for spring 1964 was that 'fashion's pendulum had swung towards dignity, decorum and elegance'. Certainly it looked that way, with Dollyrocker's demure empire line dress available at Fenwick's for £4. 19s .6d. Ironically, the dramatic rise in hemlines, which was to define fashion in the second half of the decade, was just around the corner.

The *Sunday Times* International Fashion Awards were the brainchild of Ernestine Carter, conceived as a way of promoting British designers abroad, and the first awards were made in December 1963. Three international juries met in Paris to cast their votes, and for the first ceremony the legendary couturier Edward Molyneaux was coaxed out of retirement.

'Perhaps a return to gentle clothes will mean a return to gentle manners,' pondered Mrs Carter as she harked back to the golden days of Molyneaux's Paris of the 1930s. Certainly there was a hint of the period in many of the elegant tiered and draped cocktail dresses shown for spring, together with the emergence of a neat, nostalgically styled longer bob for hair.

Spot Check on Elegance

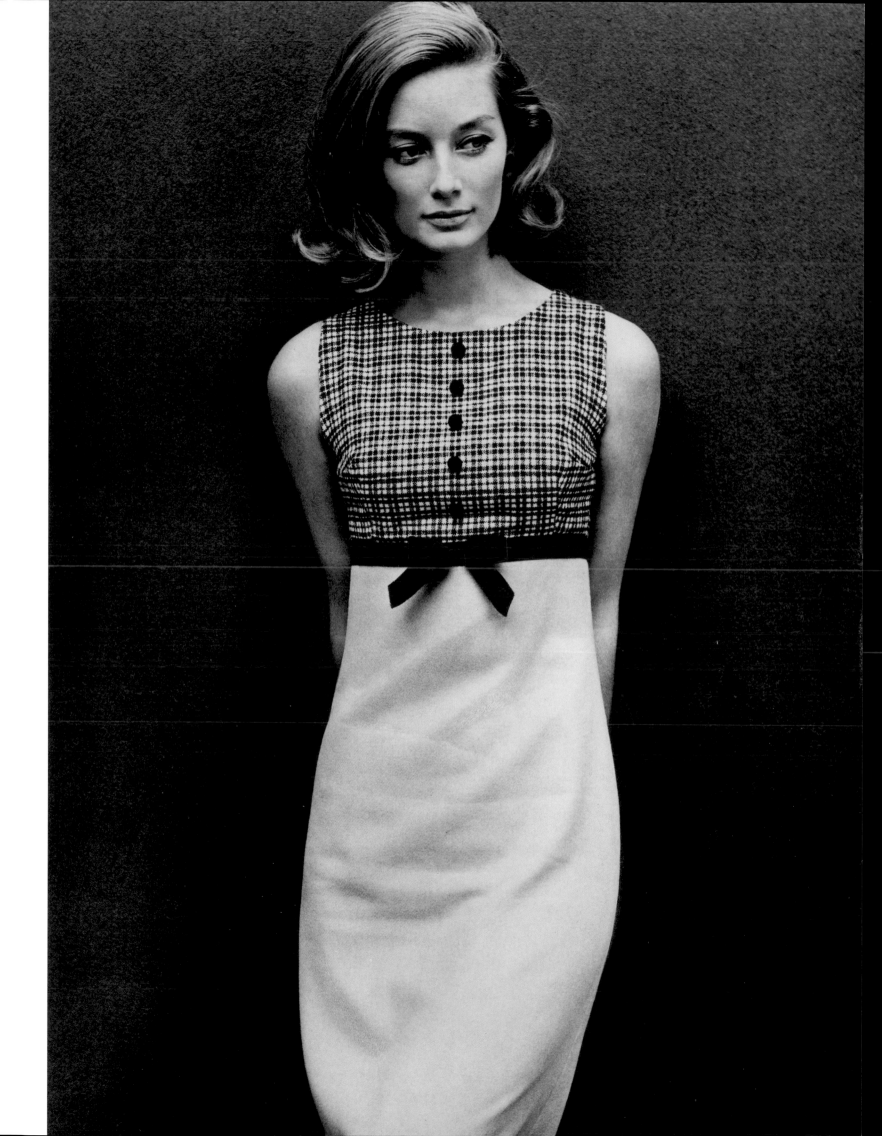

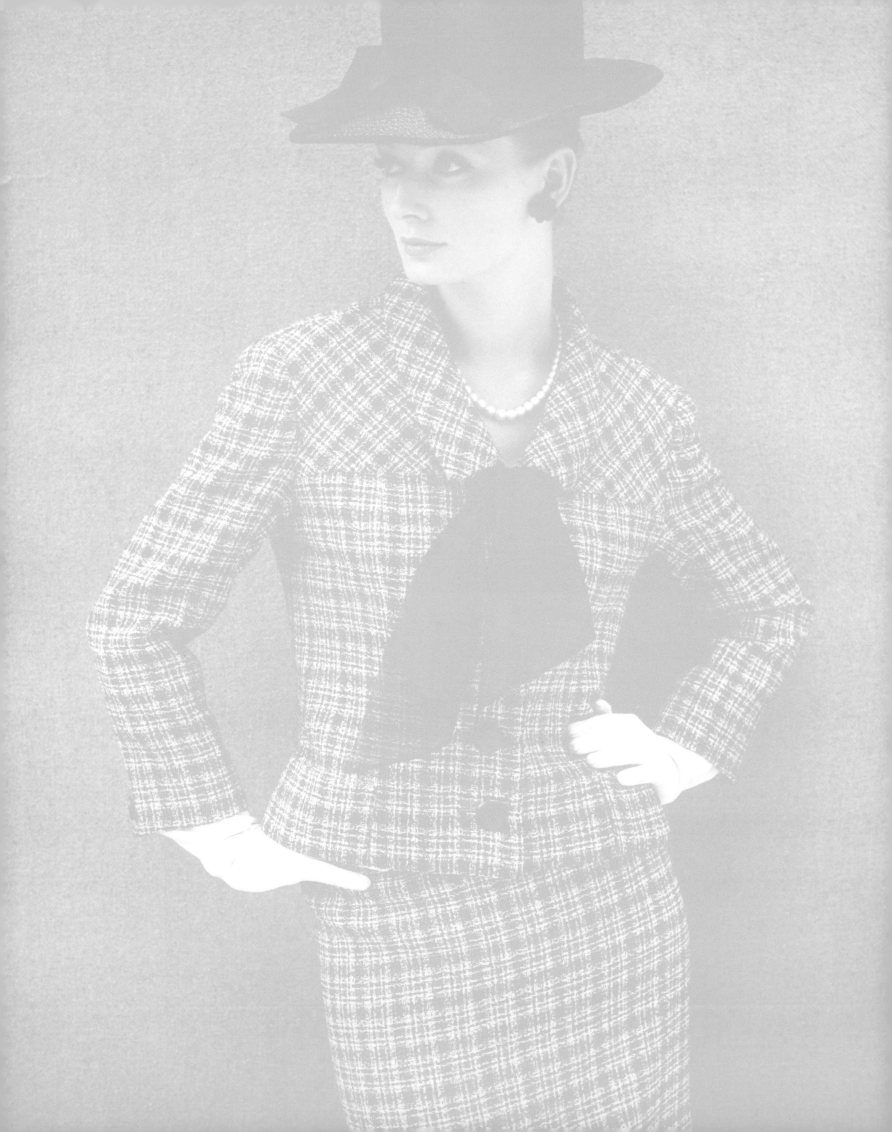

64

Published 23 February 1964
Photographer Barry Warner
Fashion Low slingback shoe by Lotus.
T-bar sandal by H & M Rayne
Original journalist Brigid Keenan

That shoes can 'make or break' an outfit was at the forefront of Brigid Keenan's mind as she investigated the newest styles from some of the greatest names in the business. 'The newest shoes have short stumpy heels, sometimes set right at the back of the heel,' she reported, and to set them off, white stockings were all the rage – 'but for those who don't fancy themselves with chicken legs, pale ones will do'.

The recipient of several royal warrants, H & M Rayne was the only British shoemaker ever to compete seriously with international rivals such as Charles Jourdan and Bally. Sir Edward Rayne was a chairman of the Incorporated Society of London Fashion Designers, and tempted Hardy Amies, John Cavanagh and Norman Hartnell to design shoes for his company, adding Mary Quant's designs for stilettos and T-bar sandals in 1960.

Equivalent to the ready-to-wear clothing designers, Lotus shoes were a Nottingham-based wholesale firm who specialised in high quality, middle market shoes. Inspired by the leading designers in London, Paris and Milan, the company survives to this day.

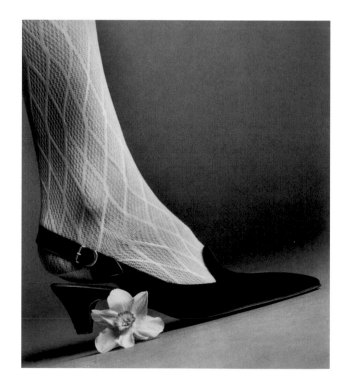

A New Look for Legs

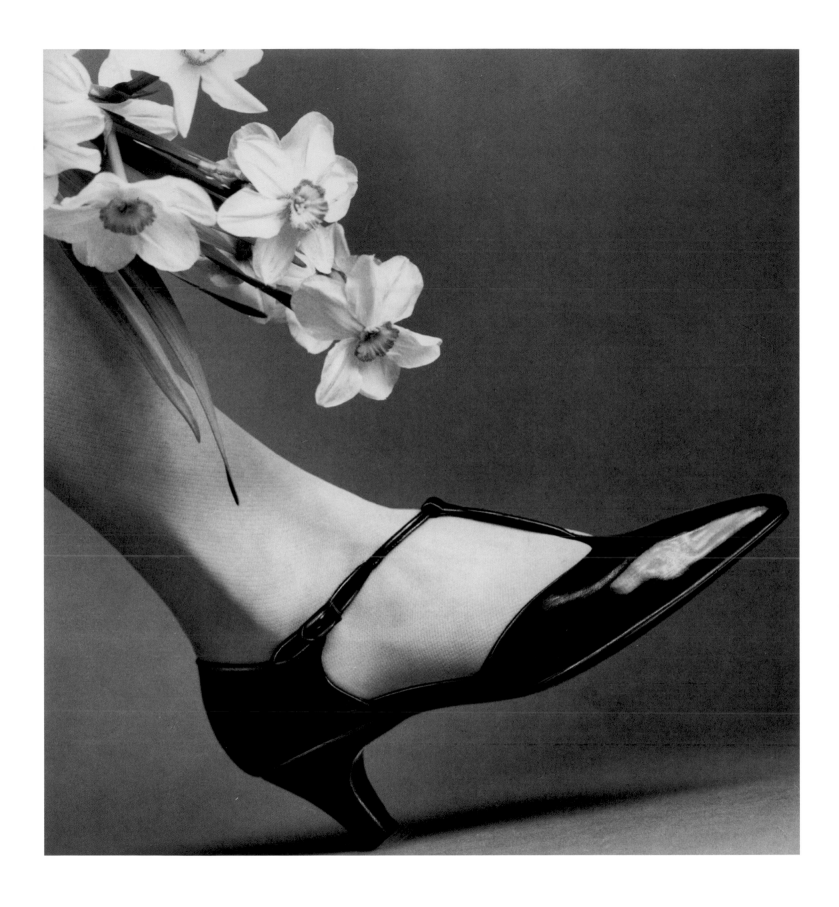

Published 5 April 1964
Photographer John French
Fashion Black cocktail dress with chiffon sleeves by Frederick Starke. Bouclé wool suit by Leslie Kaye
Original journalist Ernestine Carter

'The young of this country have never had it so good – that is from a fashion point of view. From the late 30s onwards many women now feel they are the "step children" of fashion,' commented Ernestine Carter in response to a letter she had received from a desperate reader: 'I'm tall, thin and sixty and would like to be elegant,' she wrote, mirroring many women's feelings that the new rules of fashion were becoming increasingly polarised.

'Even staid shops are introducing departments dedicated to the latest young fashions,' she added. Ironically, these were the very same stores which were so resistant to change in the late 1950s and early 1960s. Those in their late teens and twenties were no longer seen as 'Young Grown-ups' but as a whole different, and increasingly profitable, group of customers.

As an alternative, Mrs Carter selected outfits from Frederick Starke's 'Limited Edition' collection, and from Leslie Kaye, adding: 'If through luck or restraint the over 30s have kept their figure, one can find masses of clothes with no age limit.'

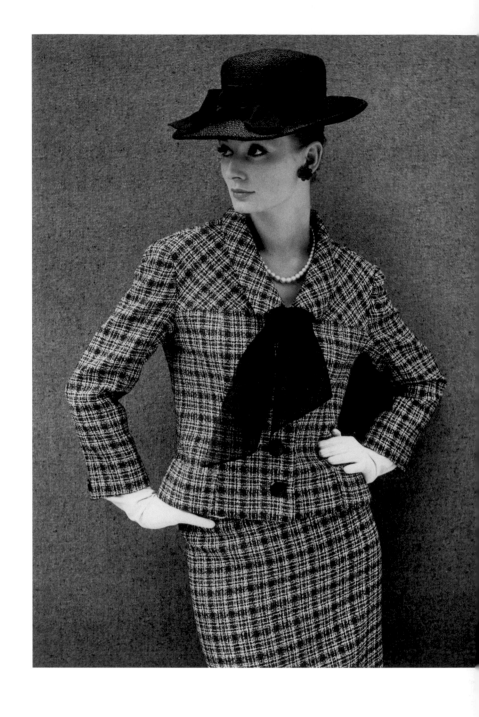

Age No Limit

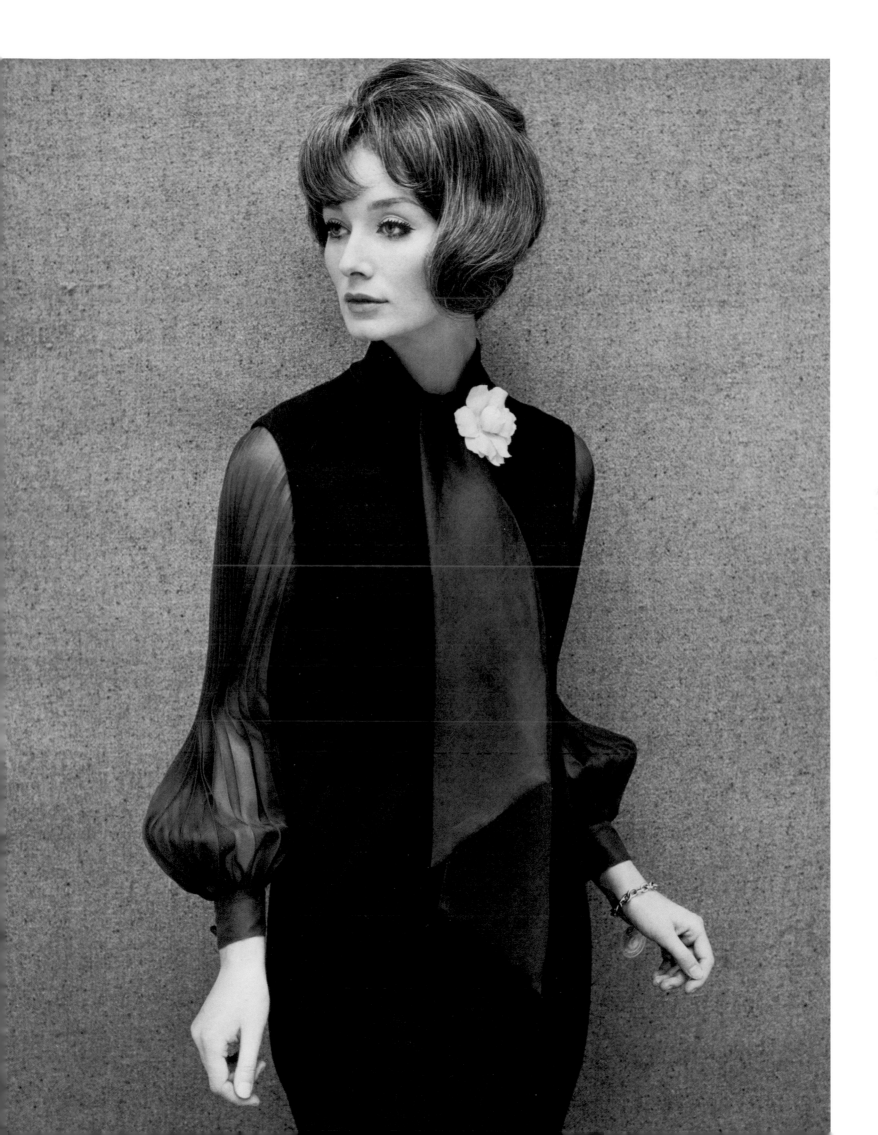

Published 3 May 1964
Photographer Norman Eales
Model Grace Coddington
Fashion Coat by Roger Nelson. Short
sleeved day dress by Moira O'Donnell
Wool dress with square collars by
Tony Armstrong
Original journalist Brigid Keenan

Three fresh talents burst onto the pages of 'Mainly For Women' in May, spotted by Brigid Keenan as 'the ones to watch'.

Roger Nelson left the Royal College of Art at twenty-five and won the Reldan-Digby Morton scholarship to travel to study in Milan. So impressed were they with his work that they offered him a job as soon as he set foot back in Britain, which he refused as he wanted to work to his own rules. Not put off, they offered to back him to set up his own business, and he soon conquered the retail giants, selling at Woollands and Harrods in Knightsbridge, Peter Robinson and Galeries Lafayette in Paris.

For a short time, Moira O'Donnell went into business with Sally Tuffin and Marion Foale, leaving to start her own firm called Mary Murray. 'I like cool, sporty clothes with the American look,' she added.

Tony Armstrong, the youngest of the group at twenty-four, didn't study at art school but soon attracted the interest of stores like Wakefords of Chelsea, Woollands and Fortnum and Mason with his snappily tailored day dresses and bright palette of colours.

Grace Coddington (b.1941) modelled two of their creations and experienced the world of fashion from both sides of the camera. In 1968 she abandoned a highly successful modelling career to join British *Vogue* as a junior fashion editor. She rapidly established herself at the magazine and was responsible for commissioning a series of distinctive fashion shoots, including classic location images from the likes of Norman Parkinson and Helmut Newton. She remains creative director of American *Vogue*.

Three of a Kind

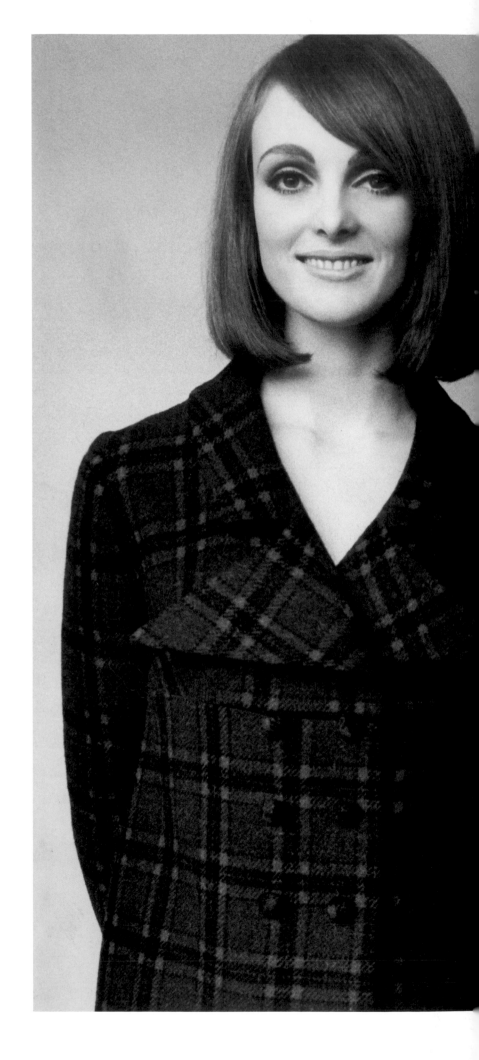

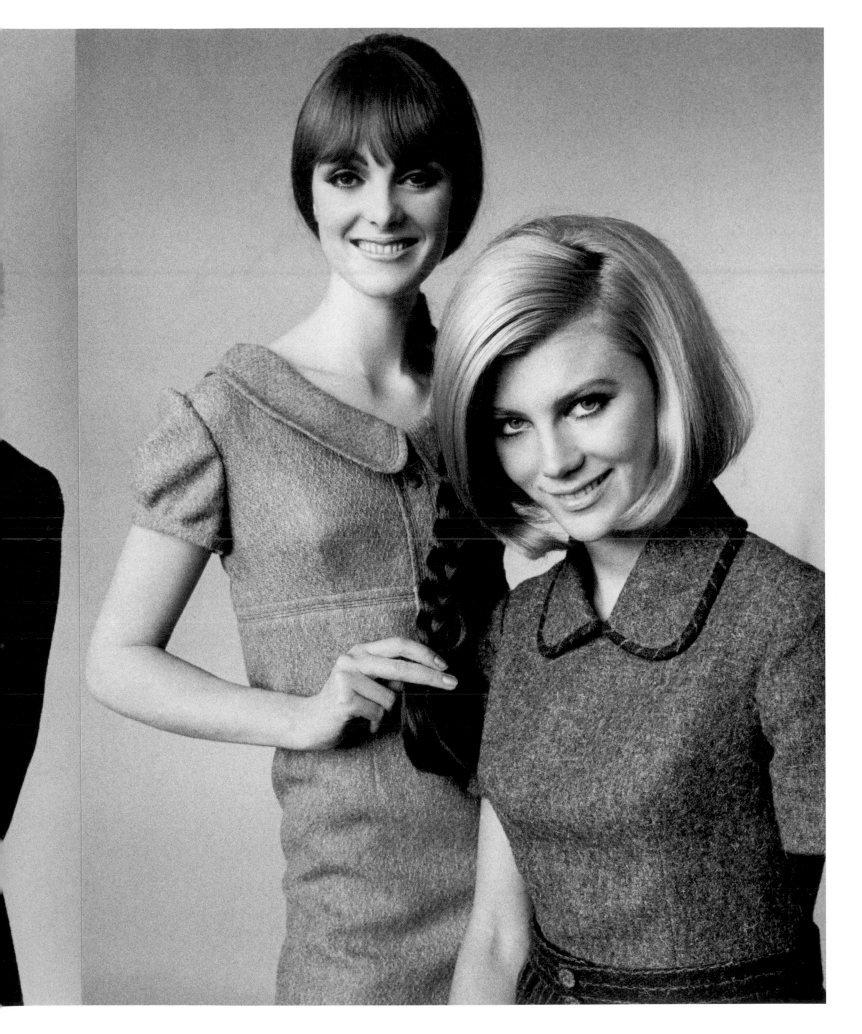

Published 21 June 1964
Photographer John Cowan
Models Jill Kennington, Jacqueline Bissett

The location shoot had always been the preserve of fashion magazines until the likes of photographers Terence Donovan and John Cowan took clothes outside.

In 1962 the *Sunday Times* had launched a magazine supplement which contained a brief fashion section each week, overseen by Meriel McCooey. Designed to complement the writing in 'Mainly for Women' and printed on a fine gloss paper, it enabled a far greater range of images to be produced effectively, even full-page photographs.

In her autobiography, *Tongue in Chic,* Ernestine Carter expressed a frustration at this new style of photographer, as she always felt that the clothes must come first, the art later. Yet it might be argued that dynamic images, such as Jill Kennington and a passer-by racing across Sloane Square on foot, or of actress Jacqueline Bissett in her Mini Cooper, did exactly what they had always done in magazines; they portray a moment in time, a lifestyle, or a theme inspiring the reader to buy into whatever aspect they could, from perfumes to fashion to cigarettes.

In this case the vitality, fashion and fun of 1964 are captured in newsprint, and it was this exemplary standard of photography that contributed to the weekly circulation of the *Sunday Times* rapidly rising above the 1,000,000 mark by early 1965.

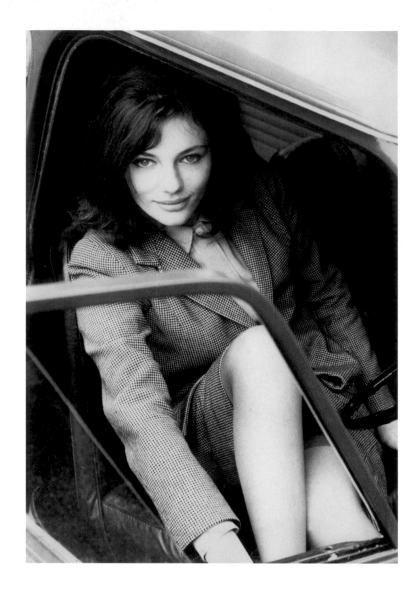

Location, Location, Location

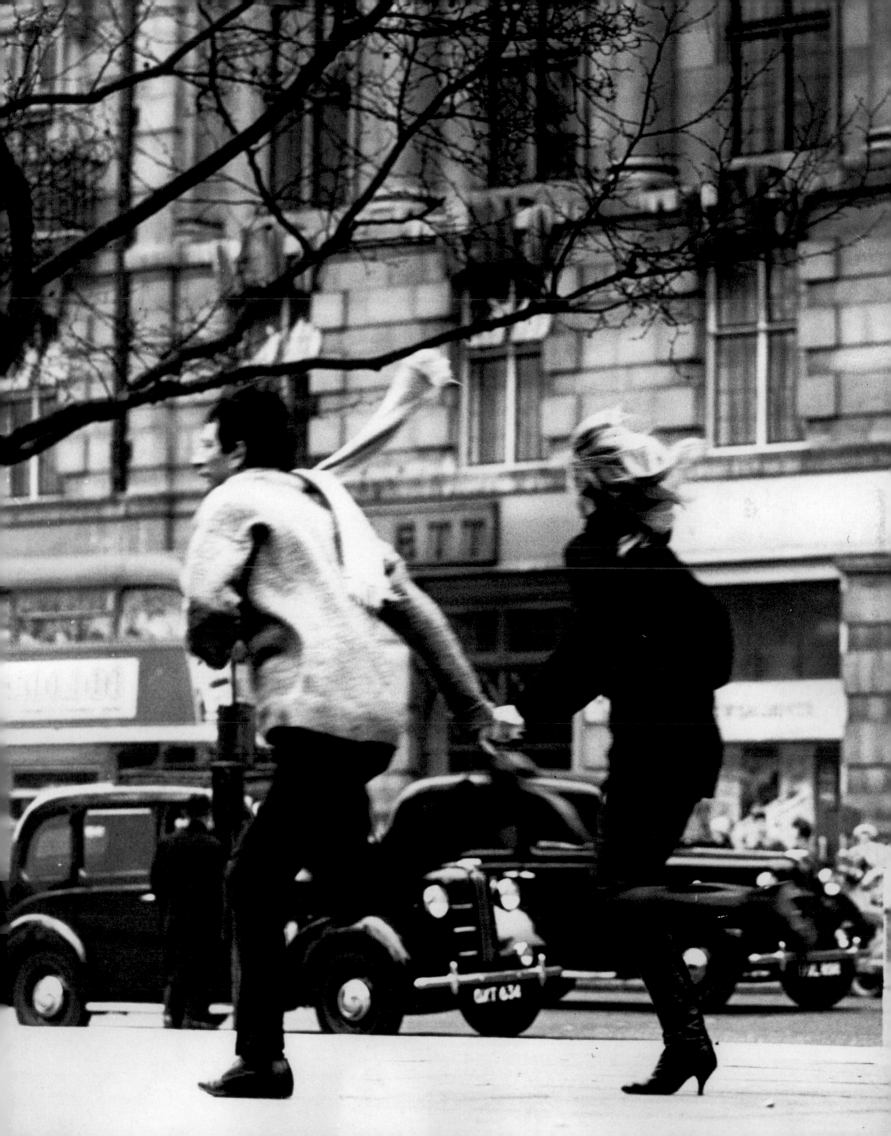

Published 7 July 1964
Photographer Norman Eales at
Vogue Studios
Fashion Oatmeal wool smock dress
by Jean Muir for Jane and Jane
Original journalist Ernestine Carter

Jean Muir (1928-1995) was a perennial favourite of 'Mainly for Women'. She began as a stockroom assistant at Liberty and, via a brief time designing for Young Jaeger, opened Jane and Jane in 1962. When this oatmeal smock dress appeared in 1964 she had just been awarded the Dress of the Year award by the Museum of Costume in Bath for her printed Liberty silk ensemble.

She had picked up on a new femininity in some of the shorter styles for 1964, and regularly used Liberty textiles in her work. Ernestine Carter believed that 'designers like newspaper editors know they must keep in step with public opinion,' and argued that modern styles were frequently not what many women could – or would wish to – wear. 'The sack dress was an initial wild rage, but men didn't like it, and it quietly disappeared. Jean Muir at Jane and Jane is one of the most adept at keeping in step.'

Jane and Jane's brief time at the cutting edge of fashion ended in 1966 when it was sold to middle market manufacturer Susan Small. Jean Muir, meanwhile, went on to greater things. Designing under her own name, she rapidly found her place amongst London's finest fashion houses.

The Simple Life in Fashion

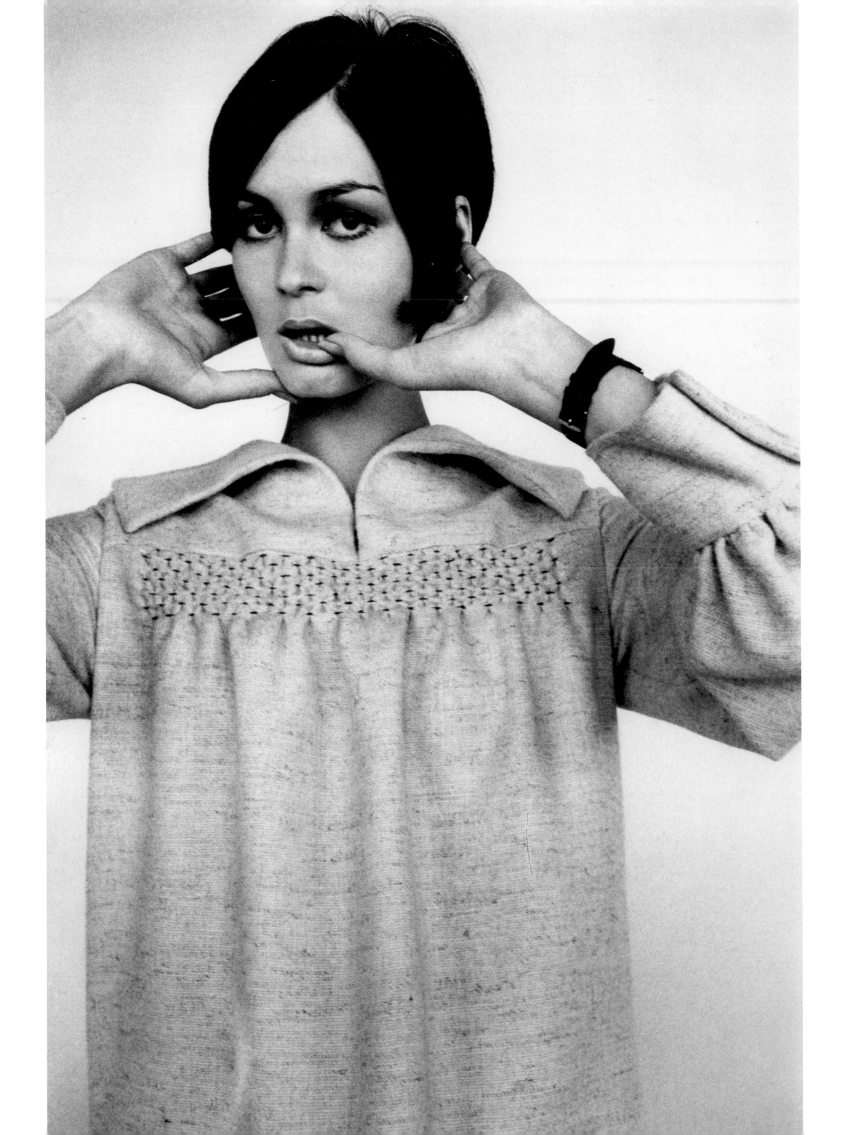

Published 7 July 1964
Photographer Philip O Stearns
Fashion Digby Morton for Reldan
Original journalist Brigid Keenan

The Beatles toured America in 1964, and the reaction was mass hysteria. Brigid Keenan travelled to New York in July to gauge whether this positive reception also applied to fashion, as British manufacturers exhibited at the World Trade Fair. At the airport, she featured six sporty outfits by British exporter Reldan, each designed by Digby Morton.

'Manhattan really is an "Isle of Joy" with a fascination with all things British,' she reported. Jean Rodenberg of Henri Bendel commented: 'Young people in England have created a miraculous new world of their own,' and the department stores of America wanted to know how to replicate their success.

James Wedge was producing a collection for American design institution Hattie Carnegie, and the *New York Herald Tribune* felt that 'a haircut by Vidal Sassoon is one of the pace marks of today's jet-set'. Even American *Vogue* produced a special British-themed edition in August.

Digby Morton (1906-1983) had established the popular London design house of Lachasse in 1928, opening his own label in 1934 to compete in the couture market with the likes of Hardy Amies and John Cavanagh and to 'translate the trends of feminine fashion into the masculine medium of tailoring'. In 1958 Reldan-Digby Morton began a successful middle market partnership, whilst a separate export business continued to sell his designs in large quantities across America.

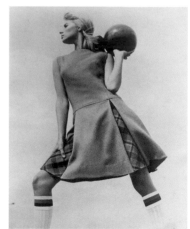
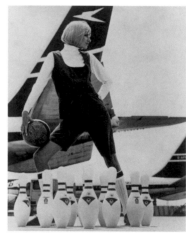
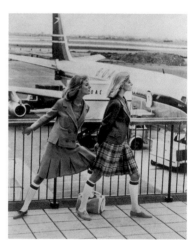

A British Invasion of New York

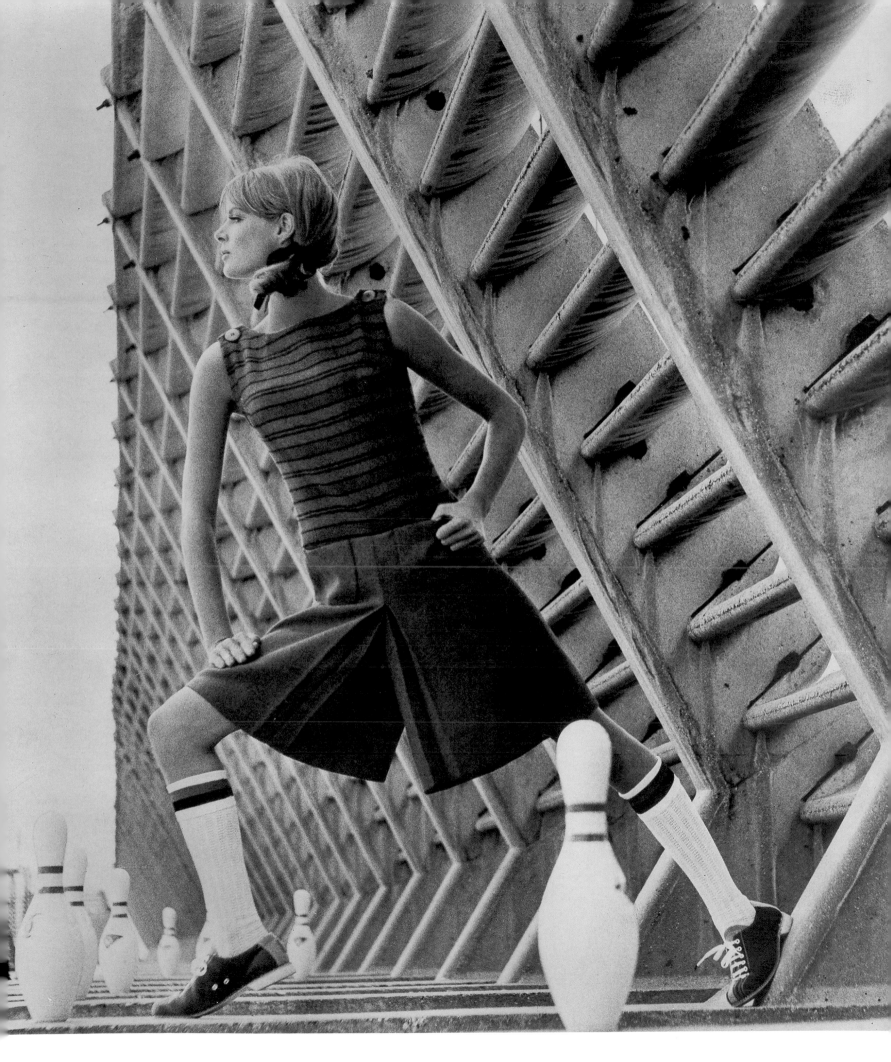

Published 11 October 1964
Photographer John French
Model Jean Shrimpton
Fashion Cord velvet blazer suit by
Jane and Jane
Original journalist Ernestine Carter

Jean Shrimpton was everywhere, and so were pretty cord suits, like this example from Jean Muir at Jane and Jane, retailing at twenty-three guineas. The stockists included Fenwick of Bond Street and Chanelle boutique in Knightsbridge, both businesses that managed to adapt to the rapidly changing face of fashion in the mid-1960s.

Fenwick was a family owned Bond Street department store which could easily have been eclipsed by some of its more fashionable competitors. Renowned for its 'Bridal Room', it recognised the talents of designers such as Jean Muir and John Bates, and in the latter's case enabled him to stay afloat by buying wedding dresses from his fledgling company in the early 1960s.

Chanelle in Knightsbridge was typical of the new generation of boutiques aimed at wealthier and more sophisticated customers than department stores, specializing in glamorous evening wear by the leading London fashion houses, as well as selling high quality designs under its own label.

The Cord Story

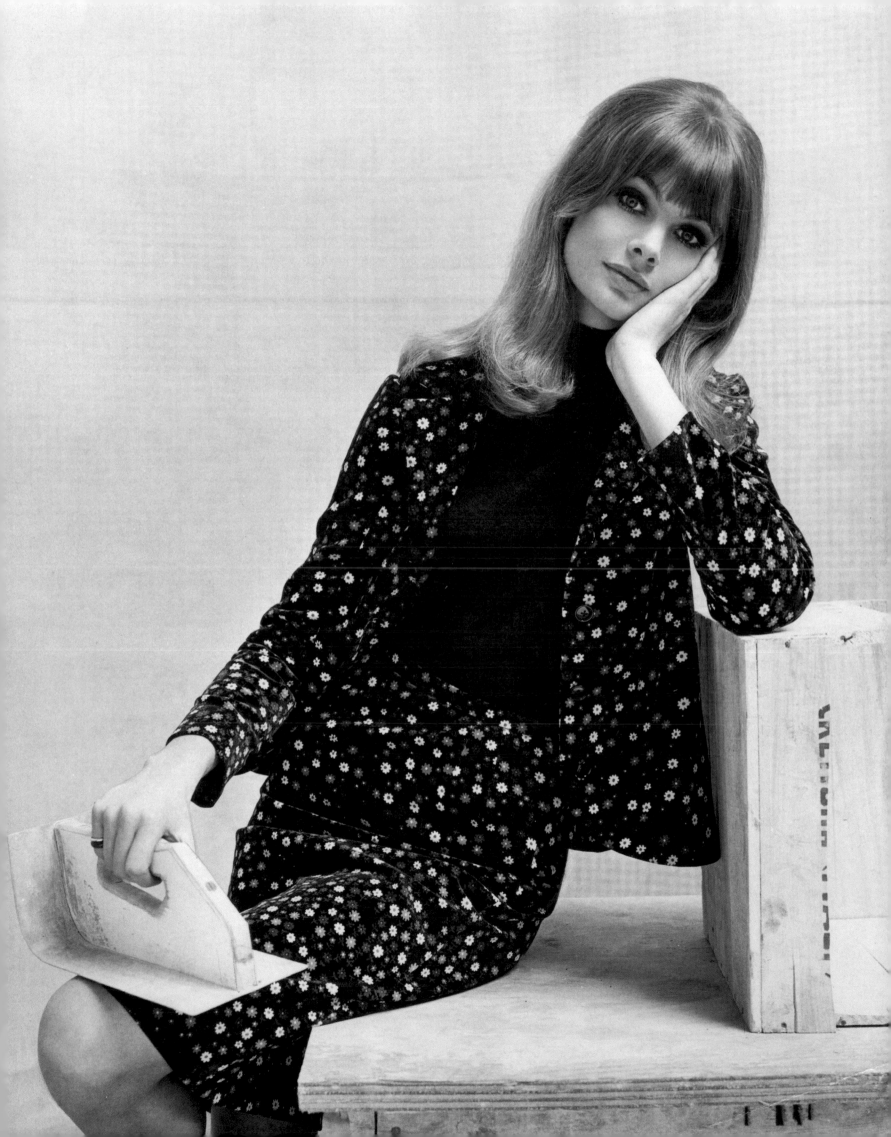

Published 18 October 1964
Photographer Richard Dormer
Fashion Short cocktail dress by
Ronald Paterson
Original journalist Ernestine Carter

With the ceremony held at the Hilton hotel on Park Lane, the *Sunday Times* International Fashion Awards were all about glamour. Top billing went to the triumphant winners for that season: André Courrèges, Jacques Tiffeau, Bonnie Cashin, and home-grown talent Ronald Paterson, for his devastatingly short and sweet cocktail dress, photographed for the paper by Richard 'Dickey' Dormer.

The winners could expect promotion of their designs in special displays in Harrods, Liberty, and Fortnum and Mason – and in the case of Scotsman Ronald Paterson, the main windows of McEwens department store in Perth.

As a way of focusing the fashion spotlight on London, the awards were a masterstroke by Ernestine Carter, and garnered enormous cachet for the paper. Open to any designer that had made an outstanding contribution to fashion that year, the competition included millinery, jewellery design, lingerie, hair and shoes. The annual award for 'Fashion Immortal' honoured the great names for their long-standing contribution to the industry, and was to become the equivalent of a peerage.

And the Winner is...

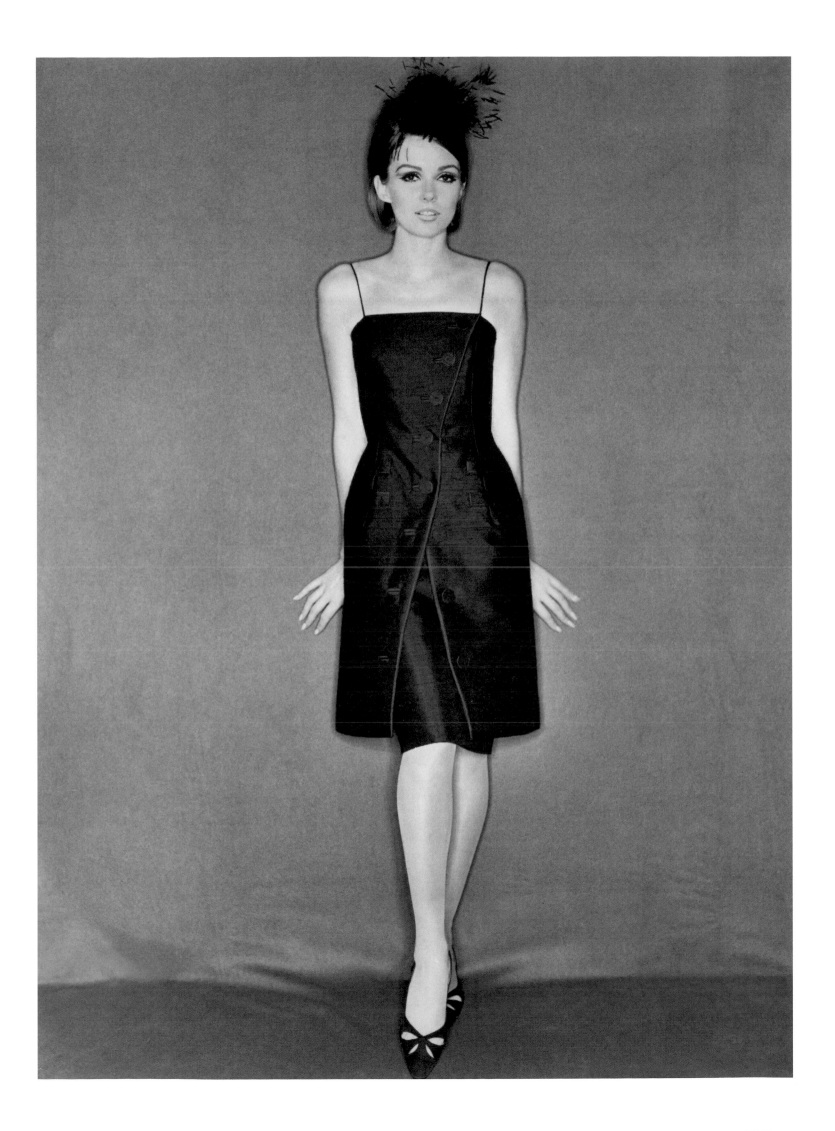

Published 1 November 1964
Photographer Hatami
Fashion Black lace cocktail dress
with crochet collar and flowers by
Mary Quant
Original journalist Ernestine Carter

After previously reporting the winners at the *Sunday Times* International Fashion Awards, Ernestine Carter followed up by casting her eye over the guests' sartorial style.

Wearing one of her own designs was Mary Quant, in a ribbon lace creation decorated with appliquéd crochet from her new collection. By 1964, her boutique Bazaar was selling on both the Kings Road and in Knightsbridge and she was exporting in large quantites to America. Having moved into mass production in 1962 with her Ginger Group label, she followed up by marketing cosmetics, all featuring her hallmark daisy logo.

In contrast to most of the other international guests, immaculate in empire line sheath dresses, beaded jackets, draped chiffon and Parisian tailoring, with hair piled high, Mary Quant served to emphasise just how individual the 'London Look' was – in clothes, hair, shoes, and even make-up.

Fashion Out Front

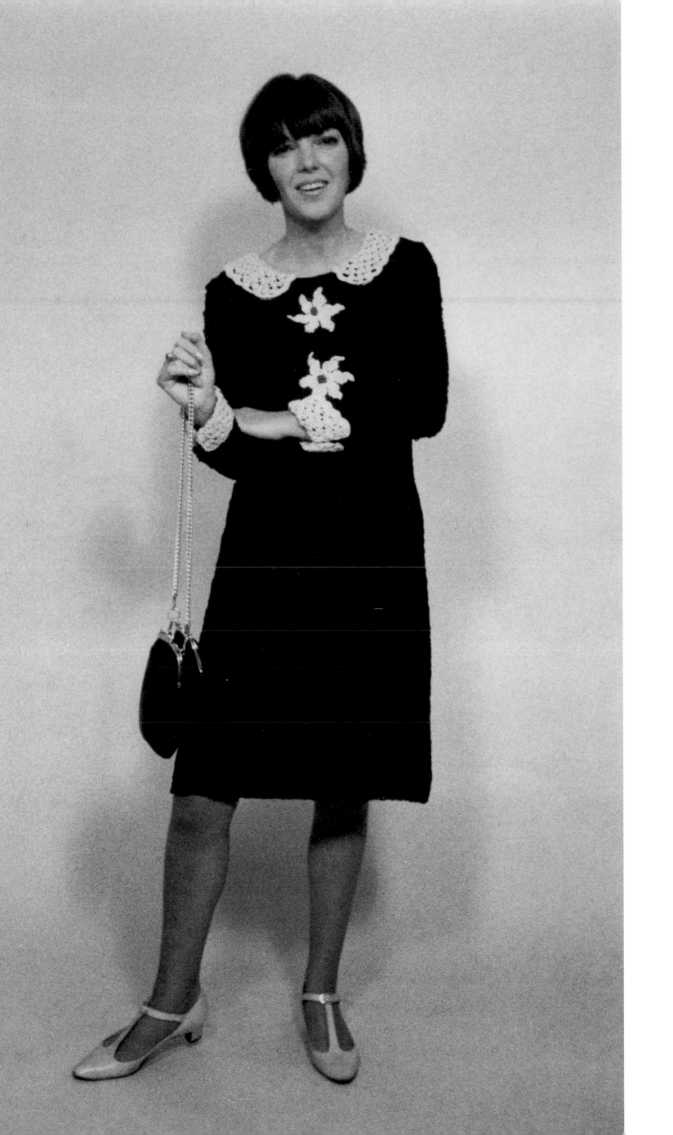

Published 1 November 1964
Photographer John French
Model Tania Mallett
Fashion Saga blue fox full-length coat by Maxwell Croft. Tweed and Mongolian lamb trimmed coat by Ascher
Original journalist Ernestine Carter

To cover up the rash of increasingly 'bare' dresses, readers wrote they were finding it hard to track down 'coats to cover up in'. The answer from furrier Maxwell Croft was a luxurious full-length blue fox coat at £445. Cunningly, the design featured two levels of Velcro, so it could be altered to 'car coat' and 'Bolero evening jacket' in no time at all.

A little more affordable, at £89, was Ascher's tweed and Mongolian lamb coat with matching hat, which Mrs Carter thought 'the most thorough cover-up I could find'.

Modelling both was Tania Mallett (b.1941), who, at the time of the photo shoot, was also a film star: she had just appeared as Tilly Masterson opposite Sean Connery in *Goldfinger*. It was to be her only film role, and she returned to modelling citing the fact that her pay for a week's filming was less than a third of what she received for a day as a model.

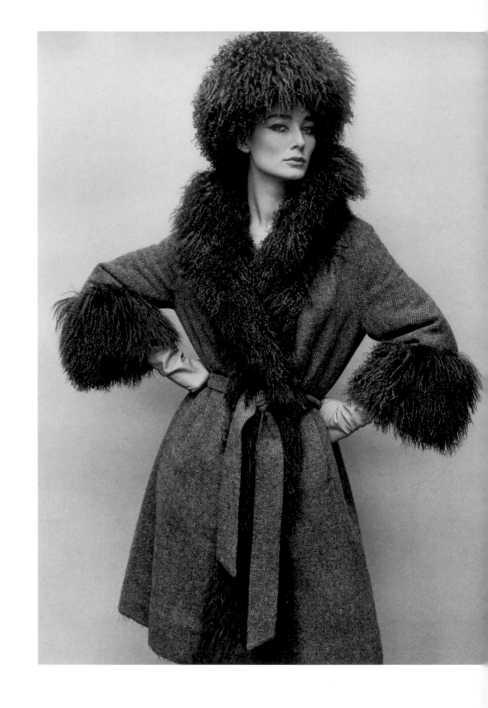

Fur Does Double Duty

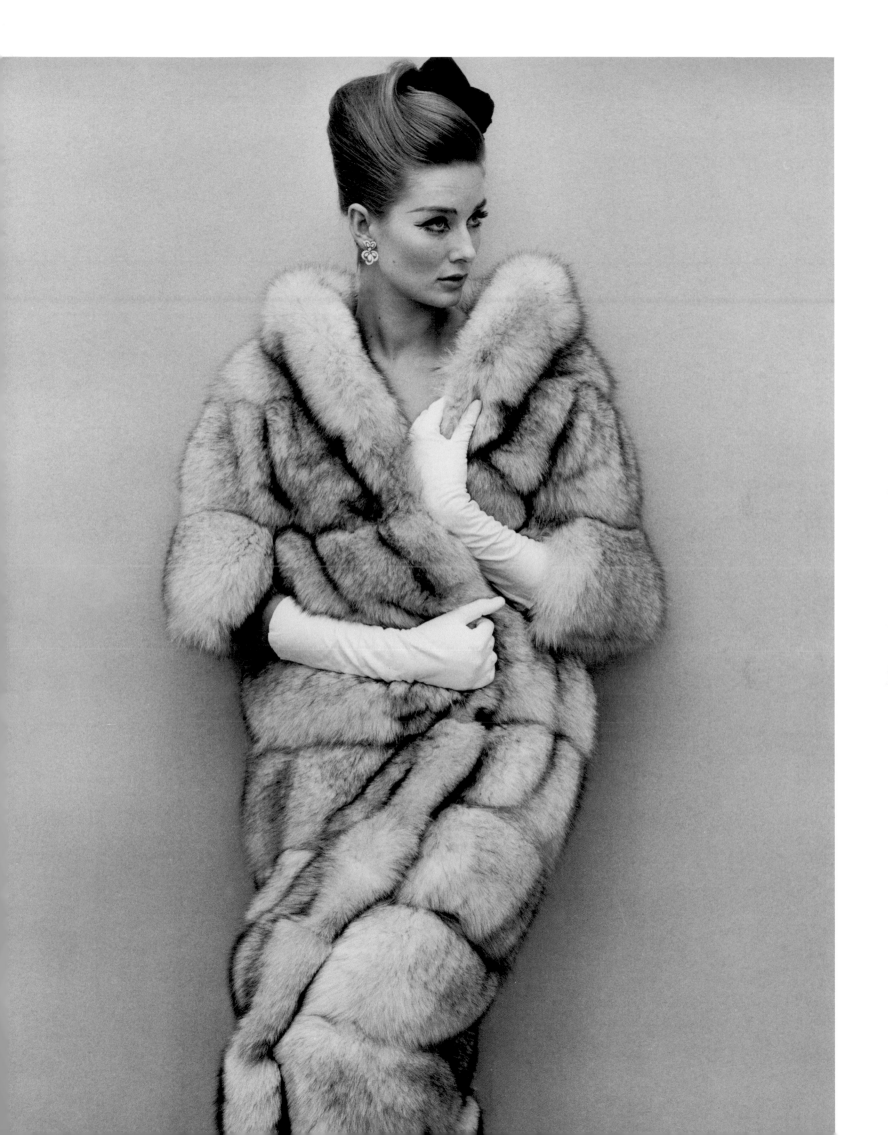

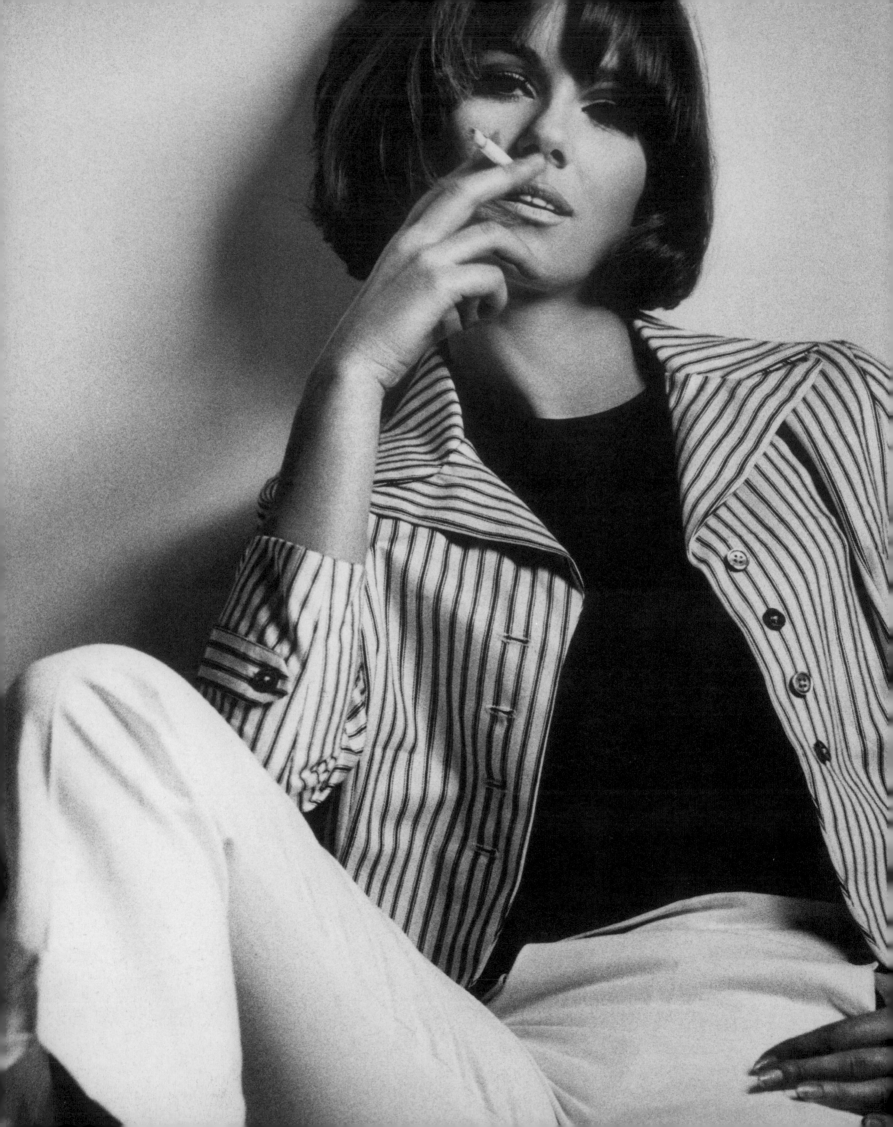

65

Published 28 March 1965
Photographer John French
Fashion Striped double-breasted blazer
by Brian Walsh. Short white raincoat by
Laurence Willcocks
Original journalist Ernestine Carter

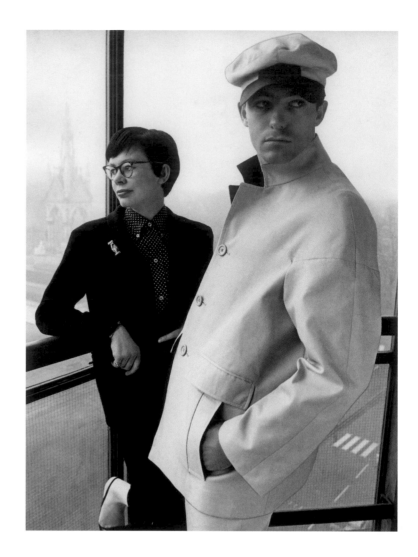

When Ernestine Carter travelled to the Royal College of
Art's school of fashion in March 1964, she investigated
new menswear designs for summer. Under the
stewardship of Professor Janey Ironside the school
nurtured some of the most notable fashion talent of
the following decade, including Ossie Clark, Bill Gibb,
Marion Foale, Sally Tuffin, Zandra Rhodes and David
Sassoon.

What Mrs Carter found surprised her. Not only was she
presented with a hall of fashion students expecting an
unscheduled lecture from her on the future of British
fashion, but she also met young menswear designers
who were recreating historical looks for modern tailors.
'Their ideal seems to be a film gangster of the 1920s,'
she added, not without a hint of disappointment.
Students Brian Walsh and Laurence Willcocks argued
that, just as with women's fashion, it was acceptable to
reinterpret and adapt looks from the past for the modern
day. 'After all we're the ones designing, constructing and
wearing the clothes,' they commented.

Photographed with the designs, and overlooking
Kensington Gardens, was Professor Ironside, with the
Albert Memorial as a backdrop.

Blazing a Trail
in Menswear

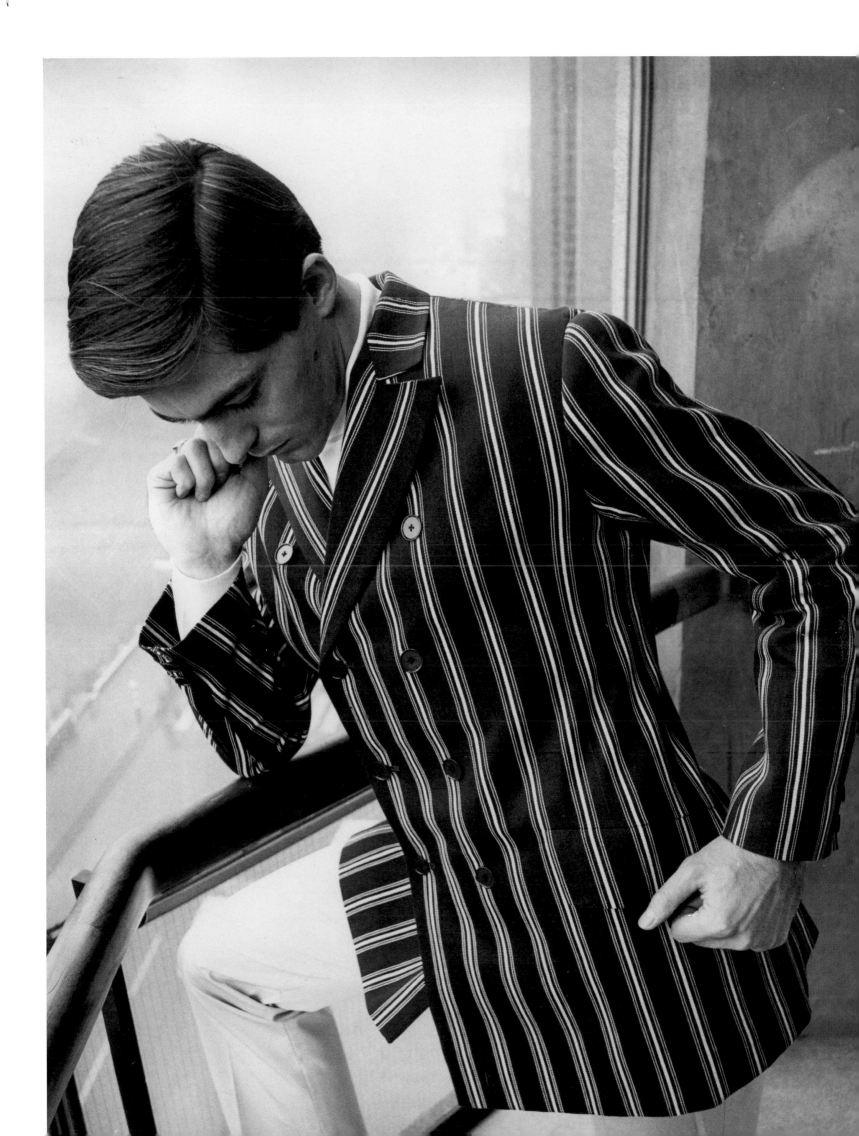

Published 11 April 1965
Photographer Norman Eales at *Vogue* Studio
Fashion Halter dress by Mary Quant for Ginger Group. White double-breasted coat by Mary Quant, own label. Summer print dress with full sleeves by Mary Quant for Bazaar
Original journalist Ernestine Carter

Ernestine Carter had long been a supporter of Mary Quant, crediting her clothes with breathing new life into British fashion, and she argued that four must be the designer's lucky number: she designed four collections a year for her brands in Britain, four for JC Penney in New York, and four for Puritan Dresses, the fourth largest manufacturer in America.

To add to the plaudits, there was a newly acquired contract with Butterick Patterns, where she was the first British designer to be recruited. As a consequence, both she and her husband Alexander Plunkett-Green joined a new generation of regular transatlantic commuters.

Britain's fashion brands had become a global asset, and other designers soon found that they had access to foreign markets where the only external influence on fashion to date had been Paris.

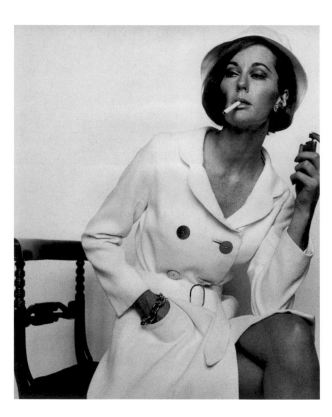
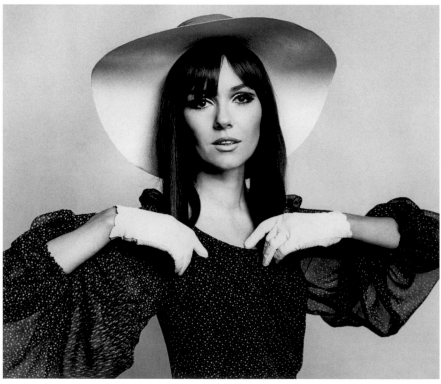

Quintuples of Four

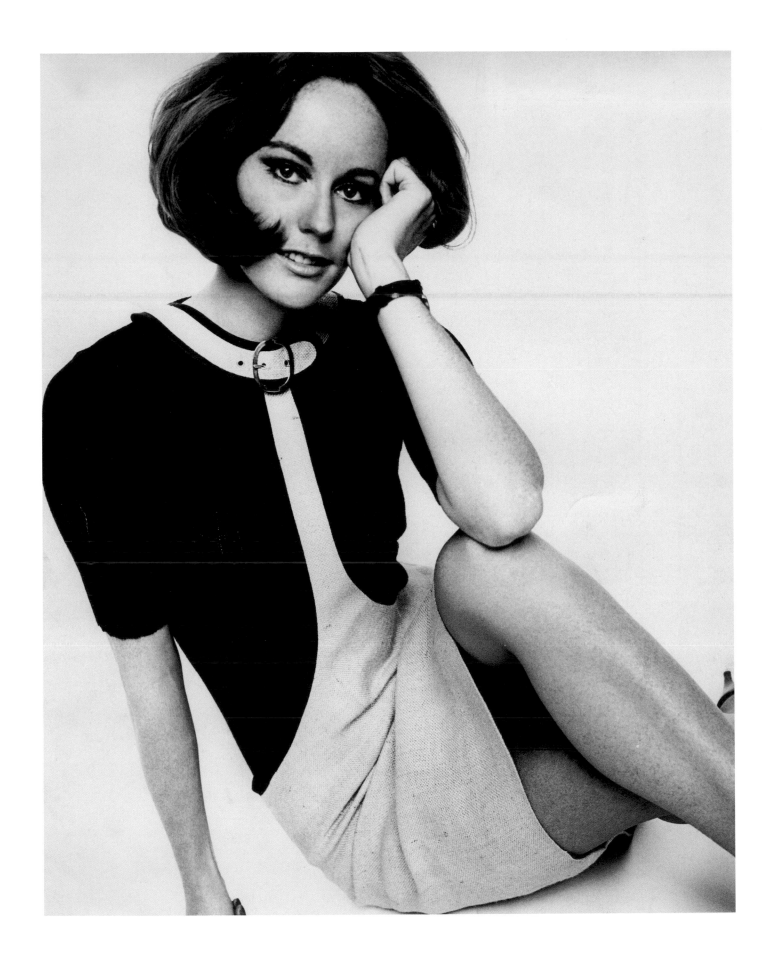

Published 10 May 1965
Photographer Terence Donovan
Models Terence Conran and the staff
of Habitat, Fulham Road
Original journalist Ernestine Carter

Design for the home matched the revolution taking place in London's fashionable boutiques when Terence Conran opened his first Habitat store on the Fulham Road.

The concept was as simple and effective as that of Mary Quant at Bazaar, or Woollands 21 in Knightsbridge. By grouping together the best of modern design in an environment which displayed innovation to greatest effect, shopping as a leisure pursuit for the young was born.

With quarry-tiled floors and white walls, Habitat was the antithesis of traditional furniture retailing, which, at the time of the opening of the first branch in 1964, was still dominated by department stores and large retailers such as Courts.

The war had all but halted innovation in furniture design, and the younger generation found they had little choice in home furnishings for their flats and bedsits. Habitat provided affordable, adaptable furniture and simple, utilitarian homeware which consigned the dark reproduction furniture of the immediate post-war years to history.

Paper lampshades, stacking chairs, adjustable spotlights, even glass pasta jars – what are now taken for granted were Habitat's innovations, and enabled the company to expand countrywide by the end of the decade.

Fashion for the Home

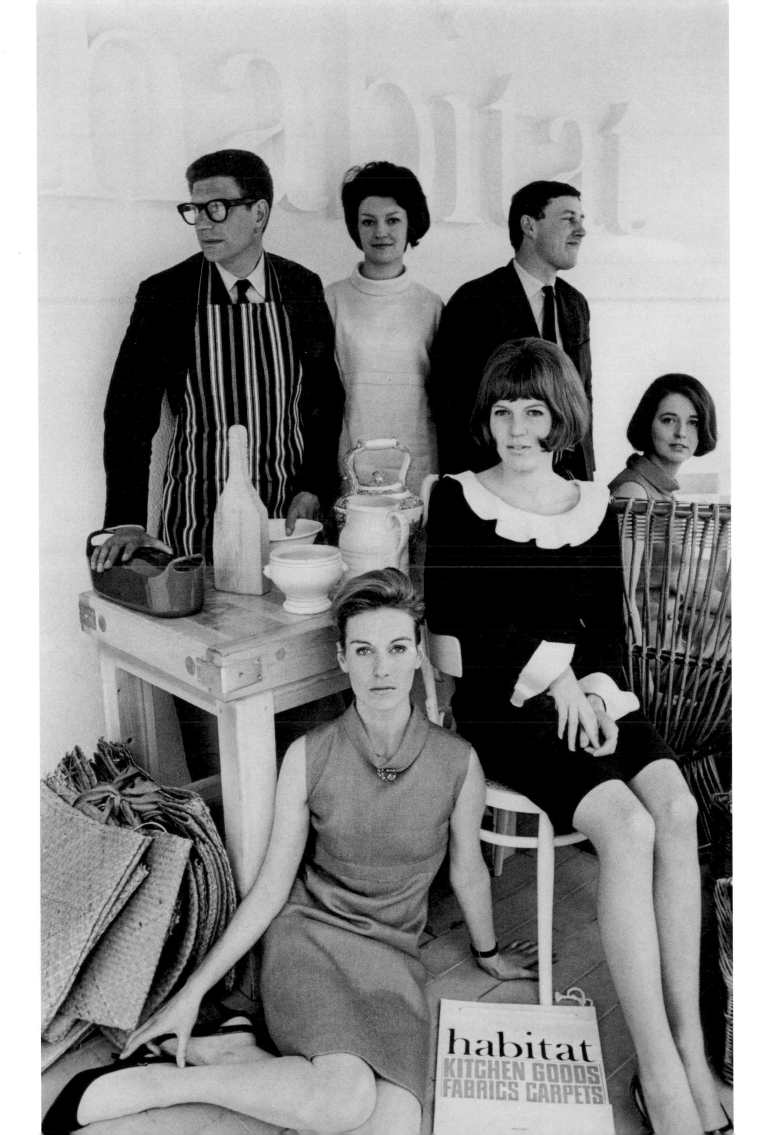

Published 16 May 1965
Photographer Norman Eales at
Vogue Studios
Fashion Navy and white piqué coat
dress by Polly Peck
Original journalist Brigid Keenan

As André Courrèges began to show clean-cut, sculpted clothes in Paris, piqué fabric underwent redemption in the eyes of the fashion press. Previously reserved for tennis dresses, the fine-ribbed fabric also suited the shorter, sharper shapes emerging from London, here edged in navy for a coat dress by Polly Peck.

Norman Eales's photograph typifies the new, exemplary standard for fashion photography in 'Mainly For Women', as models and clothes became part of larger, and increasingly challenging, compositions. In his case, the ability to exploit the impact of photography in newsprint enabled his simple, dramatic style to become instantly recognisable, with the majority of his work published unaltered by the *Sunday Times* in-house designers.

As a matter of course, other photographers' images were often cropped by up to seventy-five per cent to enable them to fit a designated space in a layout or alter the emphasis of an outfit, or if Mrs Carter felt art was getting the better of fashion.

A Fit of Piqué

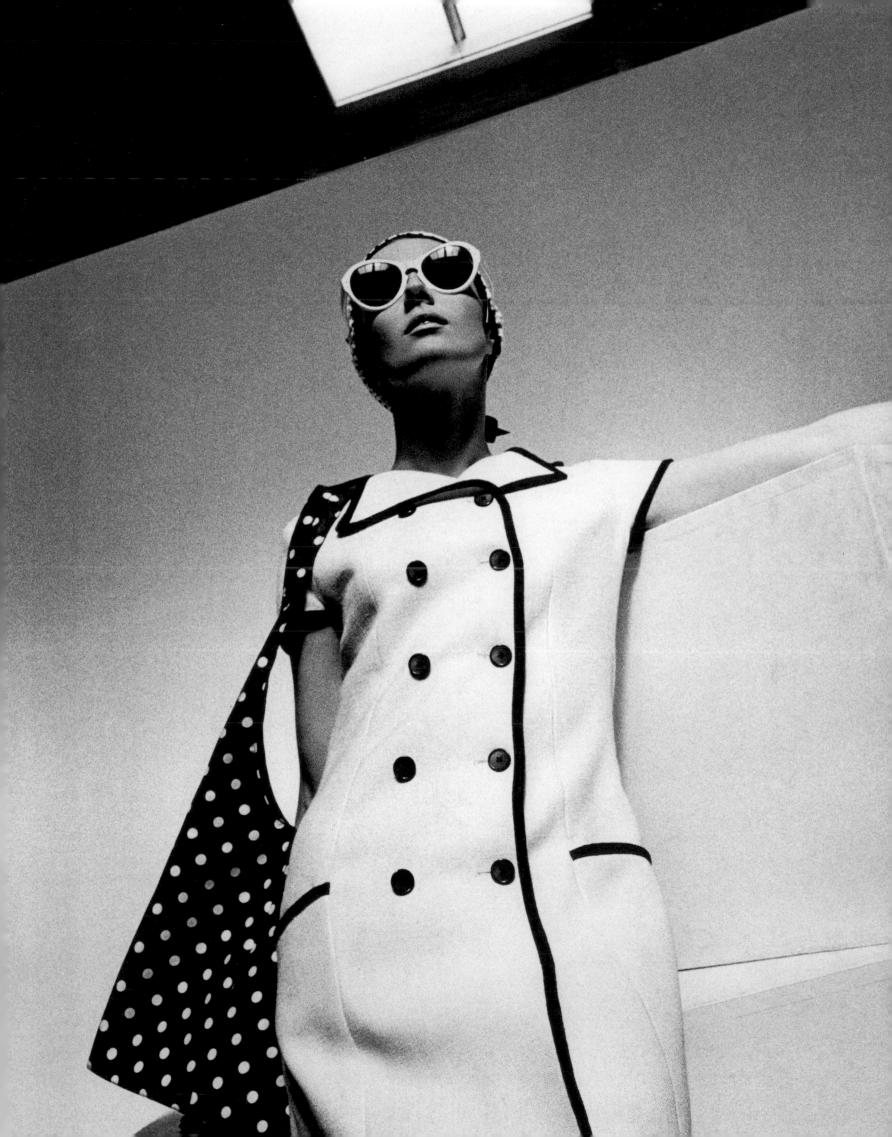

Published 23 May 1965
Photographer Norman Eales at
Vogue Studio
Fashion Thérèse and Jennifer
Original journalist Brigid Keenan

Mix and match separates were a new idea in 1965; it meant fashion 'collectors' could pick pieces from a number of a designer's looks in order to make their own.

Thérèse and Jennifer specialised in an American casual look, as an alternative to the minidress, with simple cotton ticking jackets and what were described as 'cigarette-shaped pants'. Certainly some readers felt that an alternative was vital, and 'Mainly for Woman' received as many letters from readers bemoaning the loss of elegance and sophistication in fashion as they did from buyers frustrated that 'youth and a passable dress design was a guarantee of fame'.

However, between herself and her writers, Ernestine Carter was careful to balance the pages so that a variety of styles, audiences and price brackets were dealt with each week.

For Thérèse and Jennifer this proved to be their 'five minutes of fame', in one of only a few appearances in the paper. For photographer Norman Eales, adding a little erotic charge or drama to an image came naturally, and for every photograph published there is often a quantity of alternative prints in the Fashion Museum archive. In this case it proved to be another, less provocative, image from the same shoot that was finally chosen to illustrate the article.

Collectors' Items

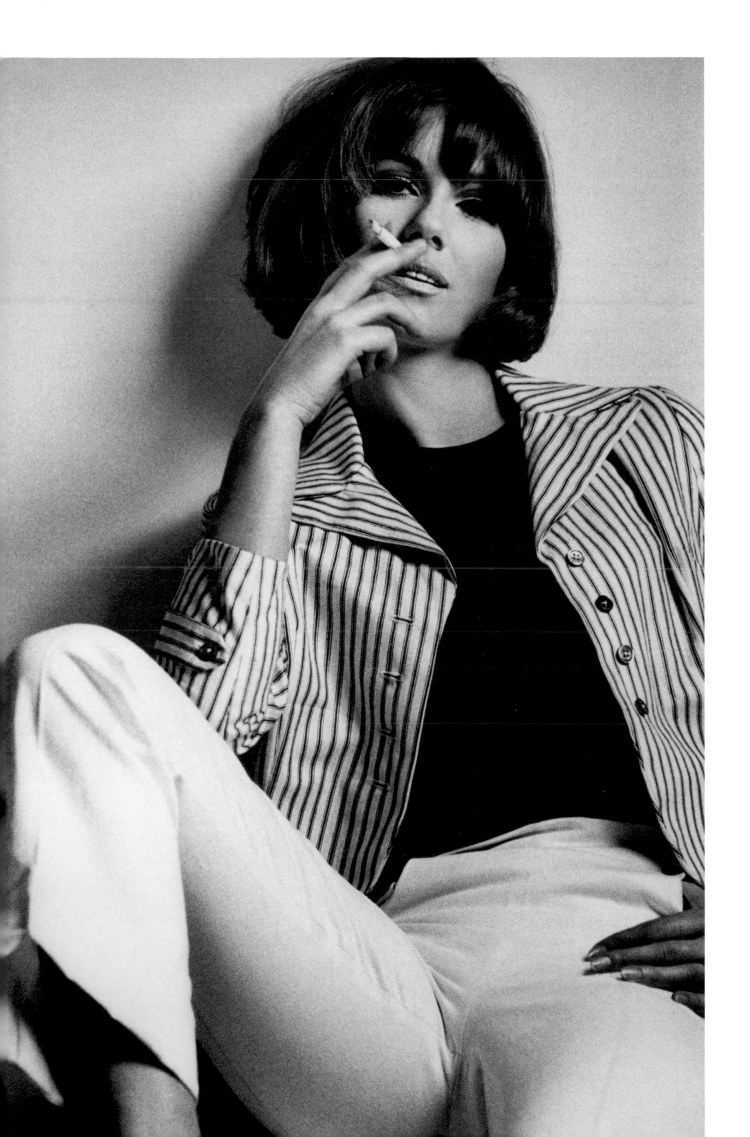

Published 30 May 1965
Photographer Hatami
Model Julie Christie
Fashion Mitzou
Original journalist Ernestine Carter

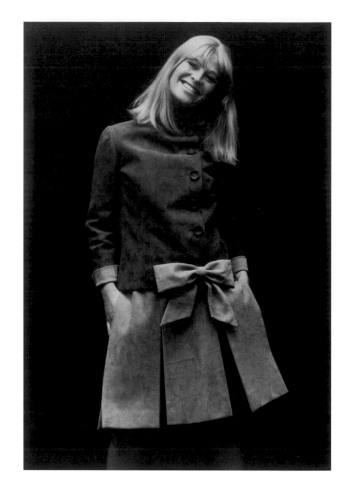

An eleven minute appearance in *Billy Liar* with Tom Courtenay in 1963 was enough to catapult Julie Christie to fame.

Filming exterior shots for *Doctor Zhivago* on location in Spain, she modelled suede dresses by Mitzou for the *Sunday Times*, combining fashion, film and celebrity in a way that is considered unremarkable today. In 1965, however, it was a rare exception to the rule that only 'model girls' modelled.

Julie Christie was born in India in 1941, the daughter of a tea planter, and her casting in *Billy Liar* and *Dr Zhivago* was to establish her reputation and in turn lead to an acclaimed performance in *Darling*, also in 1965.

She was no stranger to fashion in her subsequent roles in both *Far From the Madding Crowd* and *The Go-Between*: art mirrored life, as the romanticised nineteenth-century fashions ran parallel to a historical revival in mainstream design. For her memorable role in *Don't Look Now*, costumes were designed by *Vogue's* 'Young Ideas' editor, Marit Allen.

Julie Christie's Eleven Minutes of Fame

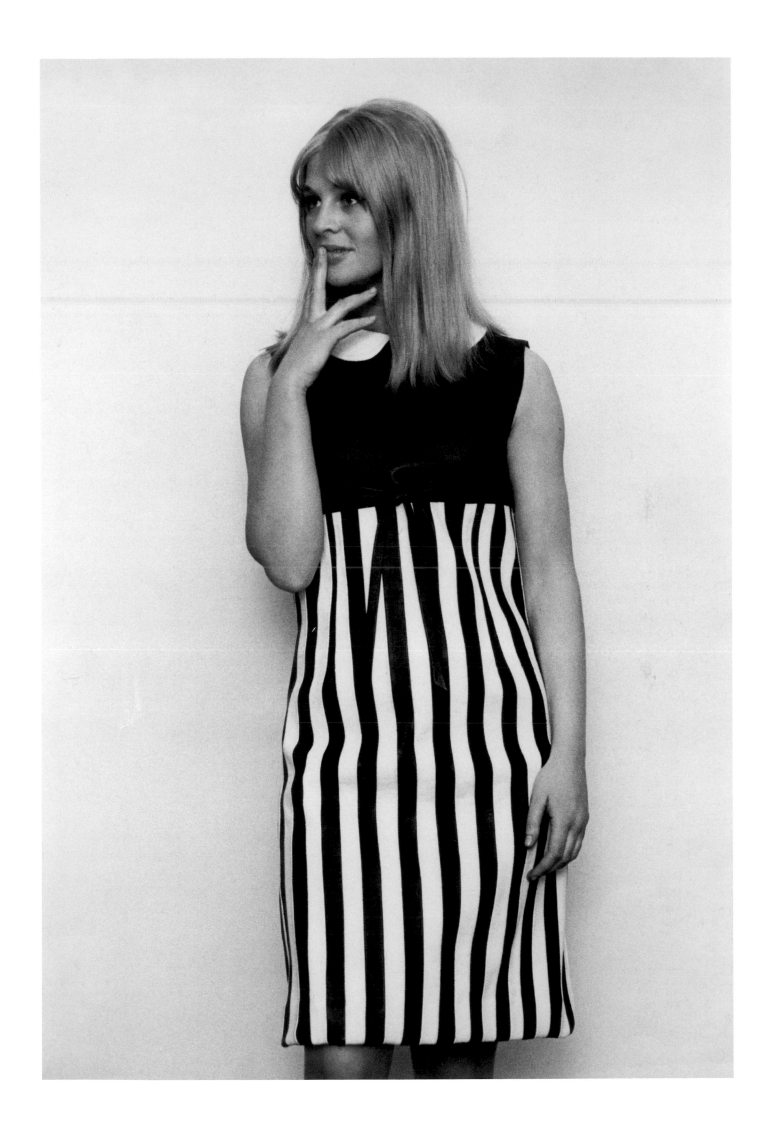

Published 30 May 1965
Photographer Norman Eales
Fashion Printed cotton dress with
tiered frill collar by Noeleen King
Original journalist Ernestine Carter

On a trip to Paris, Ernestine Carter visited one of her favourite boutiques only to discover amongst the cornucopia of fashion 'that all the exceptional designers stocked were British'. The influence of the British abroad prompted a round-up of names of those who had left these shores and were forging businesses in far-flung corners of the globe.

Among the more familiar names that had franchised their operations worldwide were smaller businesses such as Noeleen King, who originally worked with Sybil Connelly in Dublin but emigrated to Australia with her husband in the early 1960s.

There she won the rights to manufacture Mary Quant's designs across Europe, which she combined with designing for her own label, exporting back to Britain and forming a 'full circle of fashion'.

A Full Circle of Fashion

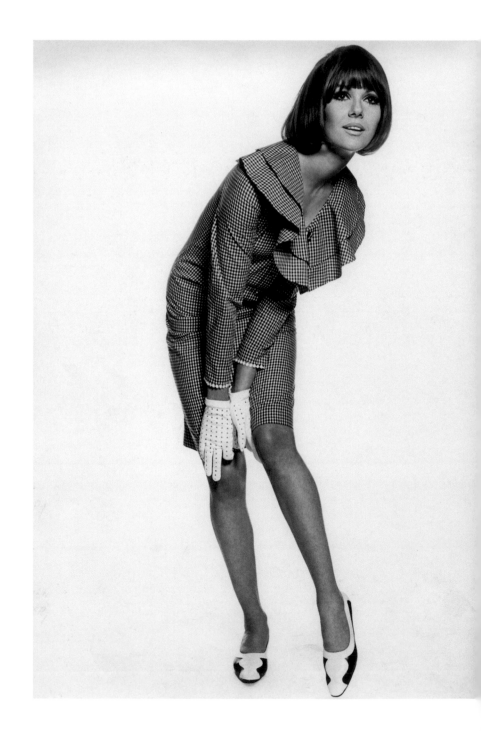

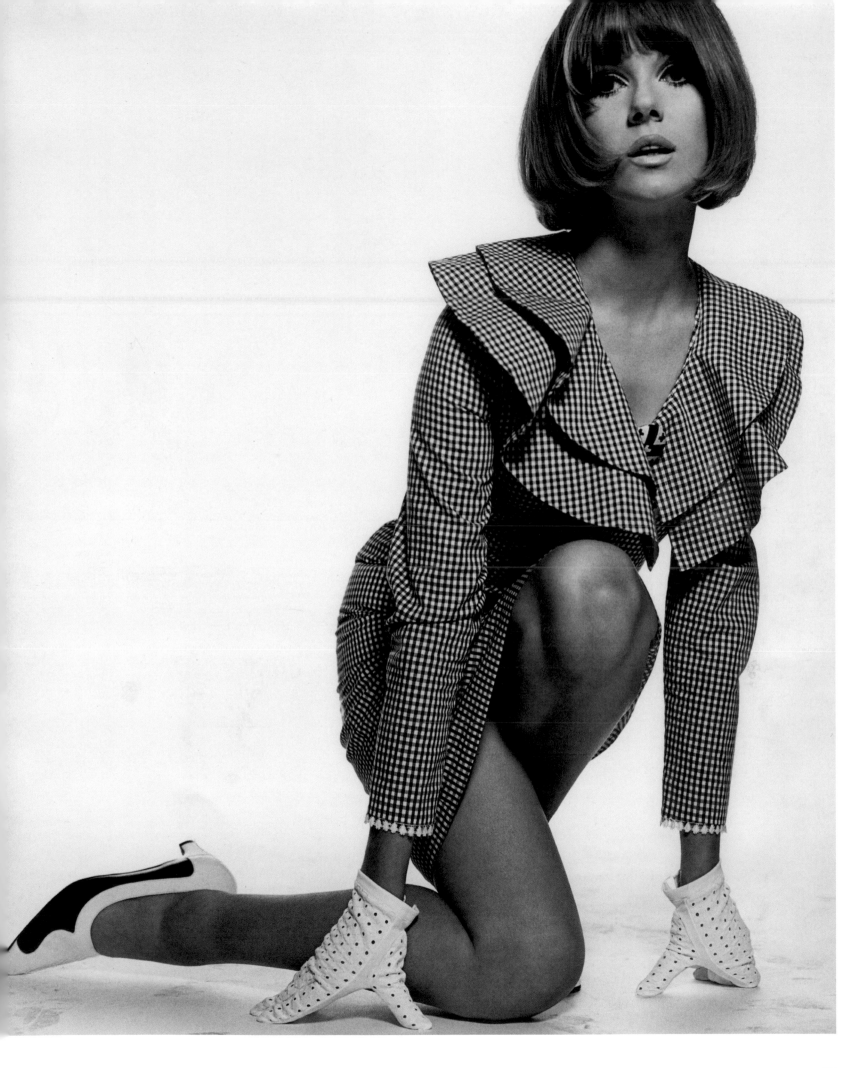

Published 6 June 1965
Photographer Michael McGrath
Models The Pirates
Fashion John Stephen
Original journalist John Stephen

Taking a break in the summer of 1965, Ernestine Carter invited guest writers to fill the gap left by her absence. Menswear designer and retailer John Stephen was first, and in a groundbreaking article he reported from Carnaby Street and invited up-and-coming band The Pirates to model his clothes.

Credited with almost single-handedly creating Carnaby Street's reputation as a design Mecca for the young, at one time he and his business partner Bill Franks ran fifteen boutiques, changing the once run-down area into a centre initially for menswear, then encouraging the London boutique scene to flower there at its most vivid and exotic. 'Ten years ago, when I first came to London, the style of menswear was very limited,' he commented.

His boutiques were totally unlike any menswear outlets seen before, and included His Clothes, Mod Male and Male W1 – all frequented by the stars of stage and screen, together with young fashion-conscious men desperate for a pair of his trademark hipsters or one of his sharply cut suits. What had started with narrow ties and 'Italian-styled' suits ended with the 'dandy' look of rich, coloured velvets, deep cuffs and collars, and wide, exotically printed ties.

Pirates band members John Weider and Phil May were typical of the aspiring stars who were sent to John Stephen's boutiques to be kitted out in the latest fashions by their record labels.

Some of the first were The Beatles, who bought their Nehru-collared jackets from a John Stephen boutique. 'We couldn't give them away until they bought them,' he recalled.

The Pop Stars' Shop

Published 27 June 1965
Photographer John Cowan
Original journalist Fleur Cowles

Fleur Cowles, a writer and artist, took up the temporary vacancy of fashion editor-in-chief in late June 1965, and it was her firm belief that the days of the 'Kookie' or modern look were numbered, heralding a return to romantic, elegant dressing.

Eugenia Sheppard agreed, commenting: 'Square it may be, but I can't help looking longingly at the good old days, when every fashion editorial made women sick with longing to look just that way.'

John Cowan's accompanying photograph of a snappily dressed girl about town strolling along the Kings Road, complete with short skirt and pale lipstick, illustrates just how far fashion had come in only a brief period from the poised elegance of the traditional ready-to-wear houses.

Short skirts, new haircuts, make-up, fabrics and the liberation of women from a strict code of dressing excited strong reactions, both for and against, with age usually the deciding factor.

How Square is Kookie?

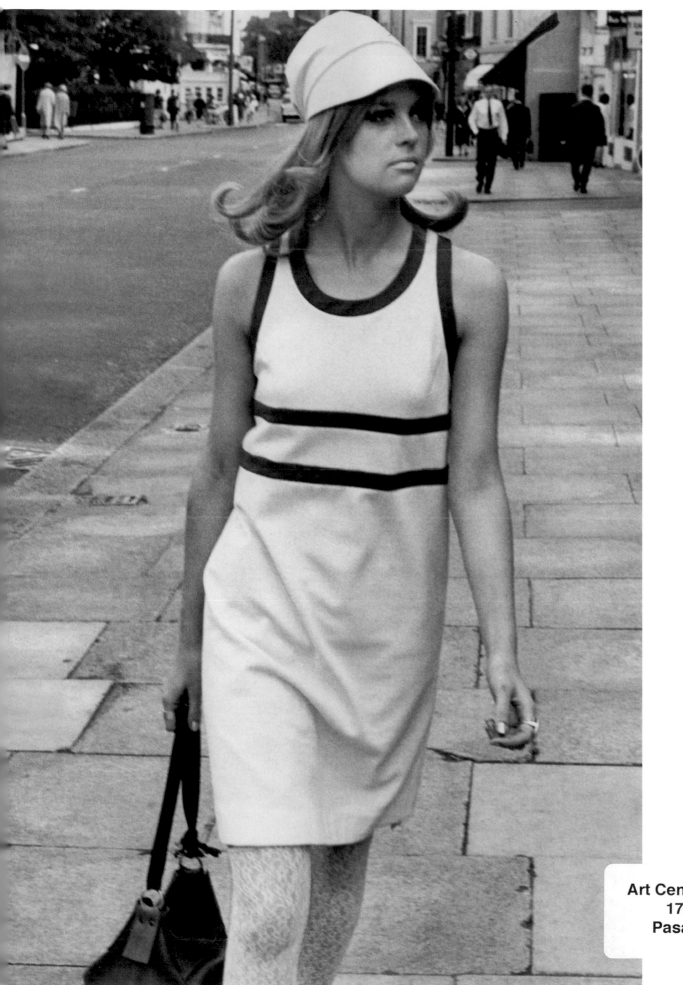

Art Center College Library
1700 Lida Street
Pasadena, CA 91103

Published 25 July 1965
Photographer John French
Fashion Cream herringbone coat by
Michael of Carlos Place. Suit with box
jacket by John Cavanagh
Original journalist Ernestine Carter

Back at the helm after a break, and almost as a shot across the bows of the modernists, Ernestine Carter chose a John French shoot for 'Couture Cuts Loose' in July 1965; it could easily have dated from any time in the previous five years with its traditional portrayal of couture elegance.

Both Michael of Carlos Place and John Cavanagh were favourites of 'Mainly for Women', and by this time both designers had diversified into ready-to-wear and external consultancies in order to weather the storm caused by the reversal of poles in the fashion world.

Of all the London couturiers, John Cavanagh is often credited with having been the most aware of younger fashion. His workrooms in Curzon Street brought together talent of all ages from around the world, with many employees having worked for the great couture houses of Paris.

His personal assistant for most of the sixties was Lindsay Evans Robertson, who described his designs as 'Paris in London. There was a lightness of touch, a feminine delicacy, a fragility, unlike the work of any of the other London couturiers'.

Couture Cuts Loose

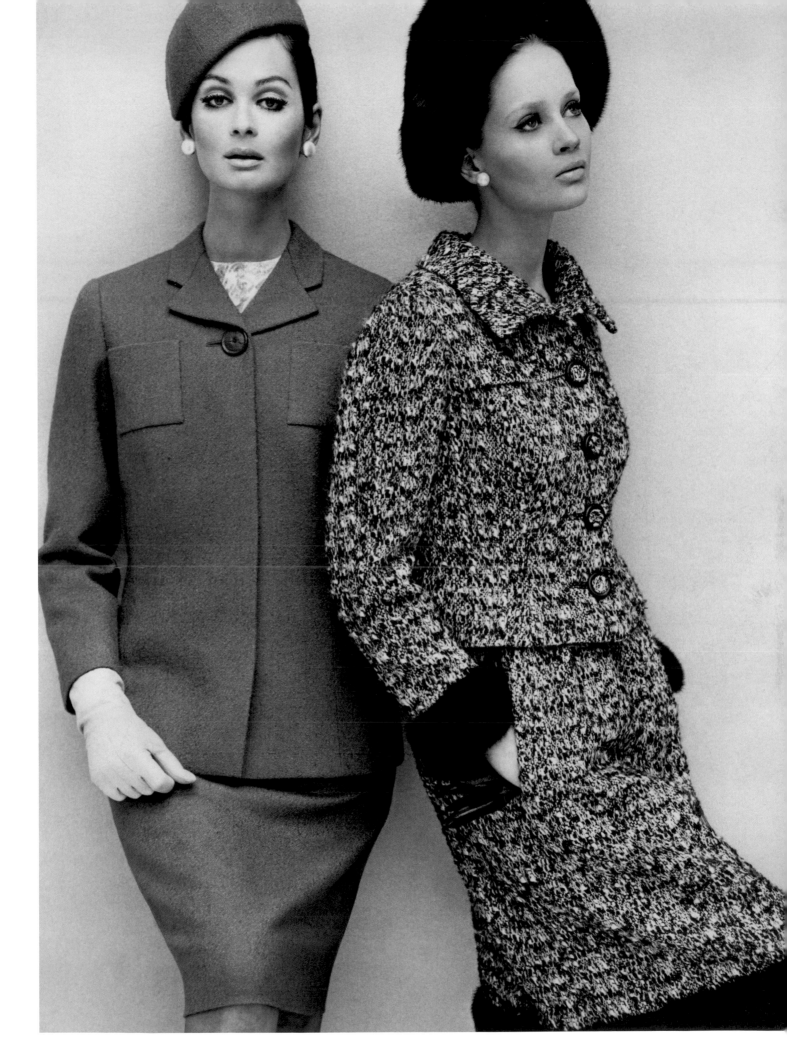

Published 1 August 1965
Fashion Hair by Vidal Sassoon
for Ungaro
Original journalist Ernestine Carter

Just as clothes had been revolutionised by the likes of Mary Quant and John Bates, hair styling was changed almost overnight by the arrival of Vidal Sassoon (b.1928).

Characterised by short, sharp, angular bobs, his work was tailor-made to complement the clean lines of contemporary fashion. His styles were low maintenance, and relied on the skill of the cut and the natural characteristics of the hair, not lacquers, to stay in place.

As early as 1963, his classic bob was popular, helped by the regular appearances in the press of Mary Quant, sporting the hallmark fringe. Asked to create a new style for his catwalk shows by Emanuel Ungaro, he introduced an asymmetrical version which was soon widely copied.

'My philosophy when working with designers was that I create the hair and they create the clothes; Ungaro wouldn't let me have an input into the clothes so I wouldn't let him have an input into the hair. It was totally my creation,' he commented.

By the end of the decade he had salons worldwide and a multimillion pound business, reportedly being paid $5,000 to style Mia Farrow's hair for the film *Rosemary's Baby*.

Although he no longer operates the business that bears his name, he is generally acknowledged as the most influential hairdresser of the twentieth century.

Headline Haircuts

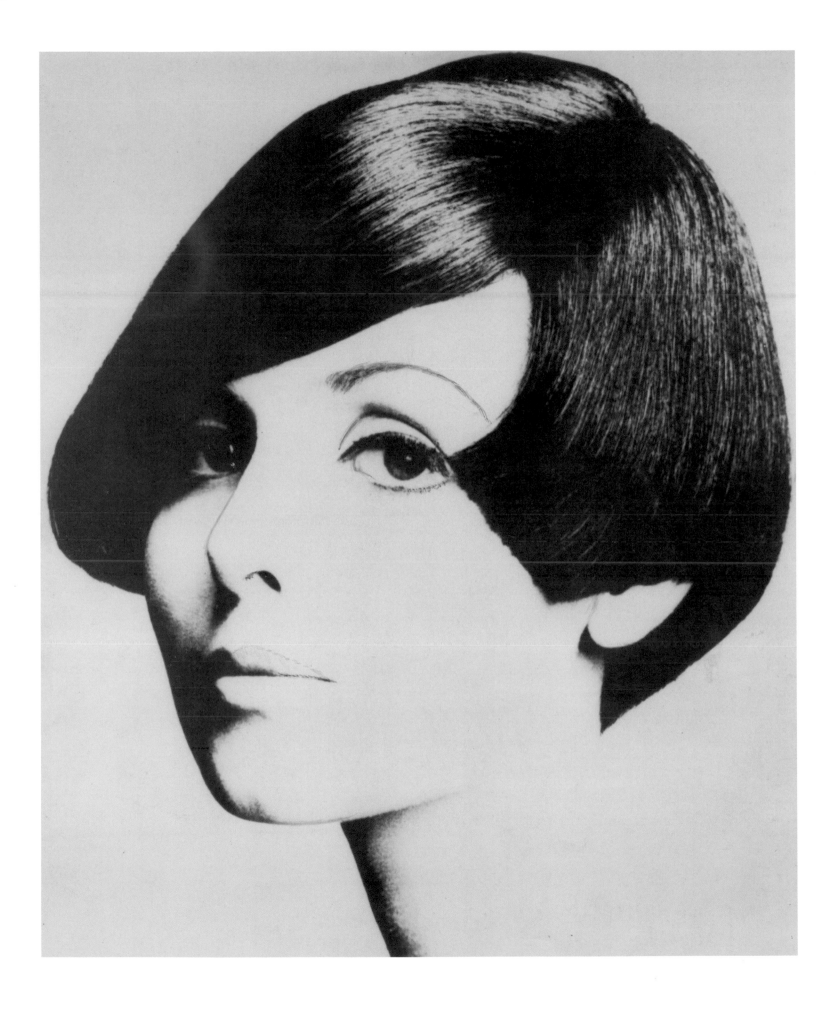

Published 12 September 1965
Photographer Murray Irving
Model Jean Muir
Fashion Jean Muir coat dress for
Butterick Patterns
Original journalist Ernestine Carter

'A fawn in the Fashion Forest' was Ernestine Carter's description of Jean Muir (1928-1995). Mirroring the success of Mary Quant, she modelled her own design (number H3707) for Butterick Patterns.

Miss Muir's career started as a stockroom assistant at Liberty of Regent Street, and via St Martin's School of Art, Jacqmar and Jaeger, she opened Jane & Jane in 1961 and Jean Muir Ltd five years later.

She preferred the term 'dressmaker' to designer, and it was not until the late 1960s that she established an instantly recognised style, mastering the tailoring of fluid fabrics, particularly jersey and wool crêpe.

Her business was typical of those of a small number of British designers who created the foundations of their firms in the early sixties, and whose success ran into the next decade and beyond. Like Mary Quant, she had accurately assessed her marketplace and had an individual look with which she could trade worldwide. She operated at several different price levels, with her keynote look of restrained elegance applied to each and admired by stars of stage and screen alike, including her most famous house model, Joanna Lumley.

The Fashion Forest

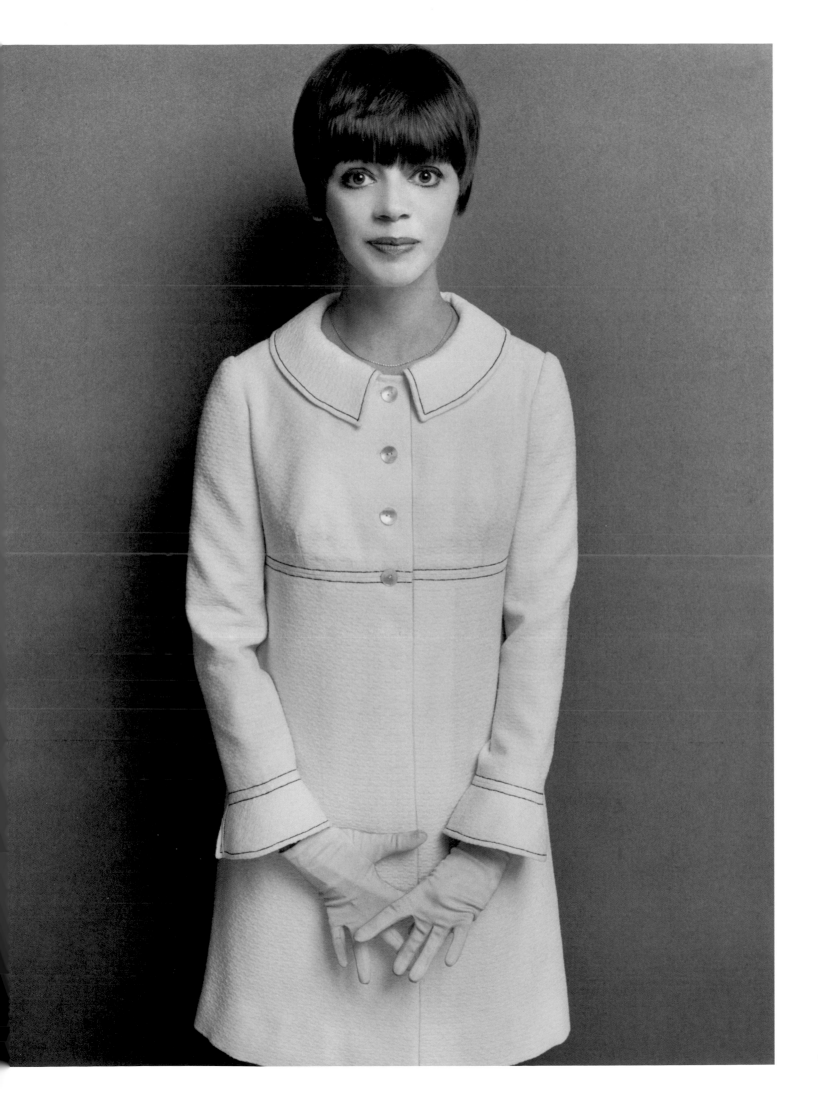

66

Published 17 April 1966
Photographer Norman Eales at *Vogue*
Studio
Fashion Coordinating tweed suits
by Maurice Attwood for Reldan-Digby
Morton
Original journalist Ernestine Carter

Maurice Attwood began his career in the workrooms of couturier Digby Morton before going on to work for a number of other fashion houses. He came full circle in 1966, rejoining his former employer in his new venture, Reldan-Digby Morton.

With a remit to nurture new talent, the firm's annual award for design excellence ensured that a steady stream of young designers contributed to a thriving business. Digby Morton was already well established in America, exploiting a market that was still conservative compared to that in Britain, but which offered huge potential. Maurice Attwood had already sold a complete collection to American giant Montgomery Ward by the time he was invited to rejoin Reldan. Like fellow award winner Roger Nelson, he was recruited as established firms realised that younger designers were the key to future success.

Reldan-Digby Morton was particularly successful in the middle market, where high quality ready-to-wear clothes were still the exception. From their factory in High Wycombe they exported bold designs, such as these coordinating tweed suits, across the globe.

The Attwood
Concern

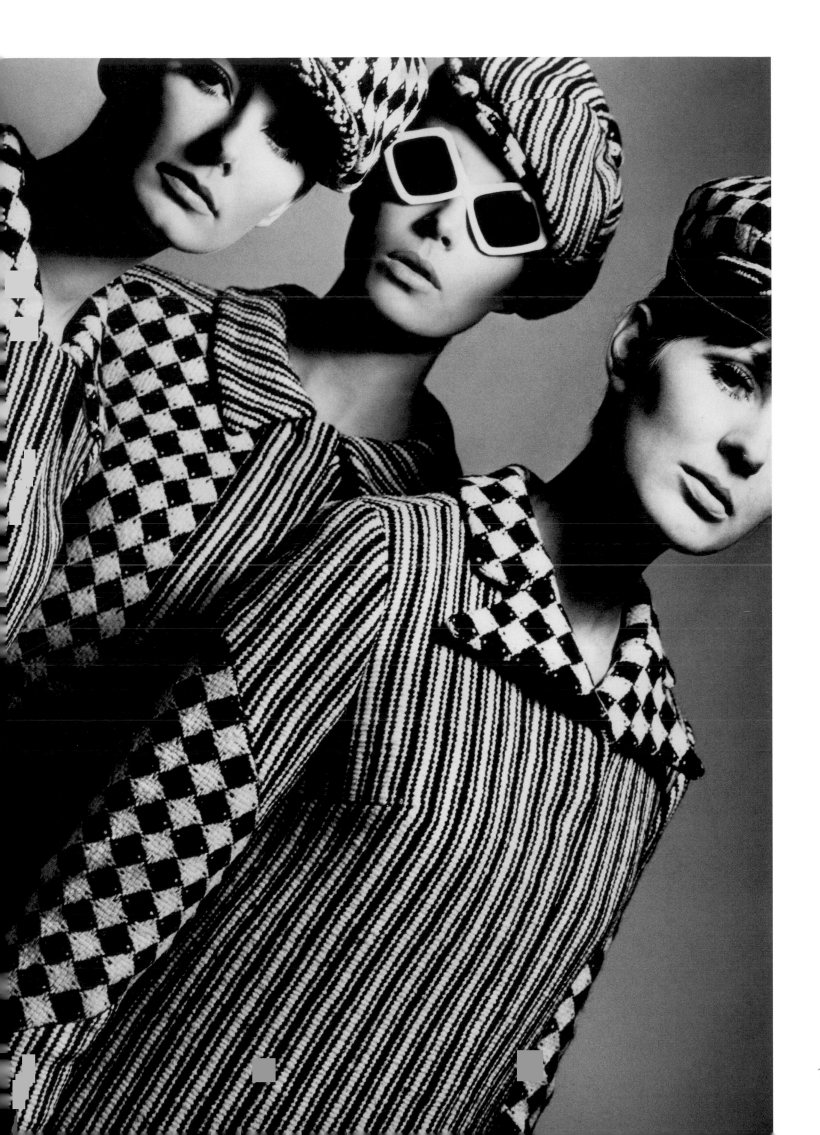

Published 29 May 1966
Photographer Norman Eales
Fashion PVC coat and dress by
V de V for Young Jaeger
Original journalist Ernestine Carter

Founded by Doris Langley Moore, the Fashion Museum in Bath had begun a 'Dress of the Year' award in 1963.

The first had gone to Mary Quant, and each subsequent spring a leading fashion journalist was invited to choose a dress or outfit that they felt had made the greatest impact on design over the previous twelve months. This was then added to the museum's collection, together with a new mannequin by Adel Rootstein.

Ernestine Carter's choice for 1966 was surprisingly avant-garde, and combined elements from a variety of designers. From V de V for Jaeger came a transparent coat and PVC dress, 'clearly' (Mrs Carter surmised) influenced by the use of plastics in mainstream design by Courrèges and John Bates.

PVC boots were by Elliott, the visor-like hat by Simone Mirman. To complete the ensemble: *Avengers* tights by Jean Varon, retailing at 9s. 1d. a pair.

Dress of the Year

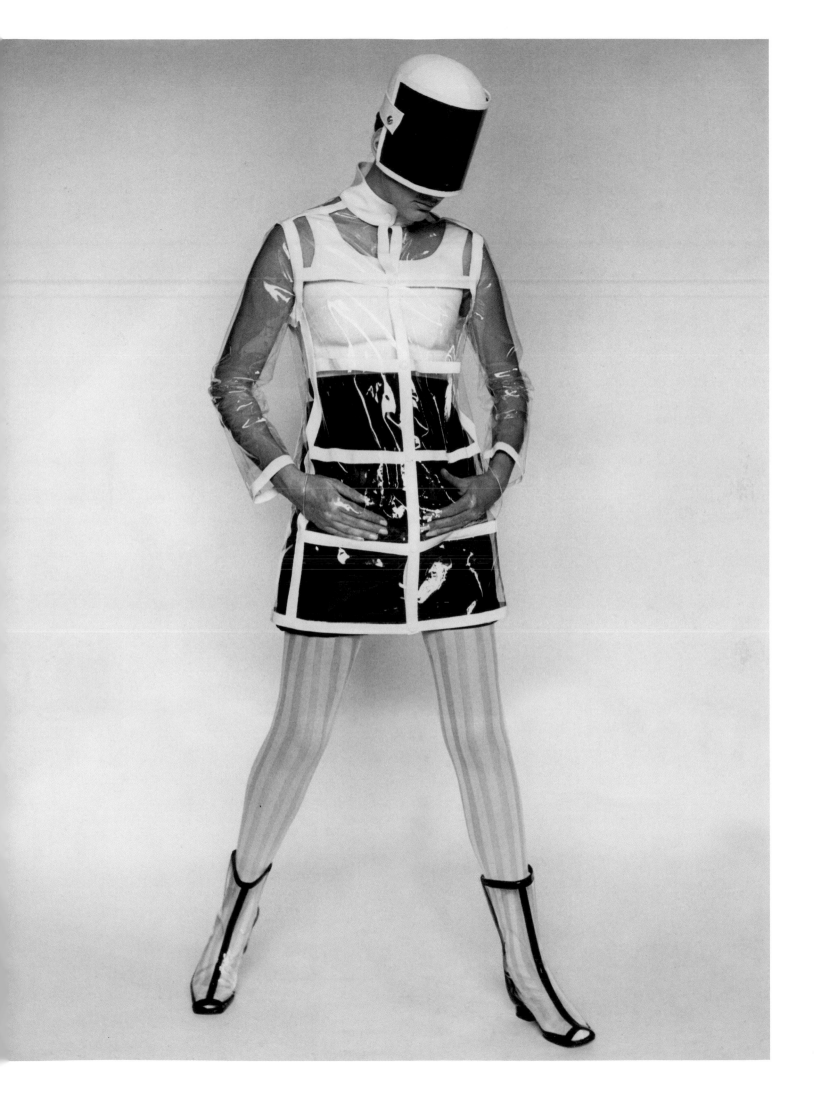

Published 29 May 1966
Fashion Sundresses by Nettie Vogues,
Estrava and Marguerite Arundel
Original journalist Brigid Keenan

Sundresses had previously been the preserve of children, but a clutch of British designers offered 'fun in the sun' versions for all in summer 1966. 'Not suitable for wearing out in town by themselves, but perfect for lounging on the terrace,' argued Brigid Keenan.

As a precursor to the shortest minidresses about to hit the mainstream, sun dresses predicted the backless dress and the shortest shifts, using simple fabrics, often printed cottons or towelling.

Among them was Nettie Vogues' strappy sundress, worn with beads by Margaret Percy, from boutique Top Gear. One of the most enduring ready-to-wear manufacturers, Nettie Vogues, like Polly Peck, had been founded in the immediate post-war years and continued into the 1980s, selling well-made fashion and specialising in cocktail and evening wear.

Designed for the Sun

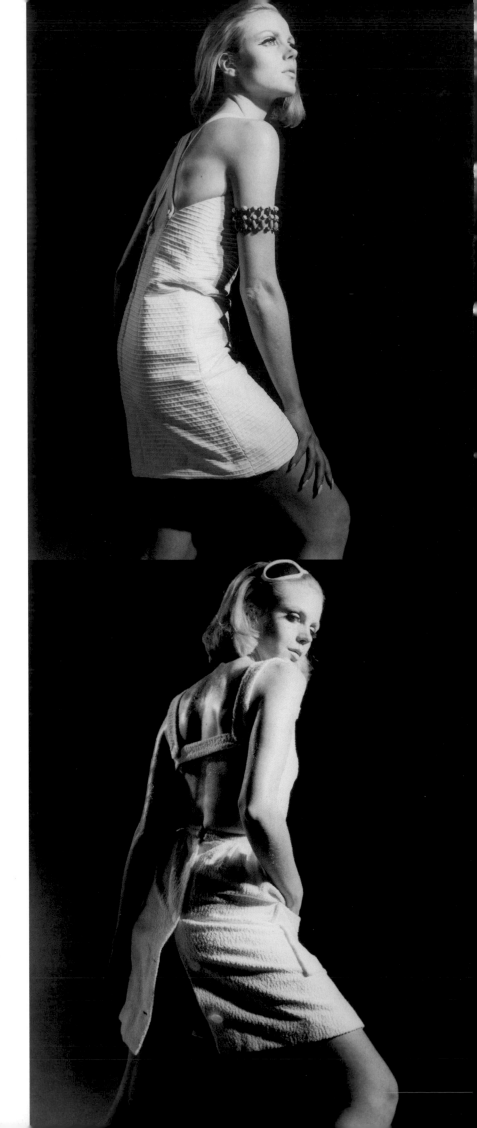

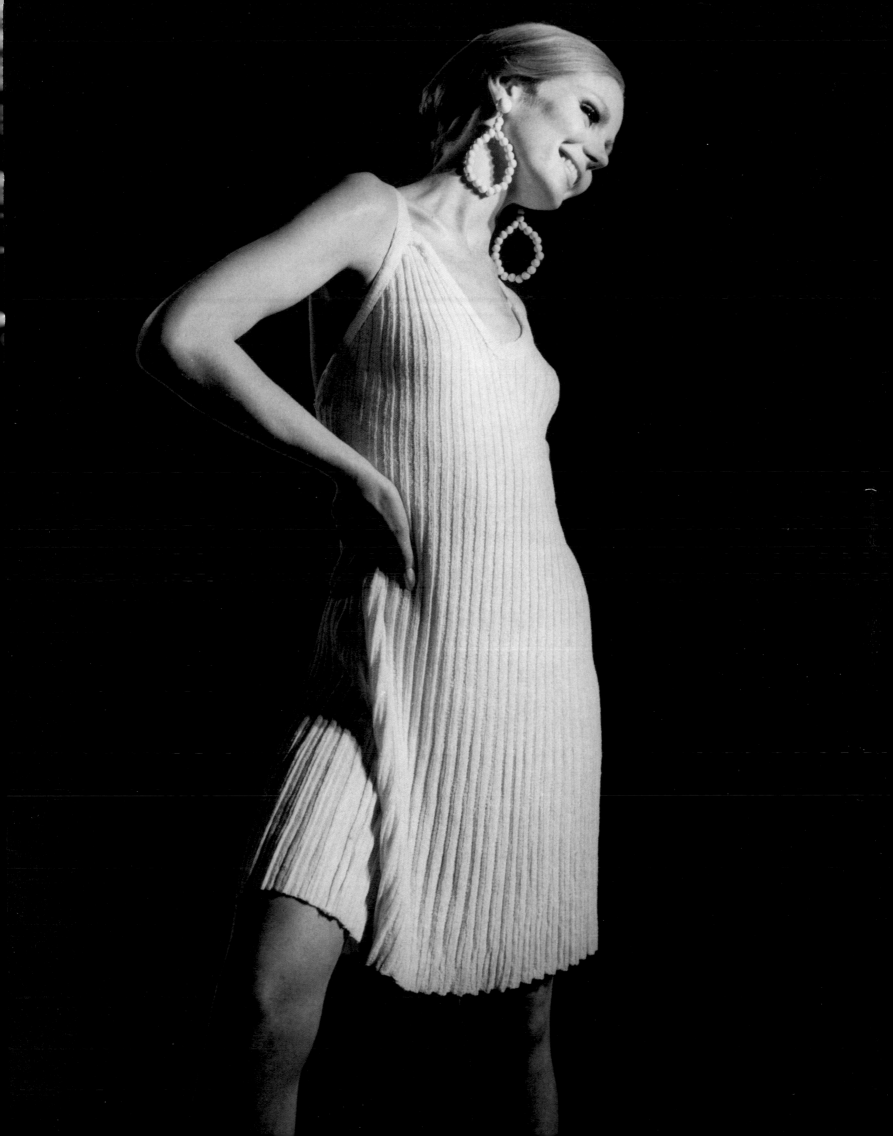

Published 12 June 1966
Photographer Norman Eales
Fashion Cheetah and Zebra print
raincoats by Christian Dior, London
Original journalist Ernestine Carter

With the model girls divided by a sheet of ICI Perspex, Norman Eales worked his magic on two striking animal print PVC raincoats from Christian Dior's ready-to-wear collection, both designed in London.

Like other great Parisian couture houses, Dior was such an established global business that by the early 1960s it no longer became practical to have the hundreds of seasonal ready-to-wear designs produced solely by Mark Bohan and his assistants in Paris.

Hiring a number of designers in both London and New York enabled the brand to operate independently in each country, with the couture boutiques still catering for clients who wished to buy designs from the Paris collections, and the subsidiary company, Miss Dior, aimed at a younger audience.

Racing in
the Rain

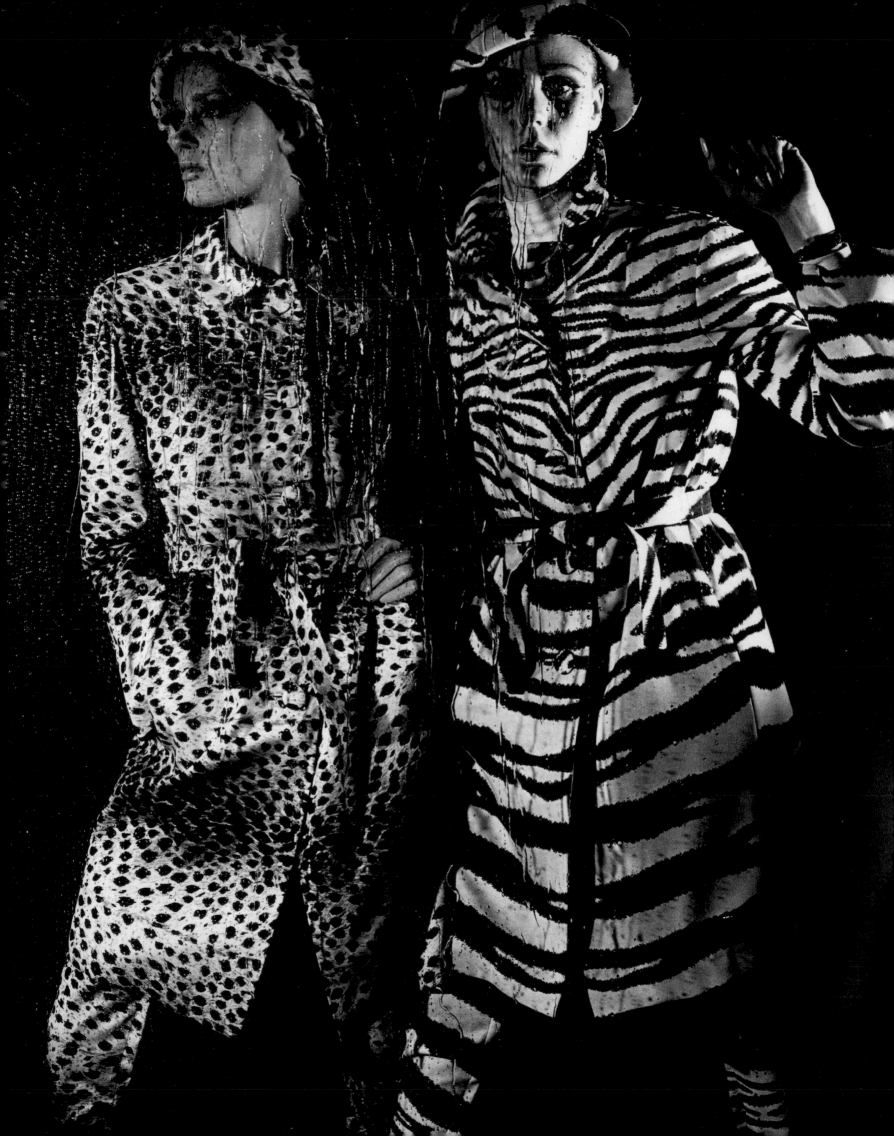

Published 19 June 1966
Photographer Norman Eales
Fashion Sleeveless summer dress
by the Tony Armstrong Boutique
Original journalist Ernestine Carter

For fourteen guineas, *Sunday Times* readers could tackle the London heatwave in a sleeveless summer shift dress from the Tony Armstrong Boutique. Like so many retailers of the time – springing up for a few years, or sometimes only months – no record of the boutique's location survives.

For the latter half of the decade Carnaby Street and the Kings Road formed two very different centres for the fashion trade. Carnaby Street started with menswear, dominated by John Stephen and his empire of shops, and later joined by a migration of smaller retailers such as I Was Lord Kitchener's Valet, Lord John, Take Six, and Gear. Loud, dark and sometimes chaotically run, their interiors often displayed eclectic Victoriana, then readily available in the street markets of Soho and Portobello. Womenswear followed, with names such Lady Jane, which opened for business in 1966.

The Kings Road shared the limelight, but because of its sheer length offered greater scope for seeing and being seen. Mary Quant's boutique Bazaar had opened ahead of the pack in 1955, and by the mid-1960s the closer to World's End fashion buyers travelled, the more exotic the boutiques became, with James Wedge's Top Gear and the psychedelic imagery of Granny Takes A Trip.

The Boutique Bonanza

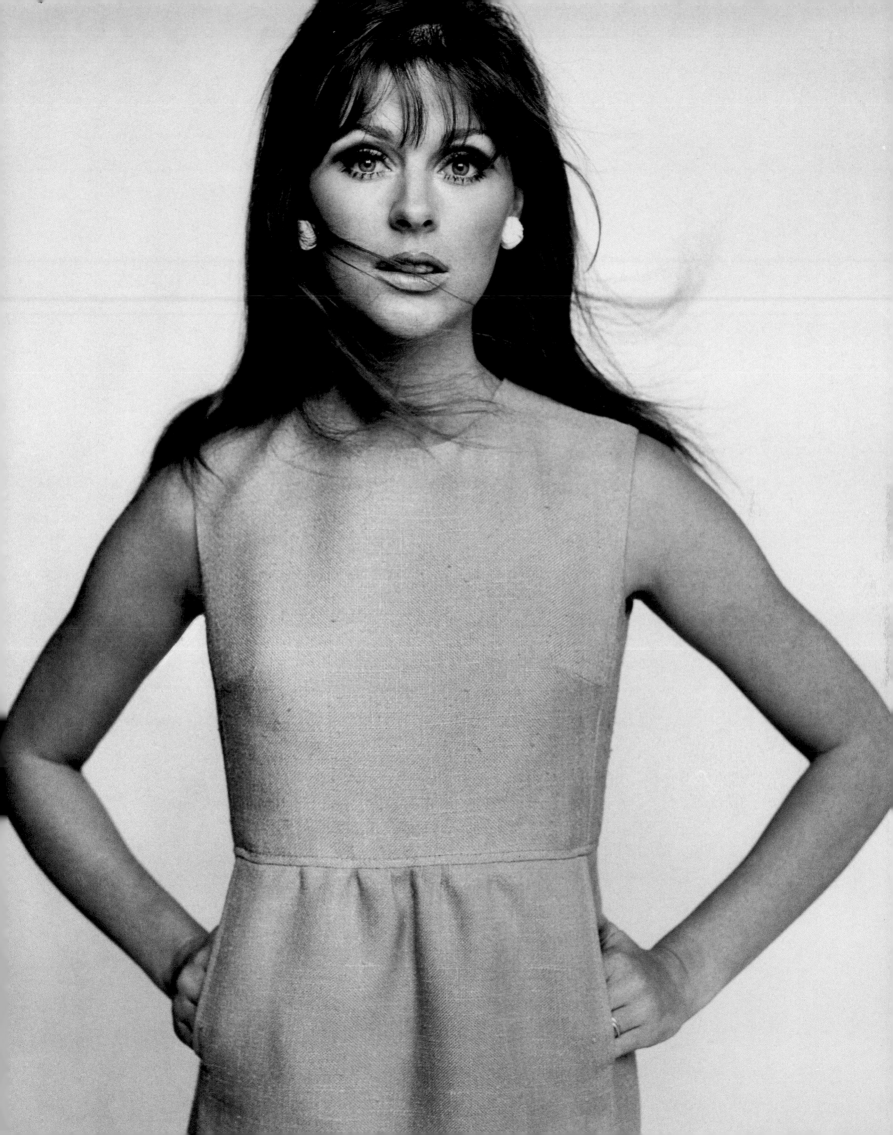

Published 2 October 1966
Photographers Studio Five
Model Jill Kennington
Original journalist Ernestine Carter

Run by photographer John Cole, Studio Five acted as a clearing house for some of the greatest names in British fashion photography, including Norman Eales and Terence Donovan, and was based in Shepherd Market in Mayfair.

Long before the days of digital manipulation of images, such studios were hives of activity, as editors such as Ernestine Carter routinely expected to receive a selection of prints to choose from – for each and every story.

Many employed technicians to touch-up their prints full-time. In this unattributed shot of Jill Kennington from Studio Five, the left-hand image was painstakingly cut from another print, overlaid on the right and then mounted on an artist's board. The vertical join was then overpainted, and by the time the image was printed in 'Mainly for Women' the alterations were undetectable.

The restrictions of newsprint meant that tonal differences were often hard to define; the same touch-up techniques were therefore applied to areas of high and low contrast, which were emphasised by overpainting or bordering. The fact that their images would often be cropped, reversed and adapted did not affect the quality of the work from the photographers used by the *Sunday Times*. Almost without exception, they represent the best that could have been produced at that time, both artistically and technically.

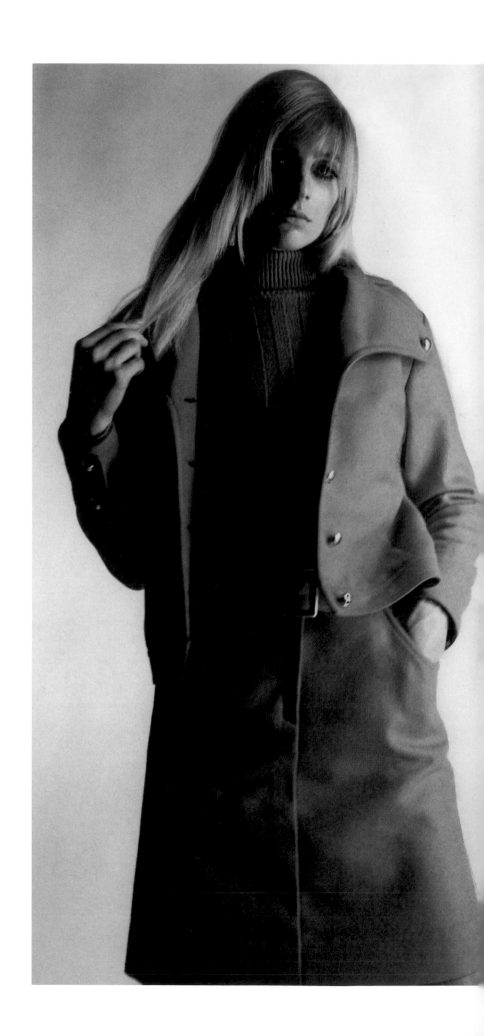

The Genius of Studio Five

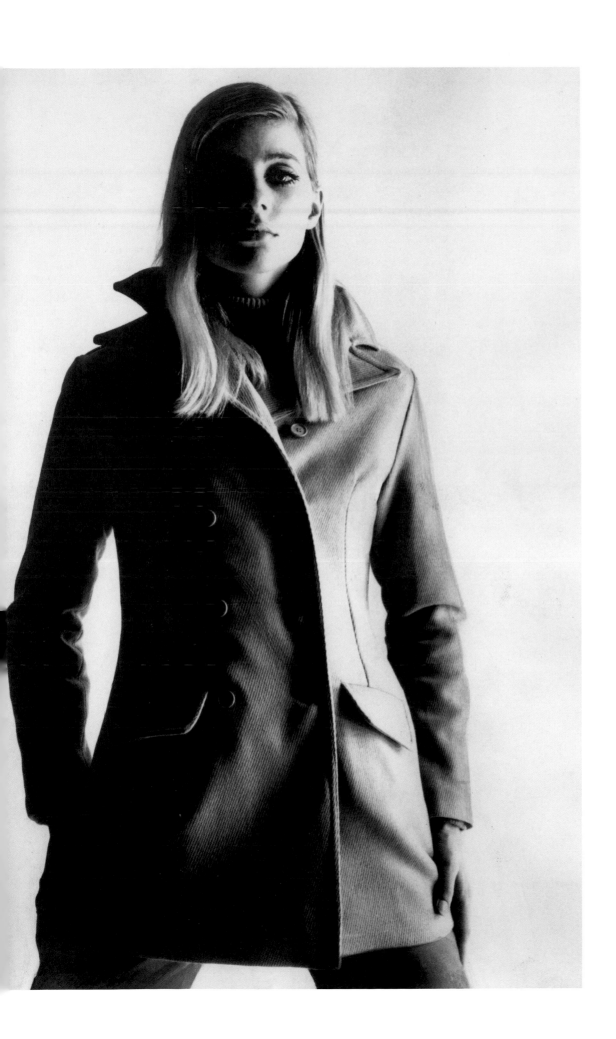

Published 23 October 1966
Photographer Terence Donovan
Model Twiggy
Fashion Turquoise moiré shorts and
waistcoat by Mary Quant
Original journalist Ernestine Carter

As British Export Week opened in Lyon, the Export Council for Europe extolled the virtues of British fashion and helped to make sure that it was available in boutiques across Europe. In a tribute to what had already been achieved, *Elle* magazine printed twelve pages of the best designs, photographed by the best photographers – in this case, Terence Donovan. Ernestine Carter was always ready to support British designers abroad and selected four of the pictures for her readers to admire in 'Mainly for Women'.

Fashion had moved so far in such a short period of time, yet it was not until the arrival of Twiggy (Leslie Lawson, née Hornby, b.1949) that modelling caught up. The new, shorter, sharper styles meant that even model girls in their mid twenties began to look too old.

Aged seventeen when this image was taken, Twiggy's beauty was unlike anything that had been previously accepted as an ideal, and perhaps because of this her rise to stardom was rapid. In the space of five years she was to dominate the modelling world, launch her own range of boutique clothing, act, and record a hit record. Even Mattel issued a Twiggy doll, specially slimmed down at the bust and hips. She remains one of the world's most recognisable faces and continues to model,

Entente Cordiale

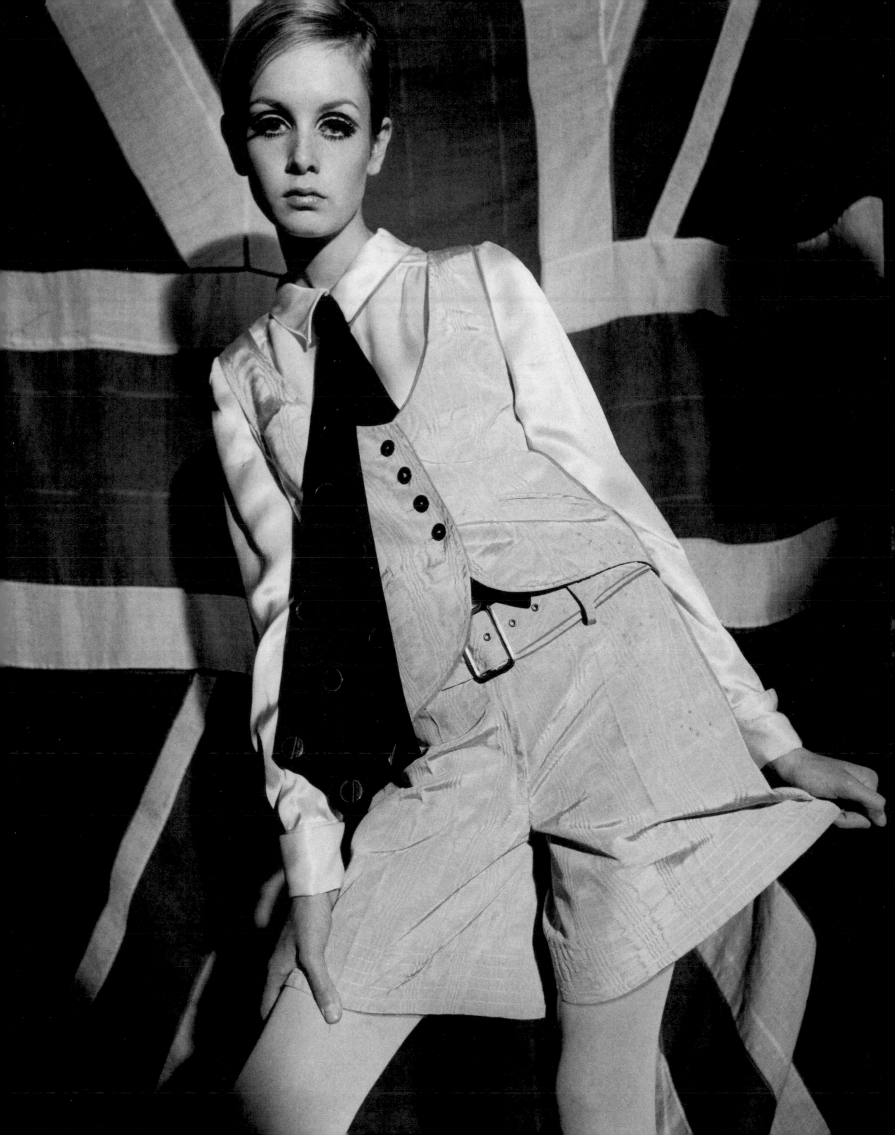

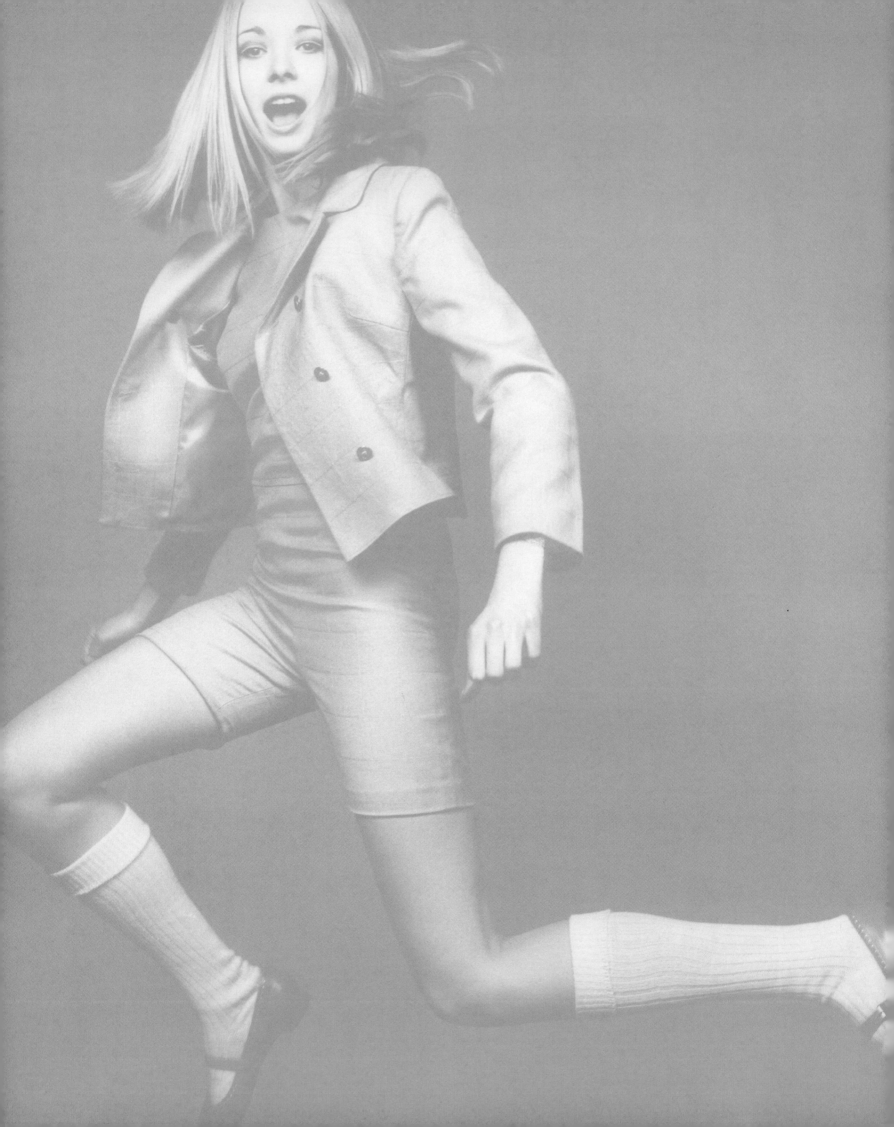

67

Published 22 January 1967
Photographer John Timbers
Models India Jane Birley and Rebecca Saunders
Fashion Children's fashion by Daniel Hechter at Woollands
Original journalist Ernestine Carter

To model the latest in children's fashion from Parisian designer Daniel Hechter at Woollands, Ernestine Carter recruited India Jane Birley, daughter of Lady Annabel (later Goldsmith) and Rebecca Saunders (daughter of model Caroline), noting that neither appeared particularly thrilled at the opportunity.

In a reversal of the status quo, parents were now beginning to dress their children in miniature versions of the latest trends, which ironically included the popular shift dresses for adults aiming to get the 'little girl look' so effectively promoted by models such as Twiggy. Adults had raided the nursery too, with patterned tights, T-bar sandals and smock dresses all the rage.

Several international ready-to-wear firms had already added children's clothing to their collections, and Woolands in Knightsbridge stocked some of the best, encouraged by the success of their bang-up-to-date Woollands 21 shop.

Junior Style Comes of Age

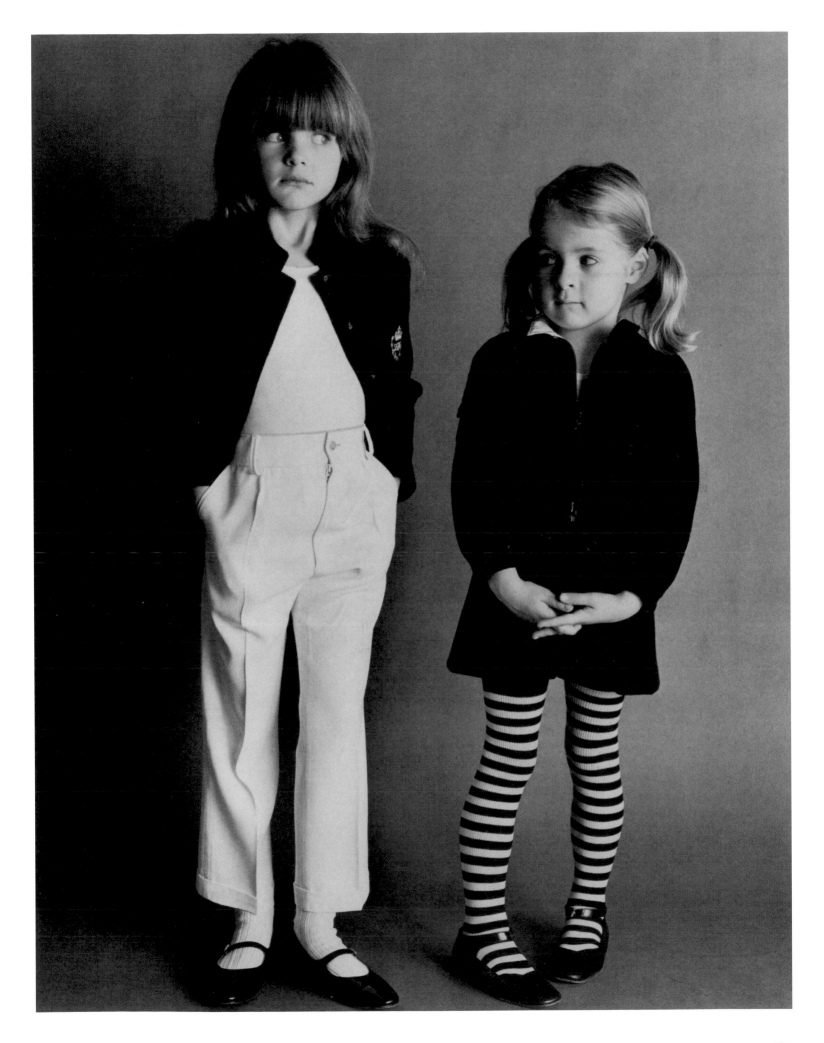

Published 26 February 1967
Photographer Patrick Hunt
Fashion Tailored suits for women in
Dormeuil wool. Shoes by Roger Vivier
Original journalist Ernestine Carter

For autumn/winter 1967 Yves St Laurent had launched his legendary evening suit for women, 'Le Smoking', which simultaneously made masculine tailoring and trousers the latest thing, especially for evening.

Using Dormeuil pinstriped wool, Ernestine Carter recreated the look in London, even dressing a model in a man's suit as an alternative to buying a woman's version, 'shirted in white organdy', to finish.

A less masculine version was the trouser suit, increasingly popular in vivid prints or contrasting plain tones, worn with a fitted jacket or sleeveless tabard over a blouse, often with wide trousers, to mimic the cut of 1940s suits.

Practically, however, it would be some years before universal acceptance, with some hotels, restaurants and racecourses refusing entry to anyone wearing them.

Suits for the Girls

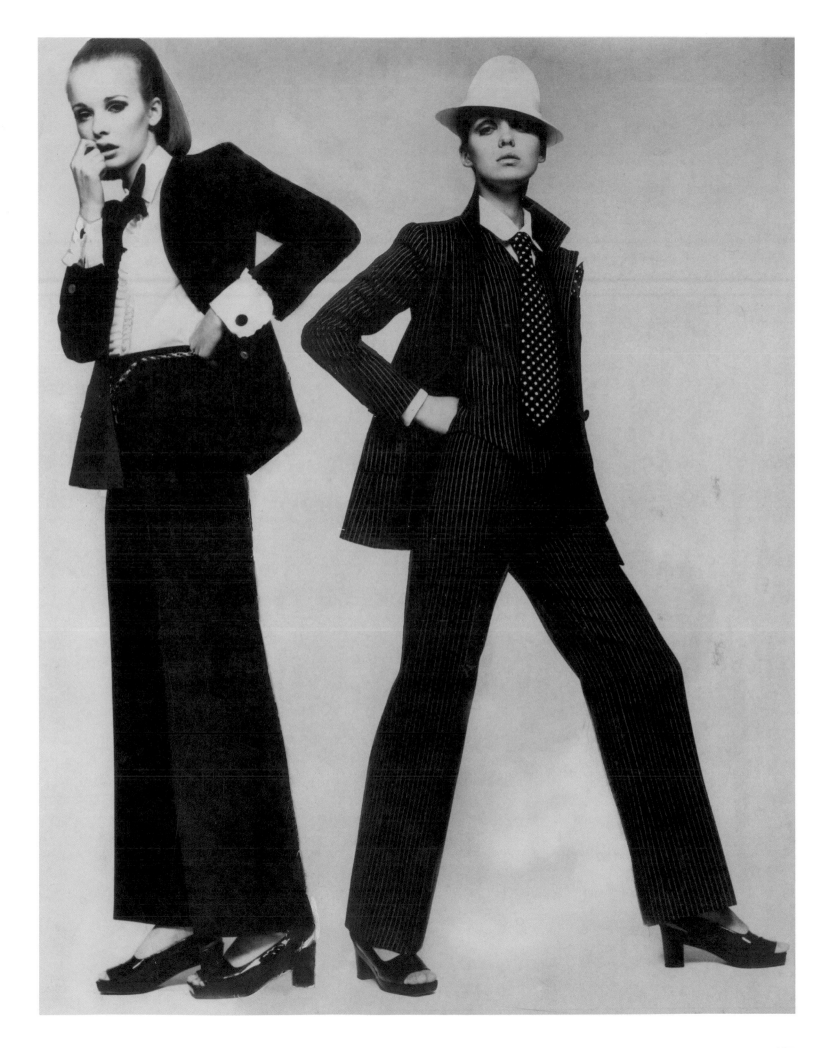

Published 19 March 1967
Photographer Patrick Hunt
Fashion All in durable paper. Trouser
suit by Mary Quant for Bazaar. Shoes
by Moya Bowler. Chair by Liberty.
Overall at Marshall & Snelgrove
Original journalists Elizabeth Good
and Brigid Keenan

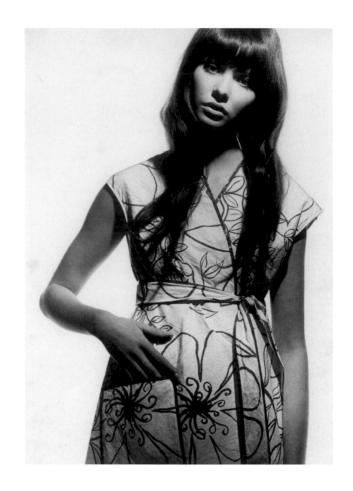

Elizabeth Good and Brigid Keenan scoured London's fashionable stores in March 1967 to bring together goods in homage to paper. What they discovered was remarkable.

From Mary Quant came a brightly printed pant suit costing six and a half guineas, which was even washable, worn with her paper earrings. To finish, square toed paper shoes from Moya Bowler. At Marshall & Snelgrove they discovered a practical paper overall with outsize floral print in red.

Even furniture was made from paper. When Liberty received a large order from Ungaro for their floral paper chairs to furnish his couture showrooms, the world descended on the store and wanted them too.

Life expectancy for each chair was around eighteen months, depending on usage, and they could be made up in a large range of signature Liberty prints.

Thoughts
on Paper

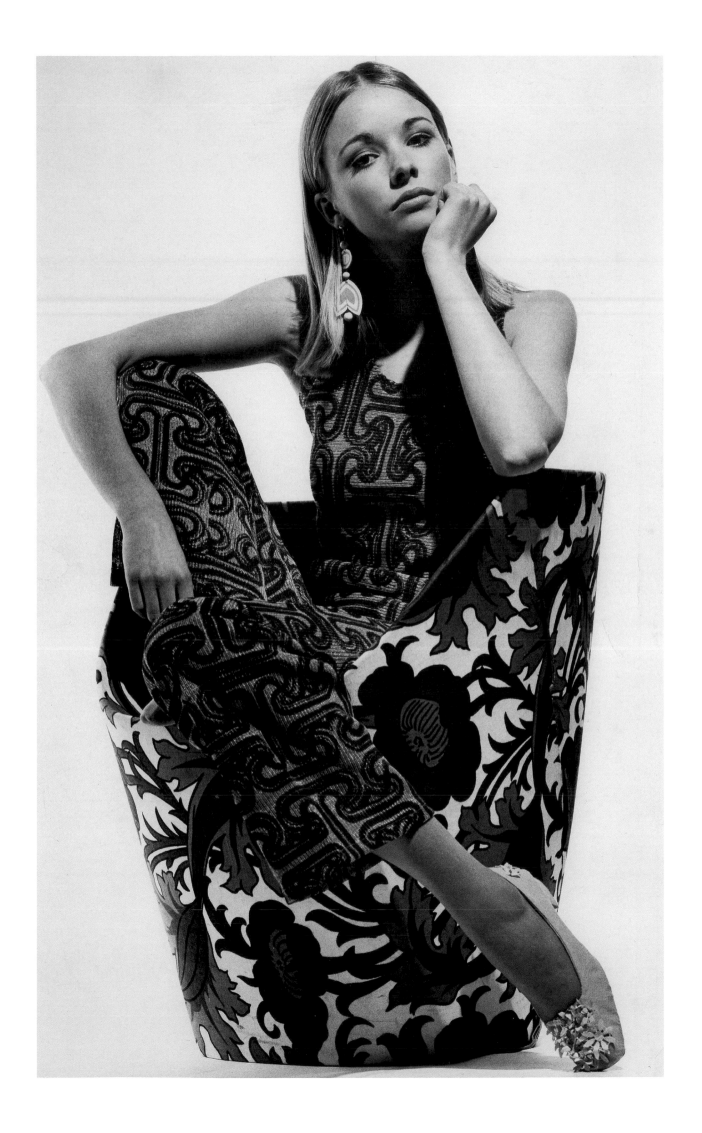

Published 19 March 1967
Photographer Patrick Hunt
Fashion Short sports jacket and
shorts by Reldan at Harrods. Shoes
by Roger Nelson
Original journalist Ernestine Carter

Advertising agents loved fashion as a way of portraying a lifestyle choice, and ultimately, their product. Fashion designers loved advertising agents for exactly the same reasons.

Just as Audrey Hepburn promoted the designs of Hubert de Givenchy simply by being seen wearing them, sponsorship deals or a specially designed collection could work just as effectively for the more mundane products advertised in newsprint.

Jean Varon designed a range of evening dresses in association with Havana cigars, and here, to promote AMF Bowling Lanes, Reldan designed just the sort of sporty outfit suited to playing the game, available exclusively from Harrods.

Designers found that they were increasingly the stars in a scenario which was eventually to lead to the myriad of diffusion collections familiar today. Hardy Amies designed menswear for Hepworths, Digby Morton for a host of firms based in America. Norman Hartnell, meanwhile, licensed middle market fashions to be produced under his name in Australia.

In Praise of Promotion

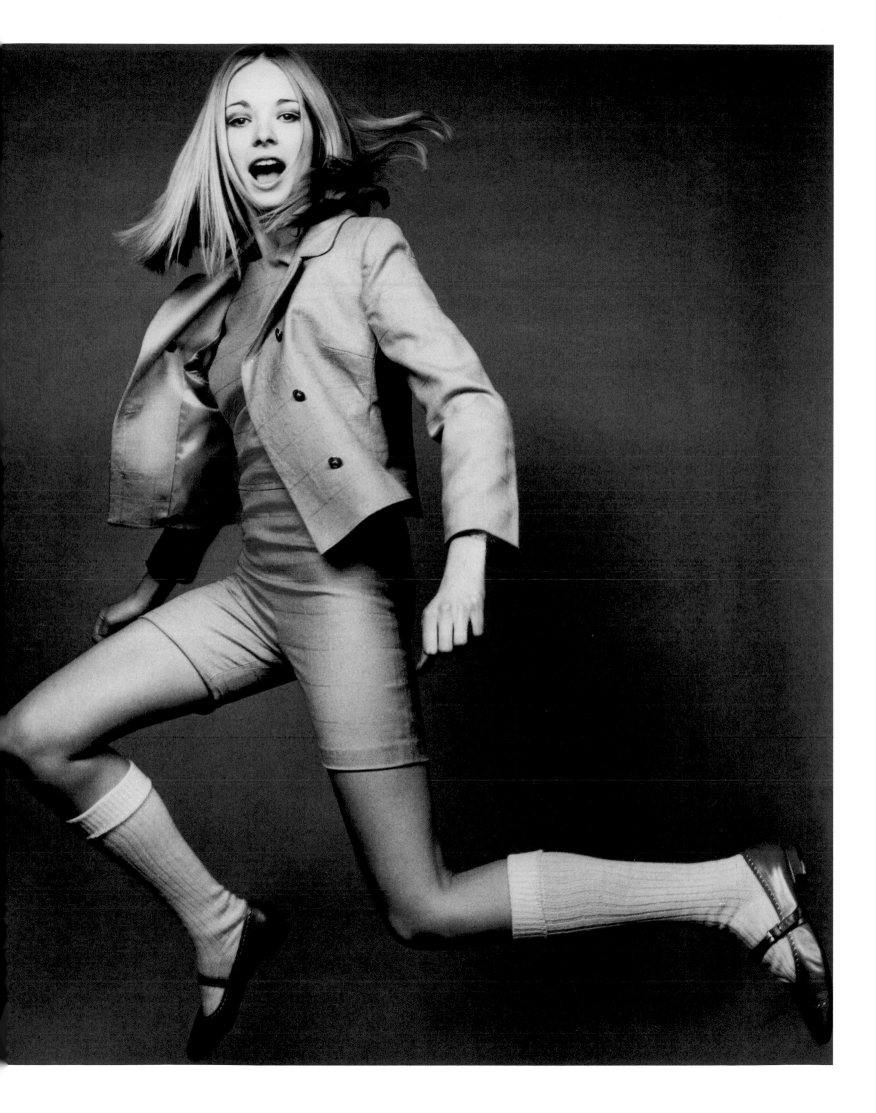

Published 19 March 1967
Photographer John Carter
Fashion 'Gangster' suit by Wallis Shops.
White trimmed shift dress with wide
cravat by Dorville
Original journalist Ernestine Carter

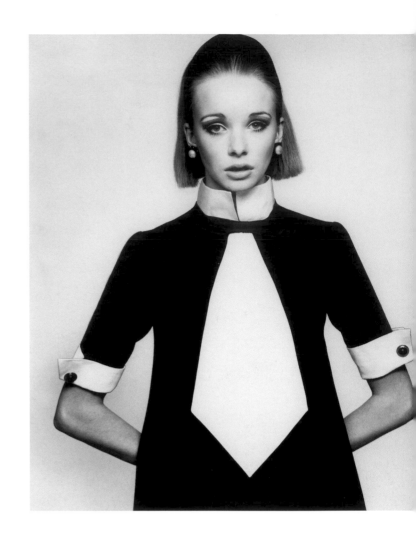

Wary of other editors' preoccupations with masculine suiting, Ernestine Carter did, however, credit Yves St Laurent with early signs of genius at Christian Dior, and again with his creation of 'Le Smoking'. As imitation was a good general gauge of influence, she quickly tracked down two St Laurent 'copies' from British ready-to-wear houses.

In St Laurent 'gangster' mode came a pinstriped three-piece suit from Wallis Shops, worn with shirt and tie and a checked, narrow-brimmed hat, '30s style.

Exaggerating and adapting the ubiquitous shirt and tie, Dorville produced their version in shantung silk, available form Fortnum & Mason.

Both British companies were particularly successful in the 1960s. Wallis Shops were retailers and manufacturers and actively recruited young talent. Their flagship store at Marble Arch was renowned for particularly well designed coats and suits, together with quality copies of Parisian designs. Dorville translated couture for the middle market, shadowing particularly Christian Dior, even in the design of their garment labels.

Fashion Fads and Fancy Dress

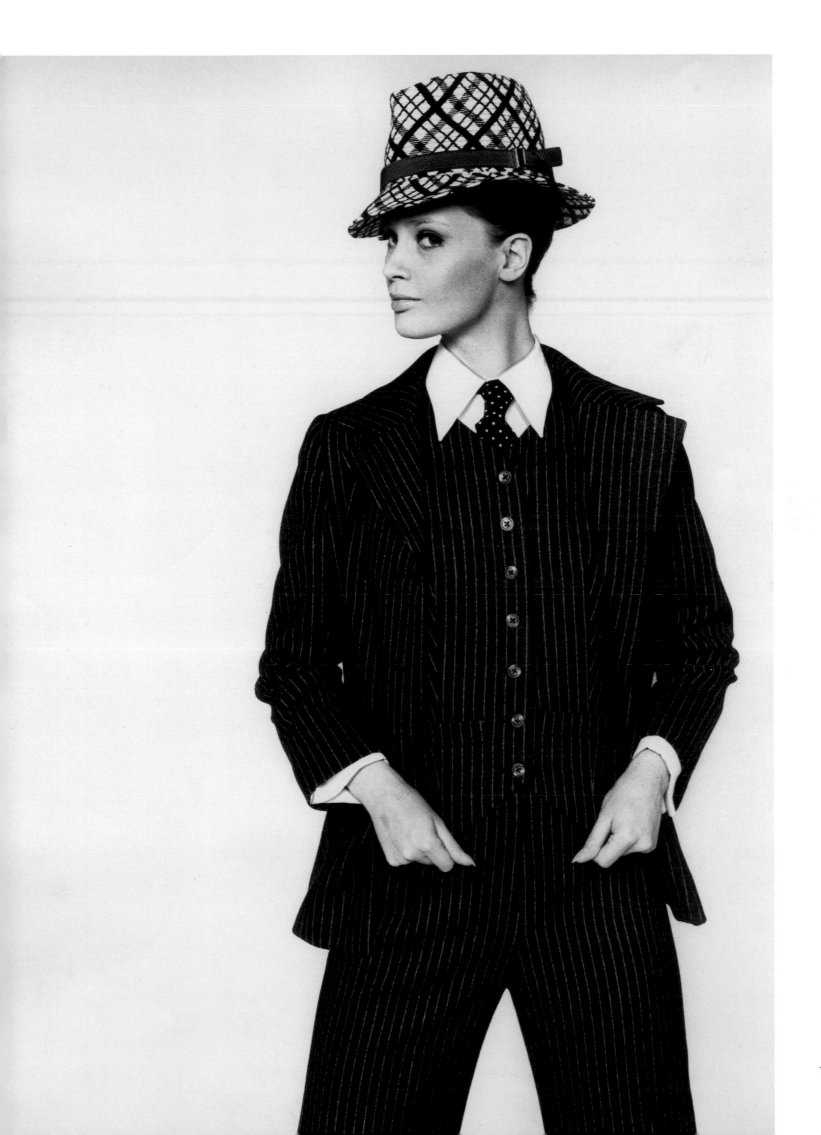

Published 23 April 1967
Photographer Gene Vernier
Fashion Exotic print party pyjamas
by Nettie Vogues
Original journalist Ernestine Carter

An American friend of Ernestine Carter had recently returned from a holiday in New York and wrote to her describing what she had seen on her social circuit: 'I needn't have taken evening dresses, everyone is wearing Party Pyjamas – get ready in London, they're on their way.'

More akin to wide trousered jumpsuits, party pyjamas looked like full-length evening dresses from a distance, but their wide, culotte-like legs added a sense of fun.

The model wearing Nettie Vogues' version was styled as a modern day Victorian doll, with ringletted hair by Ricki Burns at Vidal Sassoon and jewellery by Dickins and Jones. This nostalgic, feminine look was to translate into a full-scale historical revival by the end of the decade, as the hard edges and angular lines of high fashion became softened with broderie anglaise, lace and smocking on layered, diaphanous silhouettes.

Party Pyjamas

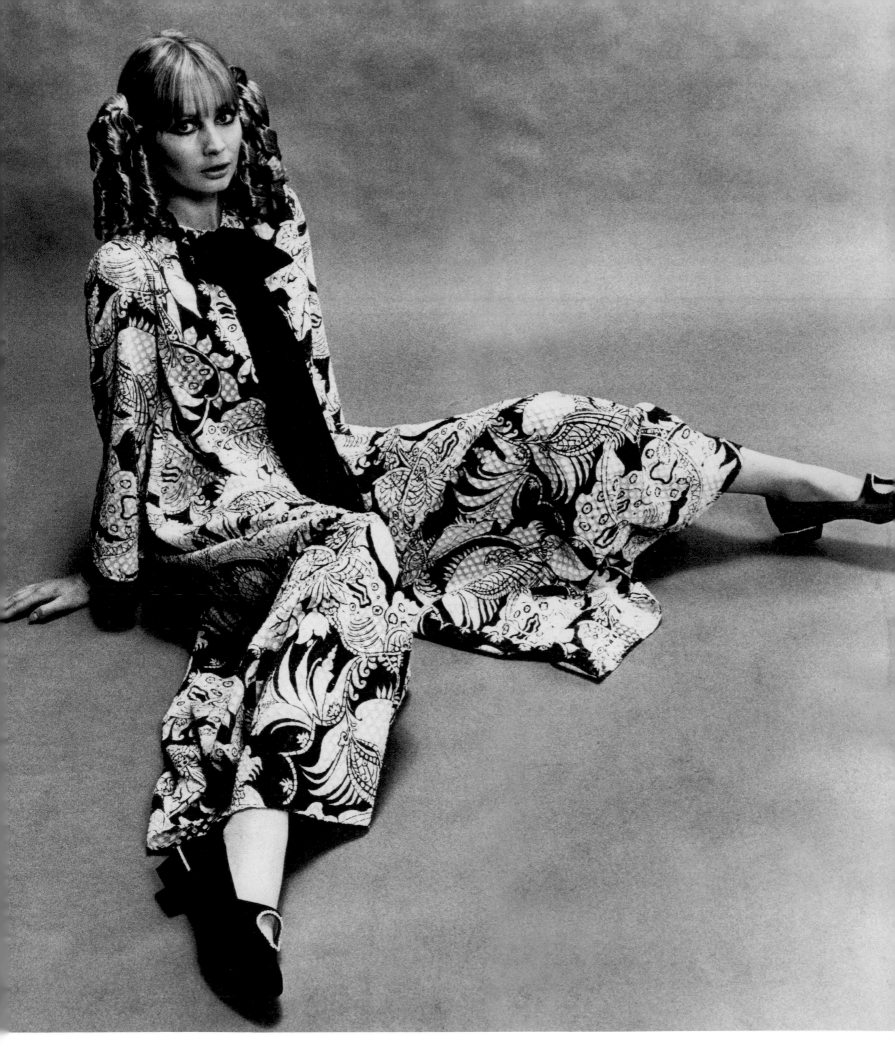

Published 23 April 1967
Photographer Neil Libbert
Model Sandie Shaw
Fashion Bold print minidress
by Bernshaw
Original journalist Brigid Keenan

The spotlight was firmly on Sandie Shaw after her hit, 'Puppet on a String', won the Eurovision Song Contest in April 1967, holding the number one spot in the British charts for the following thirteen weeks. Her approach to fashion was as refreshing and spontaneous as her performances, and she regularly shopped at middle market boutiques for interesting clothes to wear on stage.

Her trademark long bob was cut by 'my mate Linda who works at the Regent Palace Hotel', a faded Piccadilly institution that featured a hairdressing salon on the ground floor.

She was on her way to collect an award at the Lyceum Ballroom when she talked to Brigid Keenan, having 'just changed out of a Lee Cecil and into a Bernshaw print dress, both retailing at under £10'.

For anyone shopping on a budget, wholesalers such as Bernshaw meant that reasonably priced copies of high fashion were available countrywide. For designers, the wholesale firms were a familiar stalking horse of the industry, ruthlessly competing against each other to copy designs fastest and undercut each other on price.

Something to Sing About

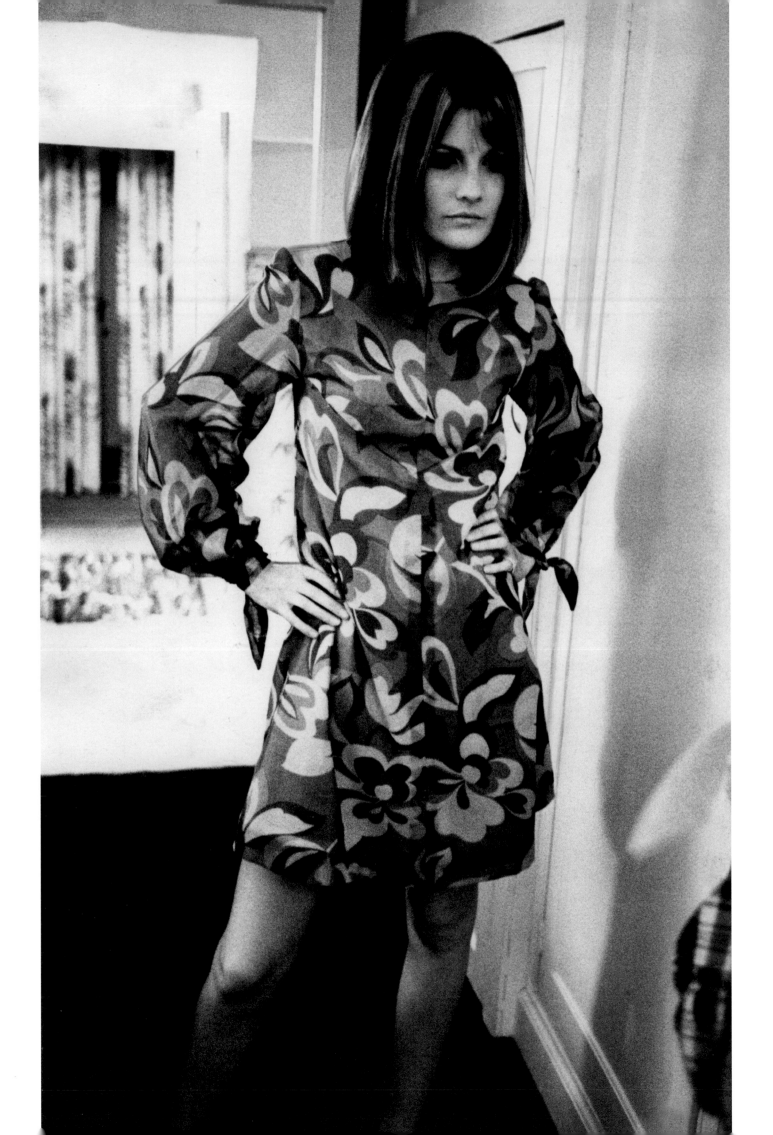

Published 30 April 1967
Photographer John Cook
Fashion Sleeveless summer dresses
by Foale and Tuffin
Original journalist Brigid Keenan

Aertex, invented in 1891, had been the stuff of underwear, school shirts and sportswear until the design team of Marion Foale (b.1939) and Sally Tuffin (b.1938) decided they would make a new collection of summer dresses in the fabric. From their studio in Marlborough Court, off Carnaby Street, they oversaw a two-woman fashion revolution, specialising in the bright, the bold and the short.

They had met at Walthamstow School of Art, and both had attended the fashion school at the Royal College of Art. By the early 1960s they had launched their fashion label, selling in their own shop and to some of the most fashionable boutiques in London. Along with a select group of other designers, their refreshing designs were championed by 'Young Ideas' in *Vogue,* which remained one of the foundations of subsequent successes. A prominent role in the 1965 'Youthquake' promotion in America brought yet more plaudits and by 1967 they had added costume designs for several films to their achievements.

Foale and Tuffin's partnership lasted into the following decade, before Sally Tuffin left to become a noted ceramicist, and Marion Foale a knitwear designer.

The Hazy Days
of Summer

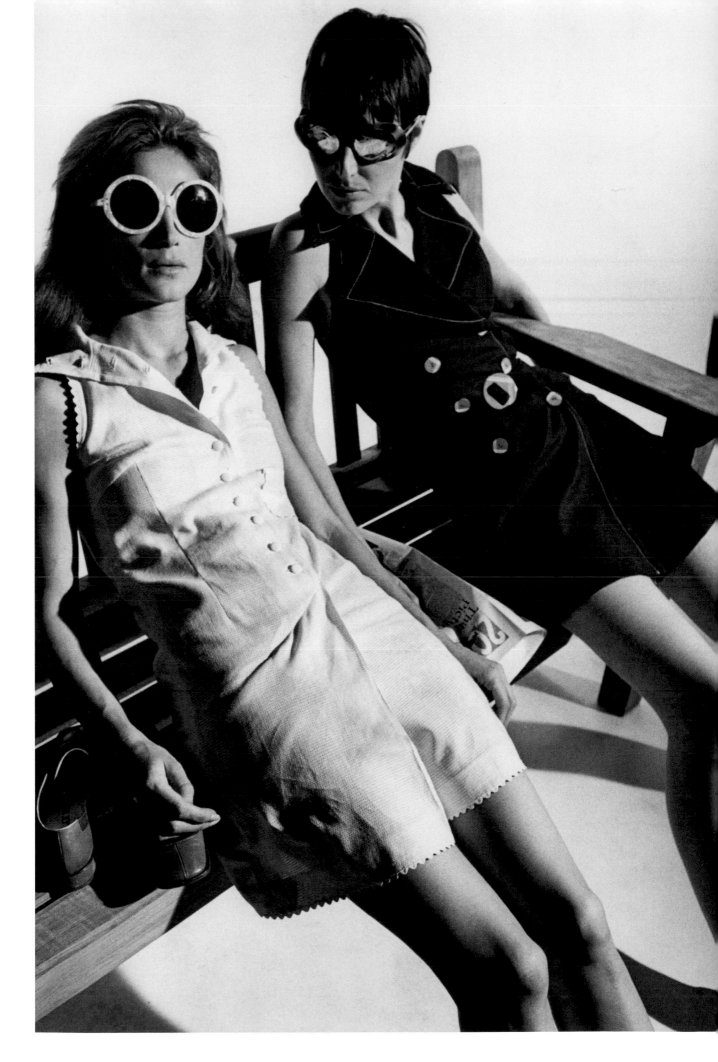

Published 14 May 1967
Photographer Patrick Hunt
Fashion Maternity dresses for all from
Fenwick of Bond Street and Jane & Jane
Original journalist Brigid Keenan

'Pregnant mothers have never had it so good,' argued
Brigid Keenan as she marvelled at the versatility of the
simple shift dresses available for summer, in plain or
printed cottons and cords.

Vogue's 'Young Ideas' editor Marit Allen was expecting
a baby at the time and commented: 'I haven't needed to
buy a single maternity dress, I just buy a current style
two sizes too big.' Another young mother on the hunt
for outsize fashion was Mary-Ann Marrian, who ran the
Marrian-McDonnell boutique on Sloane Avenue. 'I buy
all my maternity dresses from the normal stock of Biba
in High Street Kensington and Unique on the Kings Road,
it's so simple.'

The size eight models chosen to model here wear
maternity dresses by Fenwick and Jane & Jane, their
voluminous trapeze cut adding to the youthful fun of
the styles.

More Than
Just a Pretty
Dress

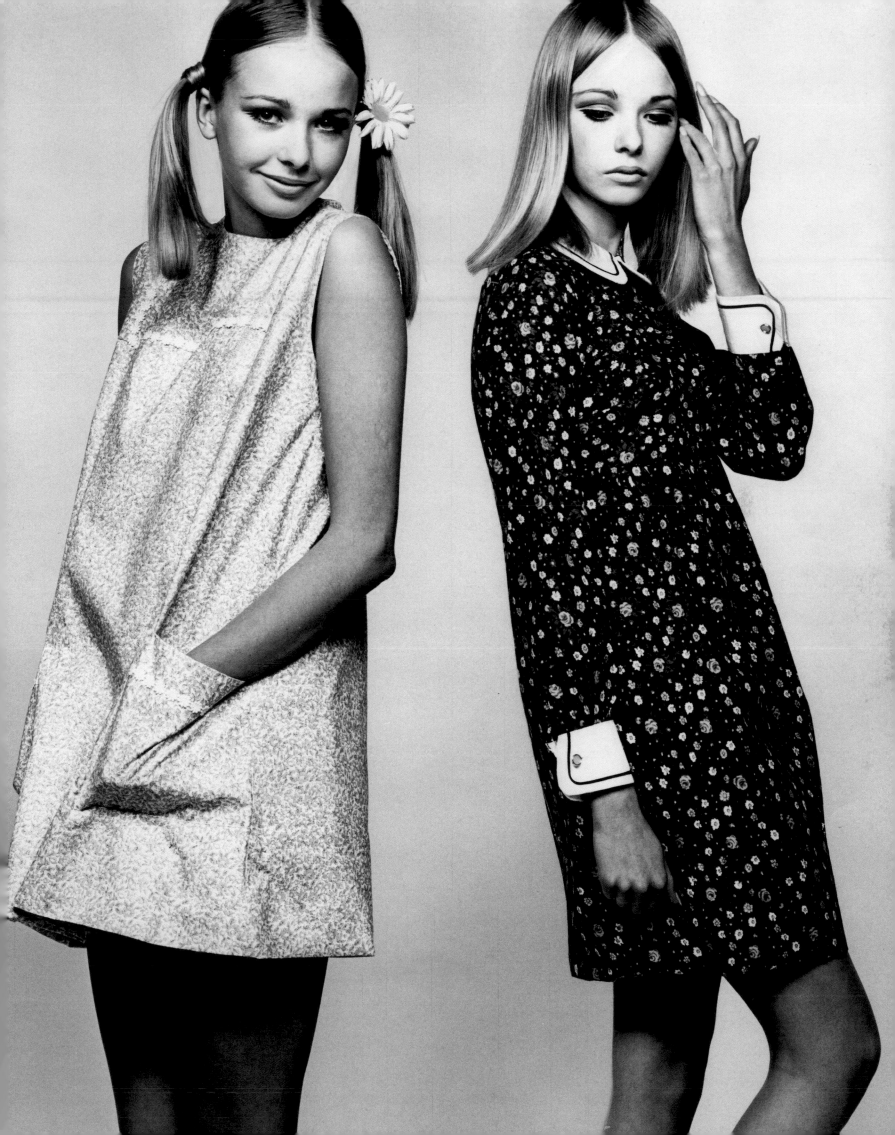

Published 25th June 1967
Photographer Patrick Hunt
Fashion Tennis dresses by Teddy Tinling
at Lillywhites
Original journalist Ernestine Carter

June meant Wimbledon, and Wimbledon meant tennis dresses from Teddy Tinling (1910-1990), their short and practical tailoring coincidentally completely in tune with mainstream fashion in the summer of 1967.

At one time the personal umpire of tennis star Suzanne Lenglen, Teddy Tinling had a brief career as a player before switching to sportswear design after the war. He continued to design well into the 1970s, and it was only after his death in 1990 that his career as a spy for British Intelligence during the war came to light.

Lillywhite's of Piccadilly Circus stocked a wide range of Tinling designs in white Dacron synthetic mix, and were finding that his tennis dresses were flying off the shelves. Founded in 1863, the store was so popular during the nineteenth century that it is widely credited with popularising cricket, tennis, badminton and croquet amongst Britain's middle classes. During World War II they supplied uniforms and equipment to British forces across the globe, receiving royal warrants from both King George VI and Queen Elizabeth in the early 1950s.

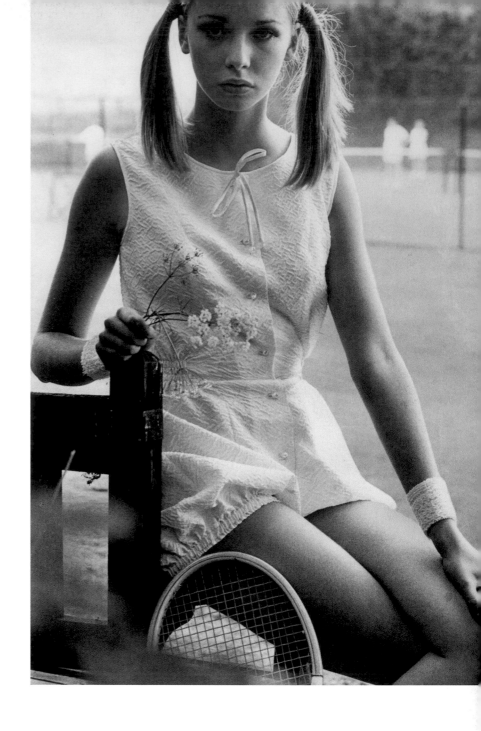

Game, Set and Match

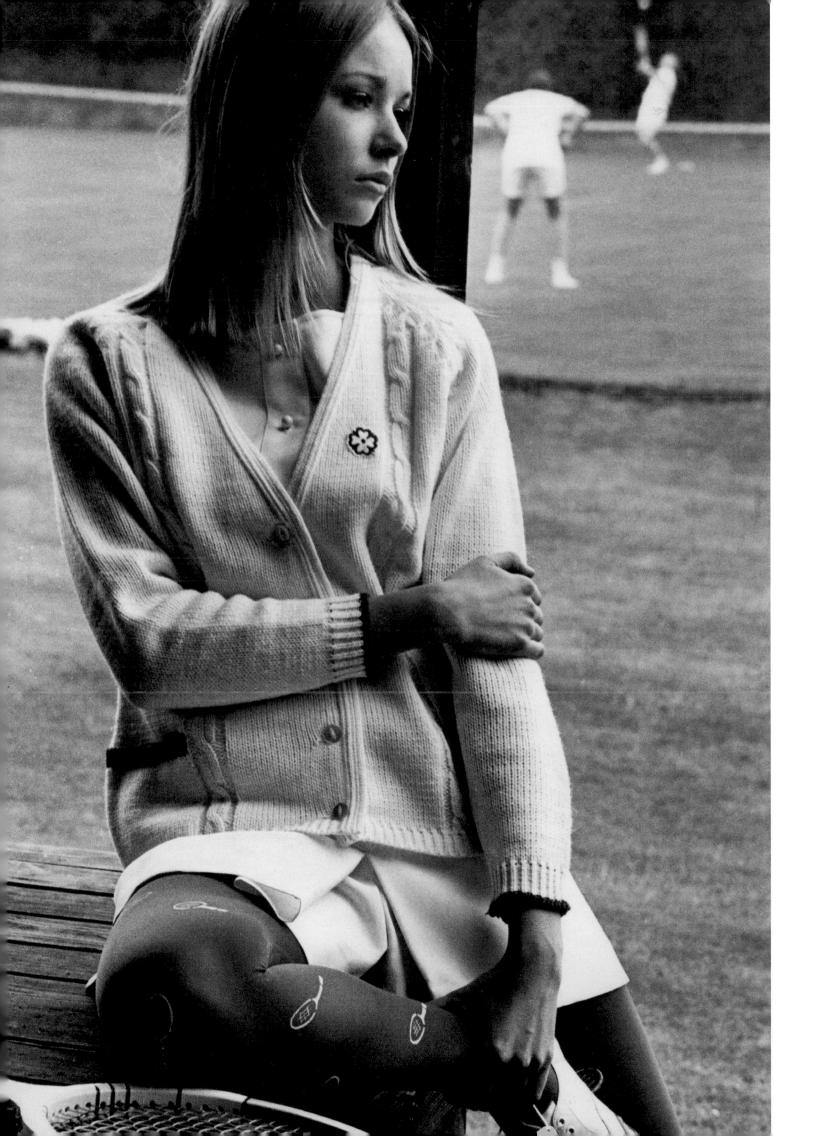

68

Published 7 January 1968
Models John and Denis Myers
Original journalist Harold Carlton

Twiggy and Jean Shrimpton had cut a swathe through the modelling world that was yet to be matched by male talent. The hottest contenders for fame were John and Denis Myers, twenty-one-year-old twins who reflected the new preferred male look. Gone was the lantern-jawed traditional thirty-something, replaced by Bohemian androgyny.

Male modelling itself became fashionable, with agencies besieged. Scotty's, one of the largest of the period, commented, 'We see 400 men a year and we might take on four'. Pay was relatively good, with an 'all round' model able to earn £2-3,000 a year. Scotty's 'top boys' earned thirty-eight guineas an hour, with the agency typically taking fifteen per cent. The real money was to be made from commercials, where a day's filming might net £40, but televised repeat fees might amount to £500.

Not everyone felt that the new fashion had lasting appeal. Peter Hope Lumley ran an exclusively female agency after having had male models on the books for a short time. 'Girls know at the back of their minds that they can always give up and get married. Men, unless they are training for something else, know they'll be finished one day, and it makes them very insecure.'

Michael Whittaker was always on the lookout for new male talent for his agency but steered clear of using Italian men 'They're too embarrassing – they've made ten dates in the audience by the time they reach the end of the runway'.

The First Male Supermodels

Published 7 January 1968
Photographer Bill King
Model Annabella Pearson Gee
Fashion Hair by Michael at Michaeljohn
Original journalist Ernestine Carter

The new face for 1968 belonged to Annabella Pearson Gee, who had been modelling for only a month but had already worked for *Queen, Harper's Bazaar* and *Vogue.*

Ernestine Carter credited both hairdresser Michael at Michaeljohn and photographer Bill King with creating a look of 'mystery and maturity', but at the time of the shoot Miss Pearson Gee was only eighteen, and lived at home with her mother and three brothers.

Norman Parkinson was credited with her discovery, made easier by the fact that they had known each other since she was a child. 'I was eight when he first photographed me and I behaved terribly badly. You know, refused to smile and that kind of thing,' she recalled.

She had been accepted at Lucie Clayton's modelling school, but they subsequently declined to take her on to their books when she had completed the course. At this stage Parkinson stepped in to help and took a series of photographs for her portfolio that she described as 'a model girl's passport and Identikit rolled into one.'

The new photographs did the trick and Lucie Clayton signed her up on the spot. 'We think she's going to do very well indeed. In fact, she's already doing so,' they enthused, in a complete about-face.

A New Face for the New Year

Published 14 January 1968
Photographer Patrick Hunt
Fashion Belted coat dresses by Hylan Booker, Liza Spain and Jean Muir. Hair by Jean at Aldo Bruno
Original journalists Ernestine Carter and Evelyn Forbes

'Belts have been back since chains first clanked their ways through the Paris and Rome Collections. Now they are inching up towards the natural waist after years of being concealed under shift clothes.' Worried that her readers had let their figures slide, Ernestine Carter published 'six of the best' exercises to get waistlines back in shape.

To illustrate her article, and in another exemplary use of overlaid images from Patrick Hunt's studio, she chose belted coat dresses from the leading names in ready-to-wear.

Jean Muir was already well established, but Hylan Booker was just beginning his career in fashion. Born in Detroit, he studied at the Royal College of Art after a brief stint at Swindon Art College. He went on to design for the House of Worth, Baccarat and Windsmoor, eventually returning to the US to work with a host of ready-to-wear companies, before establishing his own couture business.

For a brief period in the late 1960s and early 1970s Liza Spain made high quality wholesale ready-to-wear, but in contrast to Miss Muir and Mr Booker, the brand had vanished without a trace by the end of the decade.

Belted in for Spring

Published 11 February 1968
Photographer David Montgomery
Models Michael Fish and Janet Lyle
Fashion Annacat and Mr Fish. Hair
by Patti at Smith & Hawes
Original journalist Sandy Boler

The late 1960s was the golden age of the boutique, and two of the brightest stars were Michael Fish of Mr Fish and Janet Lyle of Annacat.

Mr Fish became a byword for sophisticated male tailoring, shirts and ties, attracting pop stars and the attention of the fashion press to his Clifford Street showrooms in the West End. Designed for the modern dandy, with structured, Regency-inspired tailoring, bright floral prints and luxurious fabrics, he dressed Terence Stamp in Modesty Blaise and put Mick Jagger in a smock dress that turned heads at the 1969 Rolling Stones concert in Hyde Park.

Janet Lyle and Maggie Keswick owned and designed for the Knightsbridge boutique Annacat, specialising in fun, innovative clothes for day and dramatic, romantic evening wear for night. Famed for using vibrant prints and ginghams, often trimmed with lace and broderie anglaise, both designers were particularly well connected and were featured heavily in the fashion press. Such was their popularity that the boutique doubled its first year's takings in its second, and by 1968 exported designs to Bonwit Teller, Henri Bendel and Saks Fifth Avenue in New York. However, the brightest stars often burn for the shortest time, and by 1970 the business was sold and the label's brief tenure at the heart of London's boutique scene was over.

Boutique Stars: Mr Fish and Annacat

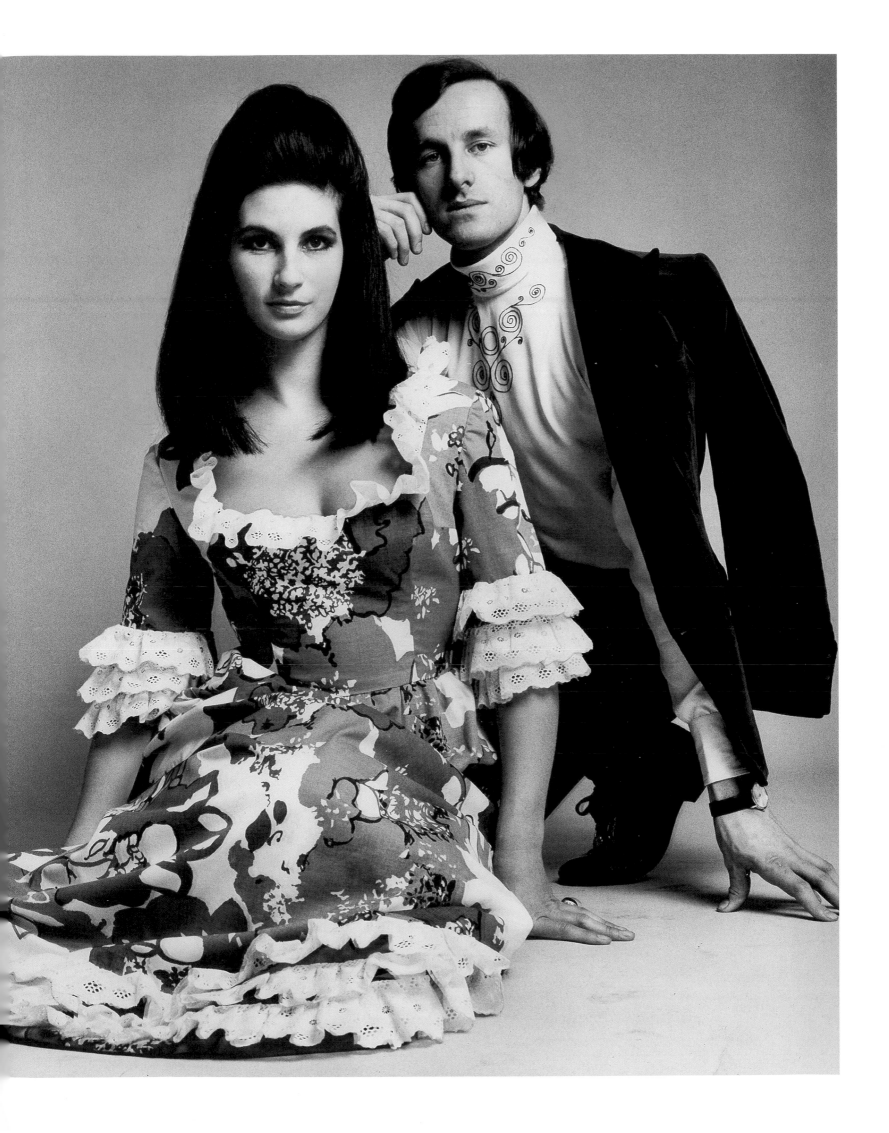

Published 31 March 1968
Photographer Donald Silverstein
Model Madeleine Smith
Fashion Bold print minidresses by Biba
Original journalist Ernestine Carter

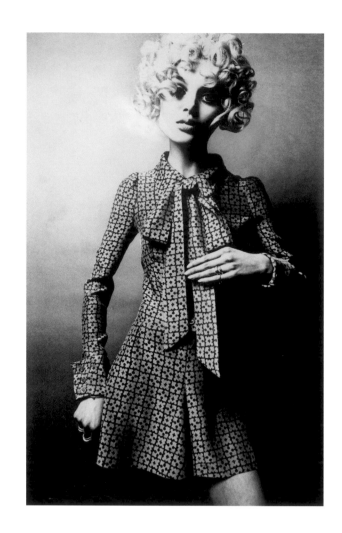

Although the late 1960s economy was looking increasingly depressed, the boutique business was booming.

Biba was one of the greatest success stories of the decade, and was described as a 'mini store that specialises in the maxi look' by Ernestine Carter. It had opened three years previously, the brainchild of Barbara Hulanicki (b.1936).

The interior was a 'forest of clothes trees', art nouveau wallpaper, aspidistras and rail upon rail of inexpensive dresses, hats, jewellery – all with a soundtrack of up-to-the-minute hits.

Turnover in 1968 was ten times that of 1967 and the firm had just negotiated a deal with a French wholesaler to take 10,000 minidresses in two of their most popular styles, to be sold across Europe.

Modelling for their first mail order catalogue was actress Madeleine Smith (b.1949), whose credits include *The Killing of Sister George* (1968) and a brief appearance as an Italian secret service agent opposite Roger Moore in *Live and Let Die* (1973).

Biba Conquers the World

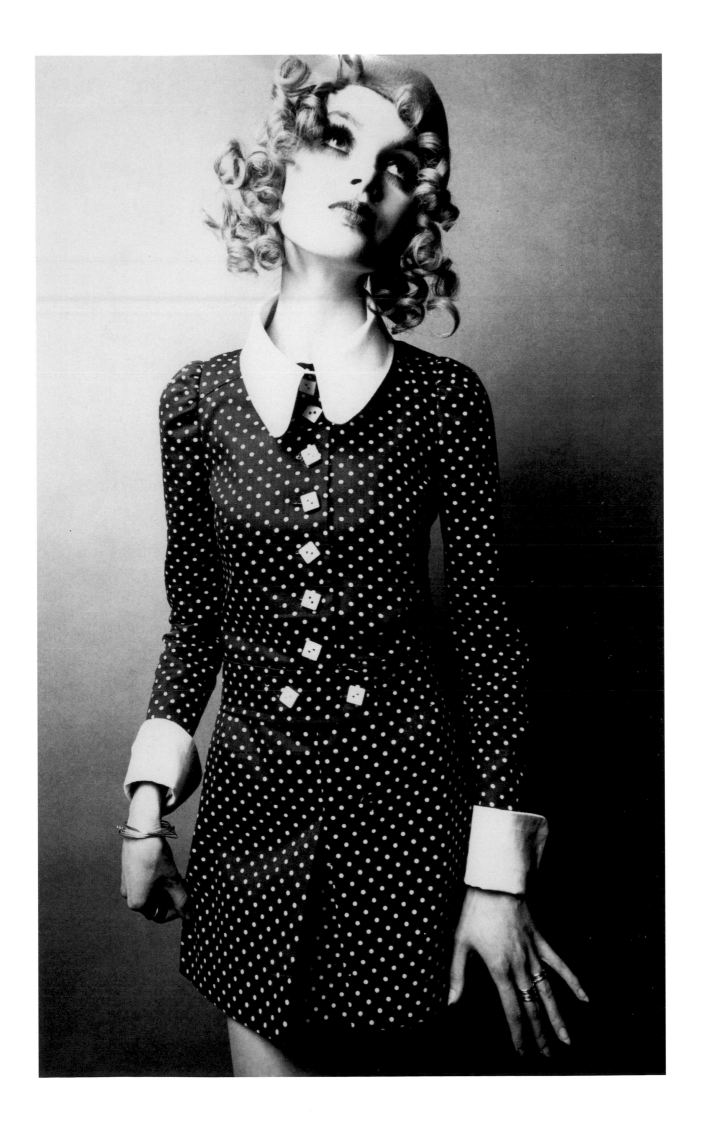

Published 19 May 1968
Photographer Clive Arrowsmith
Fashion Layered trapeze smock by
Gina Fratini
Original journalist Sandy Boler

With a dressing-up box of laces, velvet, Indian paisleys and printed cottons, Gina Fratini (b.1934) mastered the romantic mood sweeping into fashion.

Born Georgina Butler in Japan, she enrolled at the fashion school at the Royal College of Art in 1950. After a spell in America working in stage and costume design, she produced her first collection in Britain in 1966.

It proved incredibly successful. The pages of fashion magazines were soon full of romantic smocked and layered dresses, all with a hint of Victorian nostalgia. Her feminine and dramatic clothes contrasted sharply with the geometric modernism that had gone before, and she was one of the pioneers of the 'midi' and 'maxi' looks which were to eclipse the 'mini' by the end of the decade.

Particularly suited to wedding and evening dresses, her business thrived in the 1970s, when she designed for a host of society figures including Lady Diana Spencer and Viscountess 'Bubbles' Rothermere.

The First and Last of the Romantics

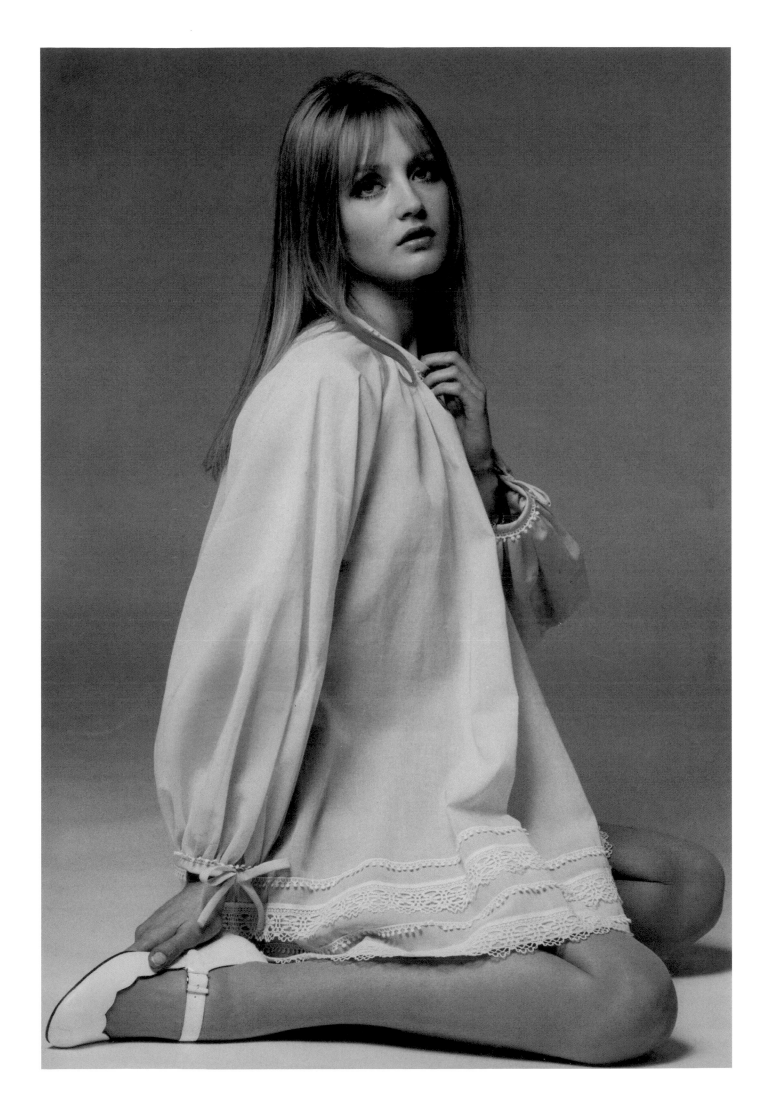

Published 9 June 1968
Photographer Norman Eales
Fashion White crêpe dress by Mary
Quant for Ginger Group. Hat by
Graham Smith
Original journalist Ernestine Carter

'June is the month for fetes and festivals,' and the increasingly contradictory messages from fashion designers were causing Ernestine Carter a headache.

In her autobiography, *Tongue in Chic,* she makes no apologies for her frustration with many of the aspects of fashion in the 1960s. 'It was a period of moral, artistic and political confusion which fashion reflected with painful exactitude.'

Advising her readers what to wear for the traditional events of the season became a problem. For men, it was still morning dress; for ladies, the rules were erratic. At the races the shortest of minidresses, like Mary Quant's white crêpe mini for Ginger Group, usually got past the stewards, but trouser suits were still off-limits.

Mrs Carter recalled that the 'midi' length of the late 1960s caused many businesses financial pain. The mini had reached almost as high as it could go, so the only way for hems to travel was down. The young British shopper 'fell into the maxi with cheers; after all, they had been trailing the King's Road for months in their granny dresses,' – but Paris took time to adjust. All those ready-to-wear firms that still looked to France to judge hemlines had ordered the short lengths as normal, and were then left with clothes they couldn't sell.

What to Wear for Ascot

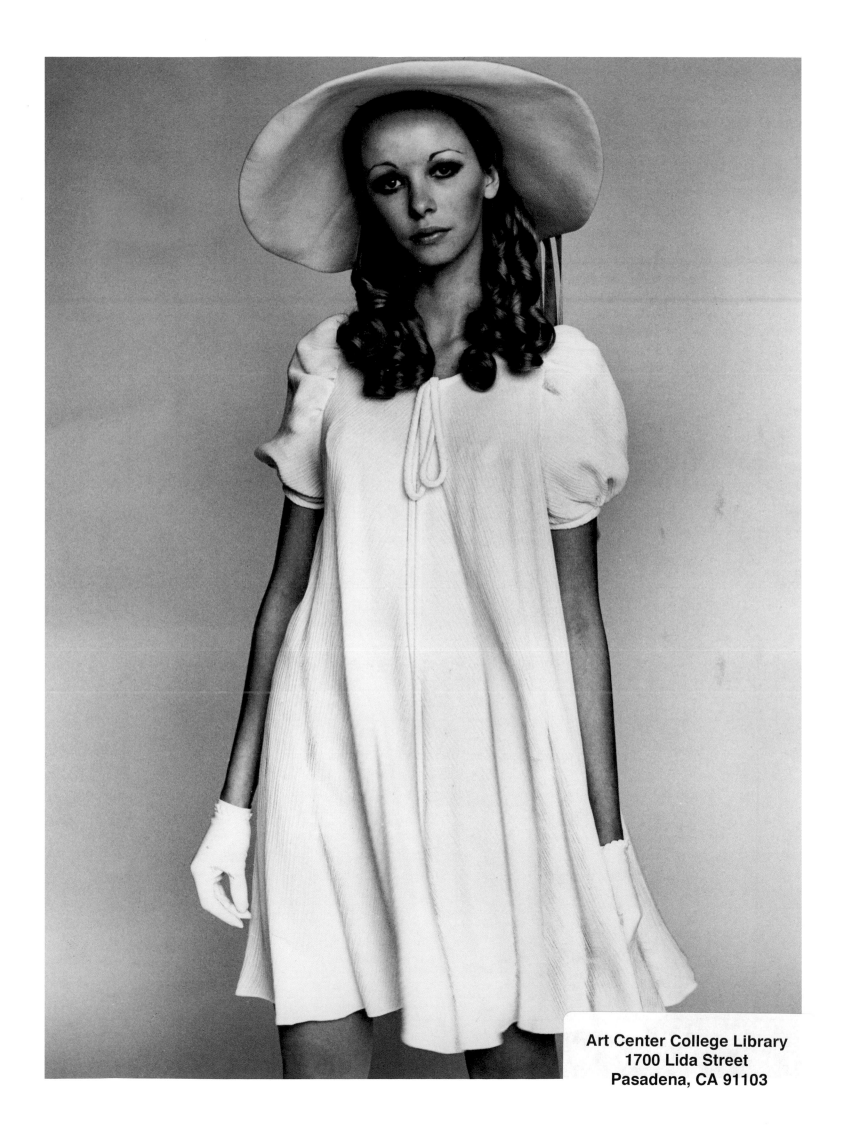

Art Center College Library
1700 Lida Street
Pasadena, CA 91103

Published 16 June 1968
Model Gala Mitchell
Fashion Lipstick print chiffon shirt by
Zandra Rhodes and Sylvia Ayton
Original journalist Sandy Boler

From the newly opened Fulham Road Clothes Shop, Zandra Rhodes (b.1940) and Sylvia Ayton (b.1937) sold a wave of innovative designs characterised by beautifully printed textiles in a refreshingly electric palette.

Both had studied at the Royal College of Art, and Sylvia Ayton had practical experience of design from Wallis Shops. Between them they produced clothes that exploited the versatility of screen-printing, in what was to be a period of renaissance for textile design. Although hugely popular in the fashion press, the business experienced problems with backers, and had closed by 1969.

With a head of brilliant red, hennaed hair, Gala Mitchell appeared as if she had stepped out of a Pre-Raphaelite painting and on to the catwalk. Her exotic, edgy, glamorous looks chimed perfectly with the rapidly changing face of fashion at the time. She had appeared in Ken Russell's film *Dante's Inferno* (1967) as Jane Morris, the muse and wife of William, and was later to find fame modelling the designs of Ossie Clark.

The Changing Face

Published 23 June 1968
Photographer Annette Green
Model Kelly
Fashion Waterproof tabard and
trousers by Margot Baker
Original journalist Ernestine Carter

Gannex was just one of a new crop of synthetic fabrics
available to students at the Royal College of Art's fashion
school, and for the 1968 end-of-year show, Margot Baker
was top of the tree with an award for her tabard and
trousers using the fabric.

The fashion school, under the watchful eye of Professor
Janey Ironside, had nurtured some of the most
commercially successful names of fashion in the 1960s,
including Janice Wainwright, Ossie Clark, Marion Foale,
Sally Tuffin, James Wedge and Gerald McCann. Yet in
1968 it came to an end, with her resignation in protest
at the decision to deny the school the right to grant
degrees when the college achieved university status.

In the three years between July 1963 and 1966, forty
of her students found jobs in the fashion world; a
remarkable number even given the rapid expansion of
the industry. One student interviewed for the *Sunday
Times* told Mrs Carter: 'My feeling is that she provides
a climate of understanding in which individual talents
can expand; a climate of thought, where the new is
welcome.'

In defence of her much admired colleague, Ernestine
Carter devoted two columns of 'Mainly for Women' to
extolling the virtues of Professor Ironside's tenure,
comparing the academic body which decided on award
procedure to the trumped-up court in *Alice's Adventures
in Wonderland*.

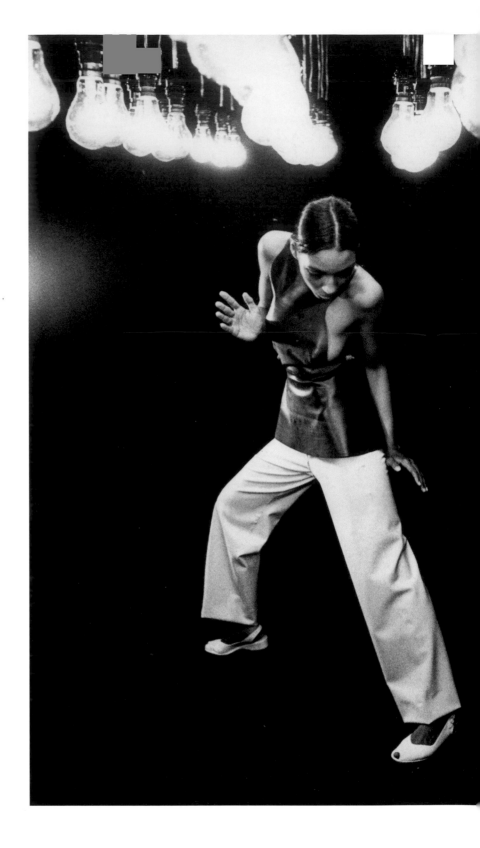

A Competitive
Start

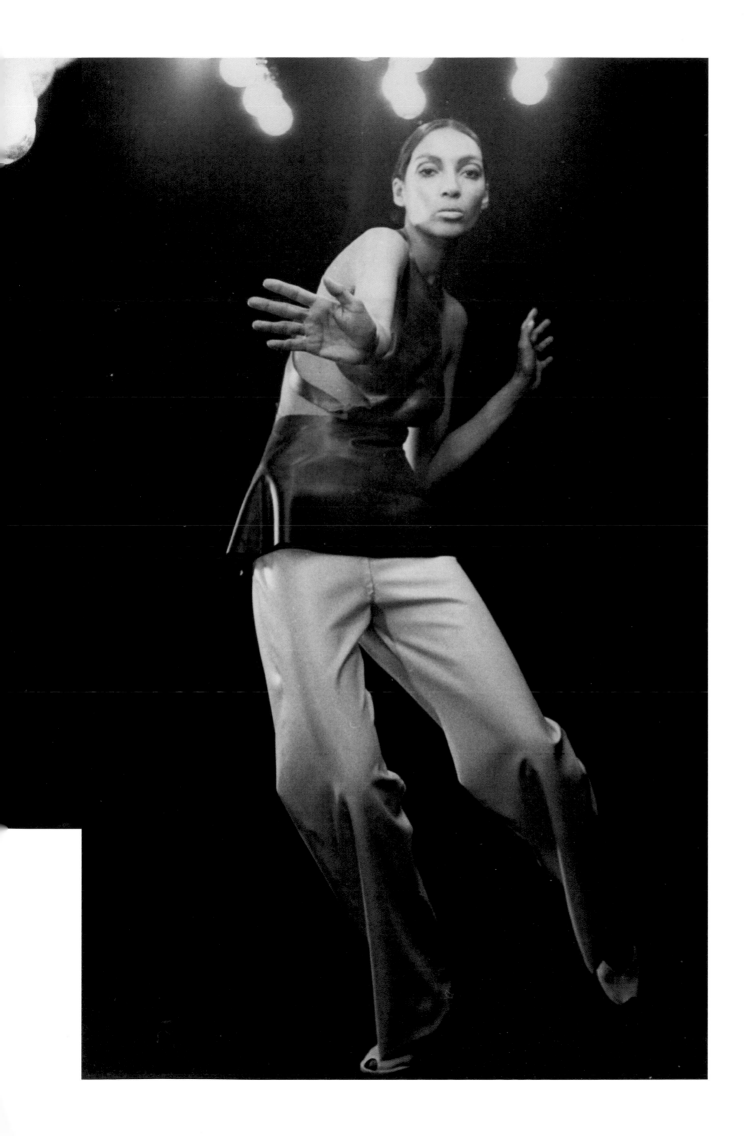

Published 23 June 1968
Photographer Patrick Hunt
Fashion Printed long jacket and wide legged trousers by Ossie Clark for Quorum
Original journalist Sandy Boler

Extolling the designs of Ossie Clark for Quorum, Sandy Boler summarised fashions for 1968 in one sentence, laden with adroit imagery: 'This summer will be remembered for the soft slipper satins, white ruffles, organdie, floppy crepe, wide trousers, droopy-brimmed hats, boleros and outrageous garden party frocks: mid-calf length, vampish and full of film star glamour.'

Historical references were drawn from a host of sources, as fashion became a dressing-up box of exotic fabrics, textures, colours and, most importantly, print.

Ossie Clark (1942-1996) was well placed to exploit the new taste for the bohemian. His partner was Celia Birtwell (b.1941), who remains one of the most commercially successful textile designers in Britain. First working together in 1966, they sold at Quorum boutique in Chelsea, along with designer Alice Pollock.

Between them they used the new art deco influenced prints to perfection, with some of their most memorable collaborations taking place in the late 1960s and early 1970s.

The Glory of Print

Published 30 June 1968
Photographer Sally Soames
Fashion Sale fashions by Peter Robinson
Original journalist Ernestine Carter

A seemingly mundane sale window of department store Peter Robinson at Oxford Circus was singled out for praise by Ernestine Carter, who regularly bemoaned the state of store windows at sale time.

She sent photographer Sally Soames to capture the moment and tracked down the window designer, Tom Ellery. He received a pat on the back, agreeing that customers often had to endure dull racks of clothes and a lack of flair at sale time.

Included in his window was a Sophia Loren model mannequin by Adel Rootstein. Founded in 1956, the company employed sculptors to model directly from life, with cover girls, actors and singers lining up to become the inspiration for new mannequins. Other sitters included Twiggy, Sandie Shaw and Joan Collins, but celebrity was not a prerequisite, and members of the office staff or strangers in the street were all invited to pose.

A Window on the World

Published 15 September 1968
Photographer Clive Arrowsmith
Models Michael Fish and Barry
Sainsbury
Fashion Evening shirts by Mr Fish
Original journalist Ernestine Carter

Michael Fish's fashion empire was expanding rapidly, and soon America wanted his sharp tailoring, vivid silk cravats and romantic shirts too.

In the autumn of 1968 he opened a Mr Fish boutique within Alexander's department store in New York, adding fashionable Manhattan to his list of clients, which that year was to include James Fox in the film *Duffy,* and even the Duke of Windsor, who was reported to have been seen buying Mr Fish shirts and ties in America.

Michael Fish modelled his own designs with business partner Barry Sainsbury, and the historically inspired shirts for evening show just how far menswear had developed in a short period of time. In what the press termed the 'Peacock Revolution', inspiration came from sources as disparate as the gilt braid and bullion rope-trimmed jackets of military uniform, the high necked stocks of the Regency period, and the bright silk and paisley prints of India.

Mr Fish ended the decade in fitting style by publishing a book entitled *Doing Your Own Thing.*

Mr Fish Goes to New York

Published 1 December 1968
Photographer John Patrick
Fashion Evening dress in printed and
embroidered tulle by Savita
Original journalist Ernestine Carter

As The Beatles returned from their ashram in India,
fashion and interior design joined music, and embraced
the influence of India, Morocco, Turkey – anywhere that
had a style to be reinterpreted.

Seen by many as an upmarket reaction to the arrival
of the hippy, 'ethnic chic' did not come cheaply for the
readers of 'Mainly for Women': this exotically
embroidered tulle evening dress by Savita cost eighty-
two guineas. Ernestine Carter saw the trend as an
international dressing-up box, offering articles on
clothes for evening with individual themes; Turkish
and Indian feature in this particular spread.

The desire to assimilate design elements from other
cultures rapidly ran parallel to what Ernestine Carter
referred to as the 'design confusion' of the 1960s. In
her eyes, 'no one designer, style or movement emerged,
as fashion searched frantically for inspiration, from
old and new films, from pop art to African art, from
Mondrian to Klimt.'

The Dressing-up Box

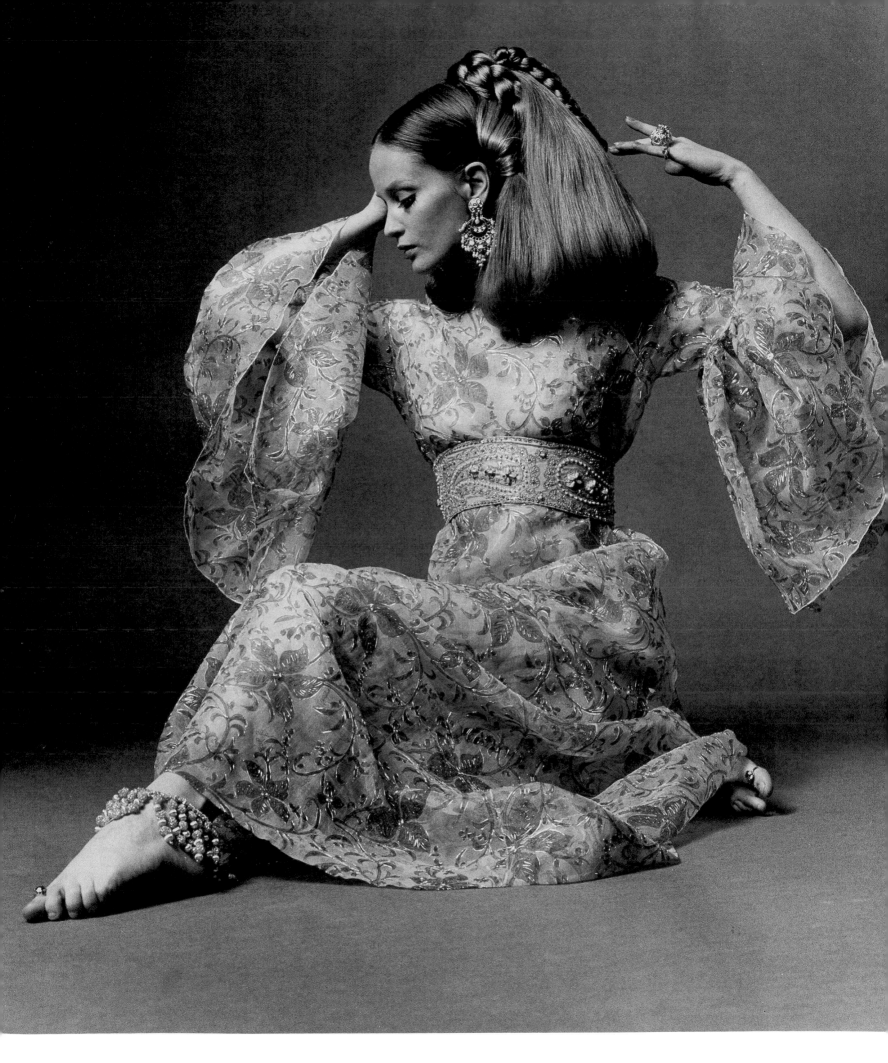

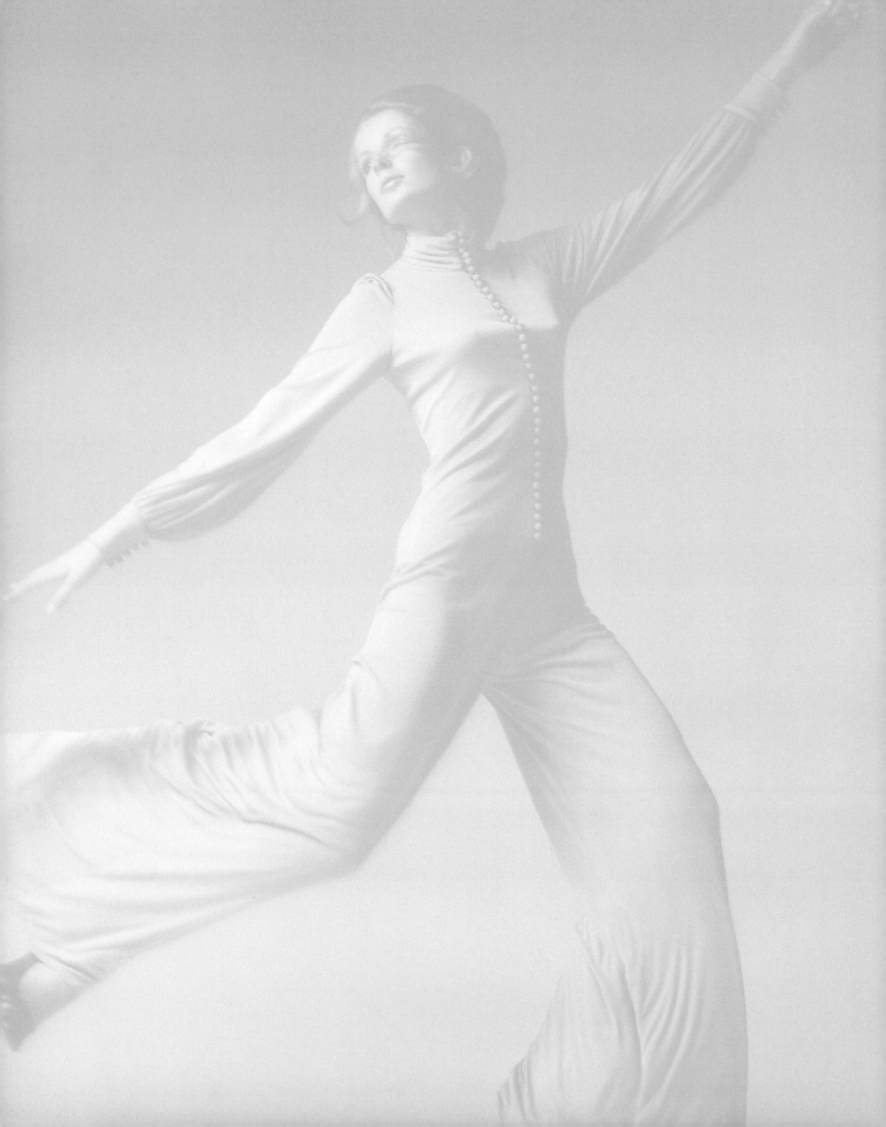

69

Published 15 June 1969
Photographer David Montgomery
Model Rupert Lycett Green
Fashion Cream morning suit by Blades
Original journalist Ernestine Carter

'Ladies Day may turn out to be a man's finest hour,' commented Ernestine Carter as she invited the man behind Blades boutique to model his alternative morning suit for Ascot.

In cream grosgrain with moire lapels, whether it ever made it past the stewards of the royal enclosure is not recorded. On his arm, Rupert Lycett Green's escort for ladies' day wears a coat dress by Mr Reginald.

Blades' success was based on the ability, like Mr Fish, to attract new and old Savile Row customers to the firm's glamorous West End boutique, with its interior by David Mlinaric.

Married to Sir John Betjeman's daughter Candida, Rupert Lycett Green epitomized the new fashion-conscious and well-connected socialite, counting The Beatles, Terence Stamp and John Aspinall as customers.

An Alternative Ladies' Day

Published 19 September 1969
Photographer David Montgomery
Fashion Silk jumpsuit by Jean Muir
Original journalist Ernestine Carter

Asked by Harvey Nichols to celebrate the opening of nine new windows at the Knightsbridge store, Ernestine Carter chose British fashion for their 'Way to Look' promotion.

Amongst the roll call of famous names, she chose a silk jumpsuit by Jean Muir, retailing at £46, and coats by luxury ready-to-wear firms Capricorn and Baccarat.

Capricorn had been started as a subsidiary business by John Bates in the late 1960s. As sole designer, he aimed to produce high-quality coats and suits, competing in the same market as Baccarat. They, in contrast, employed a team of designers, at one stage including Bill Gibb.

To complement the clothes came costume jewellery from Adrien Mann, one of the most prolific manufacturers of the 1950s and 1960s, and still in business today.

The Way to Look

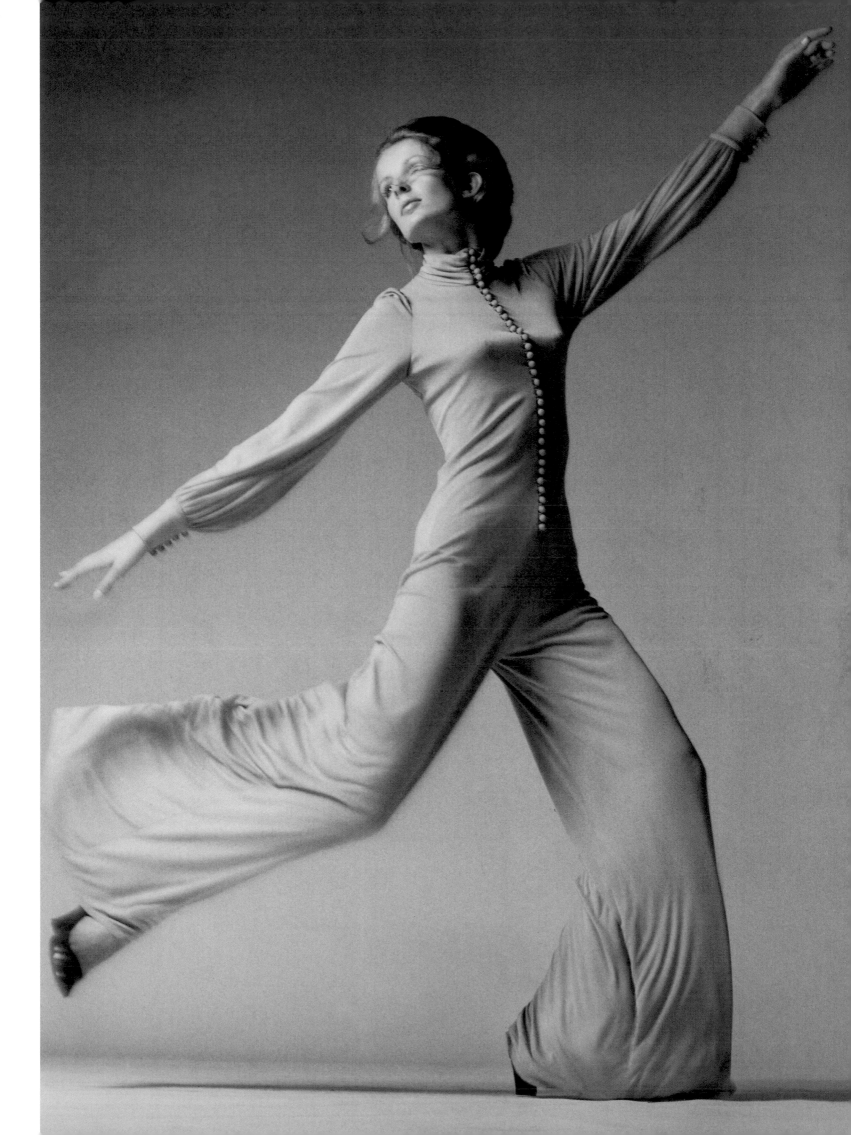

Published 16 November 1969
Photographer Patrick Hunt
Fashion Layered trouser suit in Liberty
print by Mary Quant
Original journalist Ernestine Carter

Mary Quant adapted to the end of the decade by raiding the beautiful Tana lawn prints produced by Liberty, in a layered trouser suit for Ginger Group.

'I wanted to mix prints, dots and stripes, so that they could be seen through layers, mixing as they move.'

The ideal woman of mainstream fashion had moved rapidly away from the shift-dress-wearing, short-haired waif popularised by Twiggy, towards a more feminised ideal. 'I wanted to get a well-bred trollop look,' commented the designer, confirming the last rites for beauty's previous personification.

Continually popular, the dense, floral Tana lawn prints sold by Liberty managed to weather any fashion storm, being used by a number of designers across the decade. Still in production, many designs date from the nineteenth century, but through a process of recolouring, retirement and introduction of new designs, the range continues to sell across the world.

A New Love of Layers

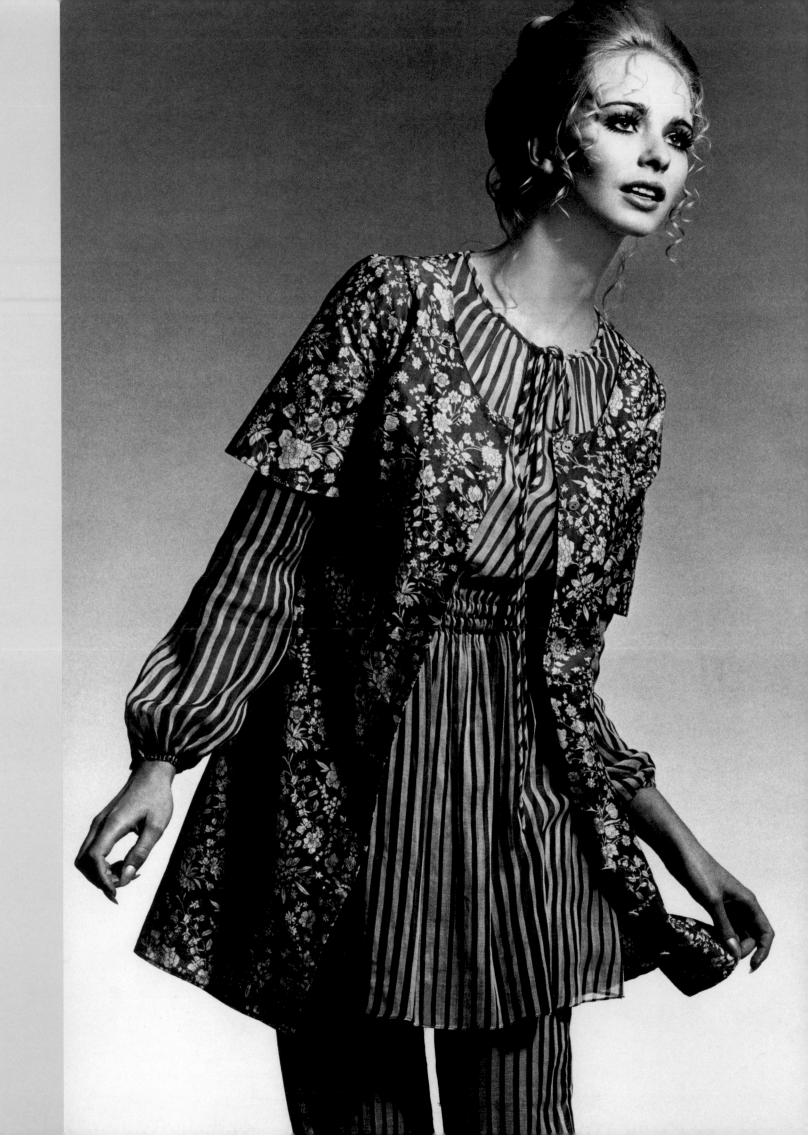

Published 23 November 1969
Photographer Patrick Hunt
Fashion Milkmaid cotton dress by
Gina Fratini
Original journalist Ernestine Carter

The maxi dress had won the battle of the hemlines by the end of the 1960s and Gina Fratini celebrated with lace, ribbons and gingham.

Like Laura Ashley (1925-1985) and her hand-blocked, printed cotton dresses, an imagined romantic past inspired designers to combine fabrics and historical references as never before. Whereas Laura Ashley grew into a High Street business, Gina Fratini's designs were always wrapped in luxury, a particular favourite with the readers of *Vogue, Harper's Bazaar* and *Queen*.

What both designers did share, however, was a love of natural fabrics. In Gina Fratini's case the layers of her Victorian dolls' clothes prompted almost all of her work to include multiple cotton and voile petticoats, in some cases even pantaloons. They also complemented a renewed interest in craft, with Laura Ashley making a selling point of the fact that all her cottons were produced in Wales using traditional methods, even when she began to sell abroad in large quantities.

Gina Fratini continued to design well into the 1980s, benefiting from a further burst of romantic nostalgia in the late 1970s and beyond. Laura Ashley ceased being a family concern shortly after the early death of its founder, but continues to trade, albeit as a mass-market brand.

Curtain Up on Drama

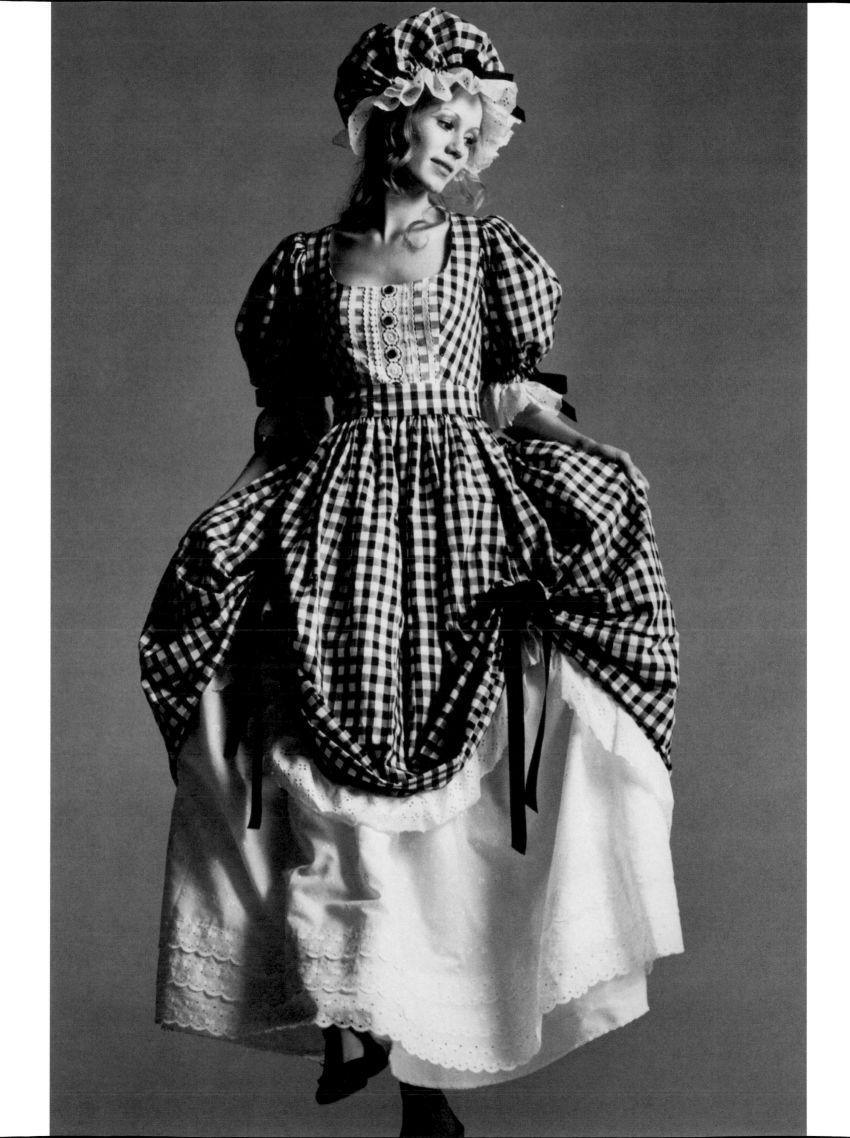

Published 28 December 1969
Photographer Patrick Hunt
Fashion Butterfly printed long coat over
satin evening trousers by Thea Porter
Original journalist Ernestine Carter

Thea Porter (1927-2000) mastered the combination of exotic Middle Eastern and oriental influences and the use of exquisite textile designs to occupy a very special position at the top of her field by the time Ernestine Carter caught up with her in 1969.

'I hate clothes that look new,' she was reported as saying in 1968, and her repertoire of harem trousers, kimono dresses and voluminous kaftans meant that she rapidly established a reputation with customers worldwide, including Elizabeth Taylor and Charlotte Rampling.

Her business had started in Soho in 1966, initially selling Middle Eastern carpets and fabrics, then moving into clothing, but unlike many of her competitors she remained out of the limelight, intent on maintaining the design ethic of beauty before profit.

Like Bill Gibb, her talent lay in the detail, the craft and the construction of clothes, with some of her most famous designs incorporating the butterfly wing print, as photographed for the *Sunday Times* by Patrick Hunt.

The New Bohemian

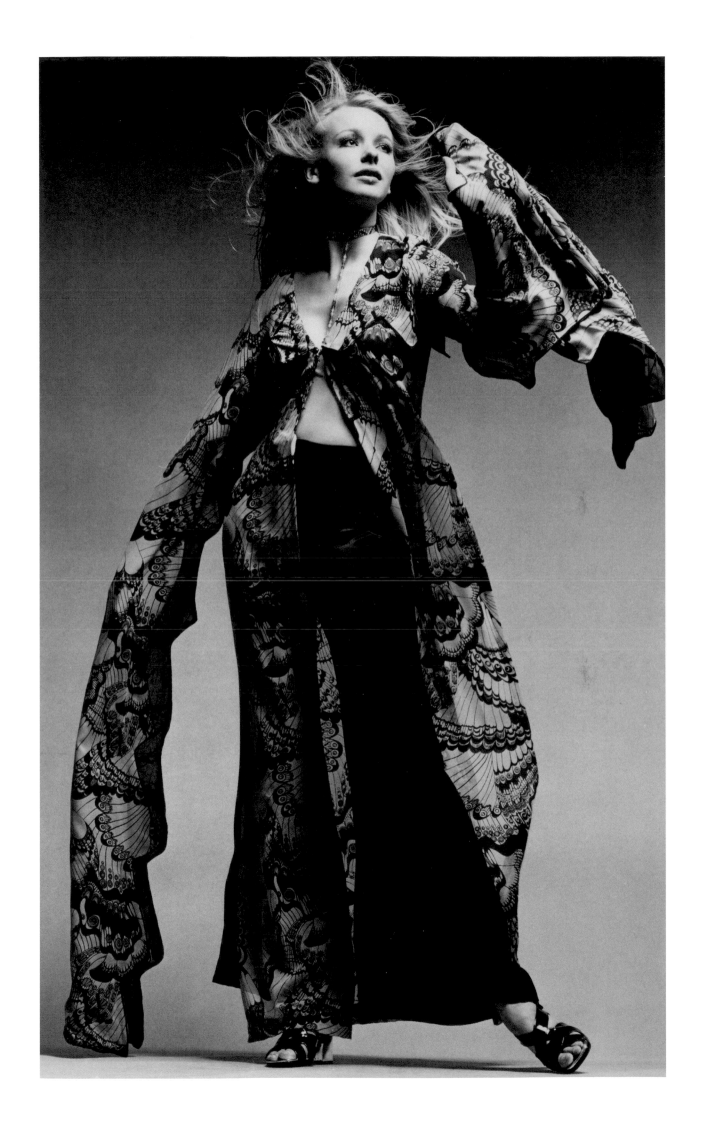

Published 28 December 1969
Model Celia Birtwell
Fashion Velvet evening coat and
organdie blouse in Celia Birtwell print
by Ossie Clark
Original journalist Ernestine Carter

To close the sixties, one of the most successful names of the seventies and beyond: only Zandra Rhodes has come close to the originality and continued commercial success of Celia Birtwell in the field of textile design.

Through her partnership with Ossie Clark, firstly selling at Quorum for his own label, and later in association with Radley, her ability to reinterpret art deco motifs has created a whole generation of modern classics, including perhaps her most famous design, 'Floating Daisy'.

Whilst her partner, later her husband, designed the clothes, Celia Birtwell worked from home creating coordinating fabrics in moss crêpe, satin and organdie. In one of the most famous portraits of the era, she appeared in *Mr and Mrs Clark and Percy,* painted by David Hockney.

Since the early 1980s she has owned her own boutique in Westbourne Grove, recently designing sell-out collections for Top Shop, reworking many of the designs of the late 1960s in new colourways and fabrics.

A Feeling for Fabric

Index

190

With thanks to Rosemary Harden and all at the Fashion Museum in Bath, Matthew Freedman, James Smith and ACC, John Bates and John Siggins, Brigid Keenan and Caroline Colthurst for their memories of working with Mrs Carter, Peter Rand, the British Newspaper Library, Robert Shaw and Northbank Design, and Geoff Cox for his continued humour and proofreading skills.

GrallACC

1. March 10 Aceom Books 55.00 108566

Art Center College Library
1700 Lida Street
Pasadena, CA 91103